Deleuze & Guattari,
Politics and Education

Also Available From Bloomsbury

Deleuze and Guattari, Fadi Abou-Rihan
Deleuze and Guattari's 'A Thousand Plateaus', Eugene W. Holland
Deleuze and Guattari's Philosophy of History, Jay Lampert

Deleuze & Guattari, Politics and Education: For a People-Yet-to-Come

Matthew Carlin and Jason Wallin

B L O O M S B U R Y

NEW YORK • LONDON • NEW DELHI • SYDNEY

Bloomsbury Academic

An imprint of Bloomsbury Publishing Plc

175 Fifth Avenue 50 Bedford Square
New York London
NY 10010 WC1B 3DP
USA UK

www.bloomsbury.com

Bloomsbury is a registered trade mark of Bloomsbury Publishing Plc

First published 2014

British Library Cataloguing-in-Publication Data
A catalogue record for this book is available from the British Library.

ISBN: HB: 978-1-4411-6616-6
e-Pub: 978-1-6289-2259-2
e-PDF: 978-1-6289-2258-5

Library of Congress Cataloging-in-Publication Data
A catalog record for this book is available from the Library of Congress.

Typeset by Fakenham Prepress Solutions, Fakenham, Norfolk NR21 8NN
Printed and bound in United States of America

Matthew
This book is dedicated to Karina and Lucia for
their love and support

Jason
This book is dedicated to Rowan, that you might one day read it

Contents

List of Illustrations

Contributors

Franco Berardi is an activist and educationalist working in the Italian autonomist tradition. He teaches social history of communication at the Accademia di belle Arti in Milan. Founder of the Italian magazine *A/traverso* (1975–81), he was on the staff of Radio Alice, the first independent radio station in Italy (1976–8). Recent books include: *The Uprising: On Poetry and Finance* (2012); *After the Future* (2011); *Precarious Rhapsody: Semio-capitalism and the Pathologies of the Post–Alpha Generation* (2009); *The Soul at Work: From Alienation to Autonomy* (2009); *Felix Guattari: Thought, Friendship and Visionary Cartography* (2008).

Ian Buchanan is Professor of Cultural Studies and Director of the Institute for Social Transformation Research at the University of Wollongong, New South Wales, Australia. He is the founding editor of *Deleuze Studies* and the author of the *Oxford Dictionary of Critical Theory* (2010).

Matthew Carlin has taught at Columbia University's Teachers College and Pratt Institute in New York City. His teaching and writing focus on: the overlap of politics and aesthetics in Latin America; violence and social change; and pedagogy. He is the co-author of the forthcoming book *The Pedagogy of Objects* (2014).

David R. Cole is a Lecturer at the University of Western Sydney (Associate Professor). He is a trained philosopher and educational thinker, concerned with opening up new modes of thought. David researches and writes in a multidisciplinary manner, harnessing impacting and motivatory ideas, and trying to move away from subjugation to any one modality or form of containment. So far, this approach has yielded nine books (including a novel called *A Mushroom of Glass* (2007)) and numerous articles, book chapters, research grants and presentations. David's latest monograph is called: *Educational Life-forms: Deleuzian Teaching and Learning Practice* (2011).

Elizabeth de Freitas is an Associate Professor in the Ruth S. Ammon School of Education at Adelphi University in Garden City, New York. Her research

focuses on philosophical and socio-cultural studies of mathematics and mathematics education, with particular interest in diagramming and the material conditions of mathematical practices more generally. She is an Associate Editor of the journal *Educational Studies in Mathematics*. She is author of the novel *Keel Kissing Bottom* (Random House, 1998) and co-editor of the book *Opening the Research Text: Critical Insights and In(ter)ventions into Mathematics Education* (Springer, 2007). Elizabeth's recent publications include *The Classroom as Rhizome: New Strategies for Diagramming Knotted Interactions* (Qualitative Inquiry, 2012), *What were you Thinking? A Deleuzian/ Guattarian Analysis of Communication in the Mathematics Classroom* (*Educational Philosophy and Theory,* 2012) and *The Mathematical Event: Mapping the Axiomatic and Problematic in School Mathematics* (*Studies in Philosophy and Education,* 2013). Her co-authored book *Mathematics and the Body: Material Entanglements in the Classroom* will be published by Cambridge University Press in 2014.

Petra Hroch is a PhD candidate (ABD), SSHRC CGS and Killam Scholar in Theory and Culture (Department of Sociology) at the University of Alberta, in Edmonton, Canada. Her interdisciplinary research on art and design, sustainability, and materialist and post-humanist theory appears in *Walter Benjamin and the Aesthetics of Change* (2010), *Ecologies of Affect* (2011), *Demystifying Deleuze* (2013), *Journal of Curriculum and Pedagogy* (2013), and *Mediatropes* (2013).

jan jagodzinski is a Professor in the Department of Secondary Education, University of Alberta in Edmonton, Canada. Book credits include *The Anamorphic I/i* (Duval House Publishing Inc., 1996); *Postmodern Dilemmas: Outrageous Essays in Art&Art Education* (Lawrence Erlbaum, 1997); *Pun(k) Deconstruction: Experifigural Writings in Art&Art Education* (Lawrence Erlbaum, 1997); editor of *Pedagogical Desire: Transference, Seduction and the Question of Ethics* (Bergin & Garvey, 2002); *Youth Fantasies: The Perverse Landscape of the Media* (Palgrave, 2004); *Musical Fantasies: A Lacanian Approach* (Palgrave, 2005); *Television and Youth: Televised Paranoia* (Palgrave, 2008); *The Deconstruction of the Oral Eye: Art and Its Education in an Era of Designer Capitalism* (Palgrave, 2010), *Misreading Postmodern Antigone: Marco Bellocchio's Devil in the Flesh (Diavolo in Corpo)* (Intellect Books, 2011) and *Psychoanalyzing Cinema: A Productive Encounter of Lacan, Deleuze, and Žižek* (Palgrave, 2012), and *Arts-Based Research: A Critique and Proposal* (with Jason Wallin, Sense, 2013.)

John Rajchman is a philosopher working in the areas of art history, architecture, and continental philosophy. He is Associate Professor and Director of Modern Art MA Programmes in the Department of Art History and Archaeology at Columbia University, in New York City. He has previously taught at Princeton University, Massachusetts Institute of Technology, Collège International de Philosophie in Paris, and the Cooper Union, among others. He is a Contributing Editor for *Artforum* and is on the board of *Critical Space*. He received a BA from Yale University and a PhD from Columbia University.

Matthew Tiessen is an Assistant Professor specializing in the School of Professional Communication (ProCom) in the Faculty of Communication and Design (FCAD) at Ryerson University, in Toronto. Matthew's research has been featured in interdisciplinary journals and anthologies such as: *Theory, Culture & Society*; *Cultural Studies<=>Critical Methodologies*; *CTheory*; *Rhizomes: Cultural Studies in Emerging Knowledge*; *Surveillance & Society*; *Space and Culture*; *Pli: The Warwick Journal of Philosophy*; *Revisiting Normativity with Deleuze* (Bloomsbury, 2012); *Ecologies of Affect: Placing Nostalgia, Desire, and Hope* (Wilfrid Laurier University Press, 2010,); and *What Is a City? Rethinking the Urban after Hurricane Katrina* (University of Georgia Press, 2008). He is also an exhibiting artist.

Jason J. Wallin is Associate Professor of Media and Youth Culture in Curriculum in the Faculty of Education at the University of Alberta, in Edmonton, Canada, where he teaches courses in visual art, media studies, and cultural curriculum theory. He is the author of *A Deleuzian Approach to Curriculum: Essays on a Pedagogical Life* (Palgrave Macmillan, 2012), and co-author of *Arts-Based Research: A Critique and Proposal* (with jan jagodzinski, Sense Publishers, 2013). Jason is assistant editor for the *Journal of Curriculum and Pedagogy* (Routledge) and reviews editor for *Deleuze Studies* (Edinburgh University Press).

Foreword

A Pedagogy of the Concept

John Rajchman

The theme of pedagogy has remained somewhat undeveloped in the philosophy, thinking and practice of Deleuze and Guattari. It has rarely been thematized as such. And yet it plays a key role in the ways their philosophy arose, the changes it went through, and the manner in which it might be taken up or reinvented today.

How in fact does one learn – and how does one teach – the singular creation they called 'the concept', where, in what kind of space, in what conditions, with whom (or with what sort of 'friends')? No doubt the question is a very old one in philosophy, there from the very start, already in Plato and then accompanying all the 'reversals of Platonism' that would follow. There were the Cynics for example, to whom Foucault would turn in his late search for styles of thinking and teaching outside constituted knowledge and power, yet involved with 'processes of subjectivization' of a sort pursued in the arts: a teaching without prior or transmissible Doctrine, working instead through shocking or scandalous acts, opening up a cosmopolitan space of 'citizens of the world' for a time yet to come (2001). But the philosophical problem of pedagogy is to be found as well in the way Wittgenstein turned the whole question of how we learn concepts into a path out of formal logic or method towards a new picture of the grammar of thinking, the game of life.[1]

It is in this light that we can read the striking passages in which Deleuze and Guattari (1994) talk of a 'pedagogy of the concept' in the last lines of the Introduction to their last book together, *What is Philosophy?* (Columbia, 1994):

> The post-Kantians concentrated on a universal *encyclopedia* of the concept that attributed the creation of concepts to a pure subjectivity rather than taking on the more modest task of a *pedagogy* of the concept, which would have to analyze the conditions of creation as factors of moments remaining singular.

[1] The story of Wittgenstein's attempt to give up philosophy and teach in a high school in an ill-fated engagement with the pedagogical movement of the day is told by Ray Monk, *Ludwig Wittgenstein: The Duty of Genius* (1990).

A 'pedagogy of the concept': no doubt the phrase takes off from what Godard had called a 'pedagogy of the image' in and through cinema, following the principle *'pas une idée juste, juste une idée'* (not a correct idea, just an idea) (Deleuze, 1995, p. 38). But in fact, the project for *What is Philosophy?* (1994) is already announced in the last pages of Deleuze's study of cinema in response to Godard's worries that cinema as a way of 'having ideas' was ending – a worry that formed part of a more general one that the singular moment for the creation, and so for the teaching, of the concept was closing down in Paris. Deleuze (2012) feared one was entering a 'poor period' for philosophy, following the 'rich period' in which the work of his generation had flourished. The same worry is to be found in a number of essays in the mid-1980s: Deleuze's 'Mediators' of 1985 (1995, p. 121) and with Guattari in 1984, 'May 68 didn't happen' (2006, p. 233). The question 'What is philosophy?' arose against this background, as if in an attempt to encapsulate the practice of a rich moment for a new time, elsewhere, where it might be taken up again in fresh circumstances. In many ways, this diagnosis has proven prescient, the situation they feared grown worse. Perhaps today the peculiar conditions that led to their own experiment in 'multi-authorship' are no longer to be found in Paris, or perhaps anywhere. Their view of a 'pedagogy of the concept', this modest task, outside any encyclopedia, without any prior 'intersubjectivity' or constituted public, has thus become part of the larger question of how we see their work, how we use it. Such then is the situation in which we ask again: what is the 'pedagogy of the concept', where, with whom, with what friends can it be carried on?

If it is hard to imagine in Paris today the kind of 'extra-disciplinary' space vital to the creation of concepts, it is no doubt in part because learning and teaching are themselves now inserted in a larger change in Knowledge, its new role in 'neo-liberal' economies or 'post-Fordist' forms of labour. The Bologna Accords – and the new programmes of art and research that have grown up in reaction to them – are one indication. The very terms of 'creativity' and 'networks' that they were then using have themselves been absorbed, neutralized within this 'new spirit of capitalism'(Boltanski and Chiapello, 2005). The kinds of 'control' that Deleuze saw arising in the post-war period, with new technologies, new ideas of information, as well as the 'social-technical machines' that accompany them, displacing the old 'disciplines' of the Factory and the old politics of the national welfare state, have spread further and grown more complex. 'What counts is that we are at the start of something new', Deleuze could still say in 1990, 'There is no need to fear or to hope, but to look for new weapons' (1995, p. 178). We now live in that brave new world; the old 'book culture' with 'acts of

writing' as its weapons is receding from us, in favour of new means, new kinds of acts. With the break-up in the 1990s of the national territorial imaginary and the ensuing search for a 'trans-nationality' (displacing the old dreams of a Communist International or a Cosmopolitan Public) has gone a 'reterritorialization' of the activity of thinking in a world of new inequalities created by financial capital and the populisms opposed to it. In this situation we find not only a displacement of the centrality of books, but along with it a shift from linguistic, textual or language-based philosophies or theories in favour of the new paradigms of Brains and Genes for which Deleuze and Guattari had hoped to elaborate a new philosophy of Nature, prior to the distinctions between artifice and nature, innate and acquired, cultural and biological. Thus Deleuze would try to develop a picture of the 'lived brain' and the role of 'vital ideas' in it, while Guattari and Virilio would attempt to expand the very idea of ecology to include not only information but also subjectivity and art, opening onto a new 'molecular revolution' (see Guattari, 2008).[2] In this new situation, we need to do more than fear or despair. In asking about a 'pedagogy of the concept' today – *for* today – we must find ways to make room for its new singular 'conditions of creation', drawing on, reinventing – and so learning from – the philosophies of Deleuze and Guattari.

How then did the problem of learning and teaching arise in their work? In Deleuze, it was posed very early on, after the Liberation, already in the 1950s, in his early essays on Bergson. Bergson would indeed remain one model for Deleuze, as exemplified in the way he had opened his own lectures at the Collège de France to non-philosophers, especially surrounding the whole idea of the virtual. But in this Bergsonian opening there was an 'image of thought' that Deleuze would go on to identify and develop in his study of Proust, who, in contrast with Plato, he saw as working out a whole new picture of learning, where 'ideas always come after', given in sensibility as a kind of 'virtuality' to be then unfolded through the reading of social and erotic signs, leading to a new 'intelligence'– a great new epic of 'aesthetic formation'. Drawing on such sources, Deleuze would elaborate a very different picture from Hegel, not simply of education (*Paidea, Bildung, Formation*), but also of thinking itself, freed from the grand idea of the Encyclopedia that still haunted Hegel. The result of this search for a new picture of formation or learning is then expounded in the passages on '*apprendre*' and '*apprenti*' (*learning, apprentice*) in the chapter on 'The Image of Thought' in *Difference and Repetition* (1994): how to extract

[2] Deleuze's unfinished philosophy of the brain is adumbrated in *What is Philosophy* (1994, p. 208).

'learning' from constituted Knowledge, how to extract 'culture' from given Method.

Expanding on what he had found in Proust's epic of 'reading signs', erotic, social, artistic, without prior sense or common sense, Deleuze then says that one only really learns in paradoxical moments or in times of problematization, such that at the heart of learning there is always a moment of 'unlearning', getting away from Method and from what is already Known. Thinking is rather something that moves in fits and starts, at the borders of constituted disciplines, following sensible encounters with persons or things, which disrupt the common sense, forcing one to think and in the process to discover new friends of thought. We thus not only have a very different picture from the grand story Hegel told of the march of world-historical Forms of the Concept towards Self-Consciousness in Germany, but more generally from the post-Kantian dream of some great emancipatory *Wissenschaft* or Science of Modernity seen as the cumulative 'learning experiences' of Mankind. For in fact, in all real learning, there is always a voyage outside constituted Knowledge or Science, where one finds the fresh air of thinking in new ways. Indeed, too much Culture, too much Method can get in the way, strangling thinking or learning to think. In thinking, in short, one must rather always be, or learn to be, a bit *bête*, a bit stupid, mute, blind, non-human or in-human. But what then are the conditions of such *bêtise* (1994, p. 198)? What does it mean for the learner, the apprentice (*apprenti*), to take up the new questions, both speculative and practical, which arise in such moments, the moments Deleuze would come to call the times of our 'becoming other', as with the events of May 1968 that took place in Paris, but also in many other places, with different sorts of economies or political regimes, thus creating new cross-national solidarities.

One can well imagine why the immediate aftermath of the events of 1968 would seem to offer Deleuze an occasion to develop this image of thought and the role of learning (and unlearning) in it. It is then that he would himself come to Paris to teach in the new 'radical' campus of Paris-Vincennes and encounter Félix Guattari. At the time many new groups took form outside the University or the Party, suggesting new relations between theory and practice, research and learning, philosophers and non-philosophers. Deleuze joyfully took part in the development of these new 'extra-disciplinary spaces', these new 'de-disciplinizing' experiences, energized by Foucault's invention of GIP (Groupe d'information sure les prisons) ('almost as beautiful as one of his books') (2006, p. 272), as well as by Guattari in his attempt to develop the ideas of 'transversal relations' and 'group subjects', which had formed the political core of his work in the 'alternative psychiatric hospital' of La Borde. The pedagogy of

the concept would thus go outside the University, into the Streets, involved with different groups, carrying on new sorts of research, investing new questions, substituting for the old models of Theory and Practice a new picture of 'relay', passing from one struggle, one group to another, in a larger, if undefined or unorganized combat.

To be sure, Deleuze, while still 'teaching the Concept' to students in the Lycée, had already been drawn to two figures outside the confines of the aegis of 'the history of philosophy' in either its Hegelian or Heideggerian forms: Spinoza and Nietzsche, each of whom had themselves worked, learnt and taught outside the setting of the university. In Nietzsche's nomadic wanderings through Europe as a 'private thinker', having given up his 'Public Professorship' in Philology, he saw a new and deterritorialized style and image of thought; and in Spinoza's refusal of a professorship, and his preference for small circles of friends, he had seen the elaboration of a 'pure philosophy', which, even if still in Latin, was addressed to everyone, according to the principle developed in his Ethics: 'to be the greatest number to think the most'. Like Wittgenstein at Cambridge, in teaching philosophy, Deleuze had thus sought (and taught) a new way out of it – a new way of getting out of philosophy by going through it.

But the new unforeseen conditions of 1968 would offer the conditions to make his own way out of the vocation of the traditional public professorship in France. Arriving at the newly founded Department of Philosophy that Foucault had helped establish in Vincennes, Deleuze joined in its refusal of the 'progressivity of Knowledge' and the related training of academic professionals through grand magisterial lectures; he then opened his Seminar instead to '... students and non-students, philosophers and non-philosophers, the young and the old, and many nationalities. There were always young painters and musicians, film-makers, architects, there with a great exigency of thought.'

> It was there [he goes on] that I realized to what philosophy has need not only of a philosophical comprehension, but of a non-philosophical comprehension that works through percepts and affects. Both are needed. Philosophy has an essential and positive relation to non-philosophy – it is directly addressed to non-philosophers. Take the most striking case, Spinoza ... or again Nietzsche. Non-philosophical comprehension isn't lacking or provisional, it is one of two halves, one of two wings ...
>
> 1994, pp. 139–40

When we look back at those heady years today, we can perhaps distinguish two general lines, each taking this 'teaching of the concept' in somewhat different

directions. On the one hand, in tandem with Foucault's creation of GIP, there would be the various groups and ideas of Althusser's former students at the École Normale Supérieure, many, together with Lyotard, becoming Deleuze's colleagues at Paris 8. Thus we find Rancière and his attempt to substitute for the old Althusserian Master of the Science of Ideology a new figure of an 'ignorant school master', outside the University, reading and learning in 'proletarian nights'. Rancière would go on to oppose this idea of teaching and learning 'outside', not simply to Althusser, but also to Bourdieu, whose work had long been motivated by a new sociological critique of the inequalities of the French school system. It was with all this in mind that Rancière would then take up Deleuze's ideas on 'visibility' and 'enunciability' in Foucault, recasting them as a *partage du sensible*, as a larger framework for the questions of art and politics. But Guattari, not a *Normalien* himself, instead a 'non-philosopher' in the academic or institutional sense of the term, a militant and autodidact, engaged in alternative psychiatry, would move in another direction. Working with 'post-operatist' Italian philosophers, then arriving at (and in the case of Negri escaping to) Paris, he began working on projects like *Radio Tomate*, carried on with Bifo. In his own writings he would focus not simply on group subjects and transversal relations or 'collective arrangements of enunciation' but on a new picture of 'deterritorialization' as a condition of thought, art, and their relations with one another, worked out in essays mixing philosophy, art and science, notably on Proust and Kafka. It is of course such ideas he would bring to the experiment of de-disciplinized multi-writing with Deleuze himself. But in contrast to the centrality the Seminar retained for Deleuze, he would push his practices of writing and teaching into a larger and different kind of intellectual field, no longer dominated by the University or the Book alone, captured in one way in the dream, he shared with Deleuze, of a new 'pop philosophy', in the manner of Warhol's 'pop-art'.

Guattari's style and itinerary in 'teaching the concept' would assume new forms, however, following his own growing sense of disappointment in the 1980s, found in his allergy to the ideas of 'postmodernism' then fashionable. He began a period of travels outside France, in what we might now call the new 'transnational' situation taking shape then, carrying on discussions with others in different locations, developing in the process a different picture of teaching, for example, than the one proposed by Ivan Illich in his search for a sense of 'community' outside Technocratic Knowledge. For, as Deleuze would say to Toni Negri in 1990, 'We no longer have available to us an image of the proletariat of which we would merely need to become conscious' (1994, p. 173). Instead,

one had to work with the idea that 'the people is always a creative minority', as already found, for example, in one way in post-war cinema in Brazil. How and where then do we see such minorities in other places and circumstances; and how are such 'creative minorities' in different places linked to one another, without the old image of the proletariat, once so central to the dream of a total grand Revolution directed by an International?

In many ways that was the central question of Guattari's travels in Brazil at a time when a certain 'extra-disciplinary' political culture that had grown up in part in opposition to the military dictatorship, was, with Lula and his Workers Party, about to take off and discover a new role in electoral politics. Indeed, after the time of his brief discussions with Guattari, Lula would go on to be elected President, displacing what would be perceived as the neo-liberal turn of his predecessor, Fernando Henrique Cordosa. In the 'document-programme' of his travels there, compiled and published by Suely Rolnik, we find a number of ideas about pedagogy, thinking and art, in relation to the 'deterritorialized' situation of 'creative minorities'. We find them already in the opening sentence: 'The concept of Culture is deeply reactionary'. For, as can be seen in the case of Proust, Guattari declared, culture is not an 'autonomous field', but on the contrary, part of a larger search for a 'people to come', a people still 'missing', in the words of Paul Klee that Deleuze had so much admired in the context of an earlier pedagogical experiment in the Bauhaus at that increasingly desperate moment in Germany. Later in response to a question about this (and about La Boétie), towards the end of the volume, Guattari says this:

> That's right. Perhaps that's what I've been looking for with all my recent travelling. That's what took me to Palestine, and then Poland, Mexico, Brazil and Japan. Is it possible there's a deterritorialized people that traverses all these systems of capitalist reterritorialization? Yes, I believe that there is a multiple people, a people of mutants, a people of potentialities, that appears and disappears, that is embodied in social events, literary events and musical events ... that's the molecular revolution. It isn't a slogan or a program, it's something I feel, that I live, in meetings, in institutions, in affects also thru some reflections ...
>
> Guattari and Rolnik, 2008, p. 456

It is precisely this new sense, this affective intuition, in meetings and institutions, of a people in the making, yet to be constituted, which he then contrasts with Illich's pedagogy with its dream of an autonomous counter sphere:

> I always trust in the people, in *childhood* ... I didn't come, like Illich, to plead for structures of togetherness, for returns to a bit more unity ... *I think the human*

masses will and must be radically deterrritorialized precisely so that they can cease being masses and engender unaccustomed rhizomes of processes of singularization …
 ibid., p. 458

With such words, with this new 'trust' in the times and processes of singularization, we can already see the problems of the larger globalized sphere in which the question of a critical pedagogy of the concept is obliged to move today outside the old, national public spheres. The question is now instead in transnational settings linked together in various networks and concerned not with 'culture' but with new experiments in thought carried on in many different places at once, how to proceed, how to 'think together'. No doubt there are many new dilemmas and questions in such an enterprise, but one is surely the problem of a 'pedagogy of the concept', with its modest task of 'analysing the conditions of creation as factors of moments remaining singular'. How can the two halves, the two 'wings' of the philosophical and non-philosophical ways of thinking be brought together again in these circumstances? Where and with whom? For both are necessary, each having need of the other, each vital for the other. It is then this contemporary problem, at once philosophical and pedagogical, which this volume promises to at once open up, to formulate and to start to work out. As such, it forms part of an open question, for all of us 'formed' by their philosophy, of where and how to read – where and how to teach – Deleuze and Guattari today.

References

Boltanski, L. and Chiapello, E. (2005) *The New Spirit of Capitalism*. New York: Verso.

Deleuze, G. (1994) *Difference and Repetition*. New York: Columbia University Press.

—(1995) *Negotiations*. New York: Columbia University Press.

—(2006) *Two Regimes of Madness*, David Lapoujade (ed.), New York: Semiotext(e).

—(2012) 'C is for Culture', in *Deleuze A to Z*. New York: Semiotext(e).

Deleuze, G. and Guattari, F. (1994) *What is Philosophy*. New York: Columbia University Press.

Foucault, M. (2001) *Fearless Speech*. New York: Semiotext(e).

Guattari, F. (2008) *The Three Ecologies*. New York: Continuum.

Guattari, F. and Rolnik, S. (2008) *Molecular Revolutions in Brazil*. New York: Semiotext(e).

Preface

For a *People-Yet-to-Come*: Deleuze, Guattari, Politics and Education

Matthew Carlin and Jason J. Wallin

Over the past decade, a number of works have appeared that focus on the significance of *Deleuzian* thought for education. Perhaps most notable amongst these projects are Kaustav Roy's *Teachers in Nomadic Spaces* (2008), Inna Semetsky's *Nomadic Education* (2008), and William Reynolds and Julie Weaver's *Expanding Curriculum Theory* (2002). Operationalizing *Deleuze and Guattari's* challenge for contemporary education, this emerging line of scholarship has begun to mobilize original conceptual resources for thought and action, and further, provokes us to do what Deleuze did: that is, create concepts for productively escaping those impasses of thought and expression to which life is made to habitually conform – including our conception of habit itself. Implicated herein are those territories of thought Deleuze and Guattari refer to as *Oedipal* – the regulation of social flows or differences under strict regimes of *statistical* and *identitarian* organization. The problematic that Deleuze (2003) brings to bear throughout his philosophical project is one of *a* people, or more specifically, the *absence of a people* not yet anticipated by models of political, social, psychological, and pedagogical capture. The task of philosophy, Deleuze claims, is not simply one of representing a people as *this* or *that*, but rather, of fabulating *a* people in the process of becoming, or rather, *a people-yet-to-come*. This political-philosophical entreaty is bound to the contemporary consideration of life itself. That is, if life is continually tethered to prior categories of expression, the question of a future not already anticipated by prior habits of thought becomes violently overdetermined. The danger of such overdetermination inheres to the contemporary problems in which much of the Euro-American educational project finds itself today. Specifically, whether it intends to or not, the contemporary educational project already presumes how it is that *a* life will go. Even the most forward-thinking work of arts-based educators, philosophers of education, and curriculum theorists all too often posits an image of life that fails to problematize the socio-political *individual*, the psychoanalytic

conceptualization of *desire* as *lack*, and the continued production of trans-
cendent foundations upon which such images of thought rely.

Such a rethinking might begin with an articulation of the political character
of contemporary education in relation to what Deleuze dubs *control society*
that, for the school system, is evident as 'the effect on the school of perpetual
training, the corresponding abandonment of all university research, the intro-
duction of the "corporation" at all levels of schooling' (Deleuze, 1992, p. 7). This
is to say that modes of social control have undergone a marked transformation
in the past half century. While Foucault's genealogy of disciplinary society
articulates a mechanism of control predicated on panoptic (centralized) power,
the confinement of the subject into spaces of surveillance, and the subject's
willing internalization of social norms, contemporary neo-liberal capitalism has
profoundly mutated this image of social power. As Deleuze documents, we live
in an era in which bio-political power functions in collusion with the decoding
of social codes under capitalism. While panoptic power functioned by means
of restraint and confinement, what Deleuze dubs *control society* functions by
'freeing the subject' into complex meshworks of registration and consumption.
This turn is apparent in the contemporary reconceptualization of the University
as a space of 'consumer choice', flexible transfer credits, and pliable modes of
distance delivery. It is the integration and use of new technologies that not only
makes the transition from consumer life to school seamless, but also enables the
new corporate model of schooling to further encroach upon the lives of students
and teachers who are now identified and measured merely as so many potential
producers of surplus value and profit. While existing within the context of
classrooms and institutions of formal learning, the increasing formal curricular
focus on job preparation and entrepreneurship[1] leaves little doubt as to the
extent to which the corporate model has seeped over its original boundaries to
saturate schools at all levels – a contemporary occurrence that has built upon,
and seemingly perfected, the techniques of the *fabrica diffusa* – the term first
utilized in 1970's Italy to describe the way that workers were tracked down by
capital in other spheres of everyday life after their exodus from the degrading
existence of factory work.[2] While it is certainly the case that schools have never
been immune from the axiom of profit or capital, it is also the case that there

[1] The focus on entrepreneurship is most clearly exemplified in new developments in the field of
 neuroscience where the brain is becoming the site of new forms of manipulation in order to create
 the ideal capitalist. See, for example, Yale Psychiatrist Bruce Wexler's work on utilizing particular
 brain exercises to create better entrepreneurs, work that was initially experiments on rats and has
 since moved on to working on humans in Connecticut, and Harlem.
[2] See Raunig, 2013 for more on the *fabrica diffusa* and its relationship to contemporary education.

is continually less and less space available in which to contest and escape such economic truths.

Within this model, education mutates into an open system of training that is itself rhizomatic (smooth). That is, the commodification of contemporary education is characterized by the often valorized notions of *perpetual becoming, interminable prolongation,* and *recommencement* – most clearly expressed in the increasing axiological weight given to the notion of 'life-long learning'. Ostensibly, the commodification of education desires both to attract and to produce *vagabonds,* subjects constantly on the move for whom new forms of flexible training and registration (educational 'services') can be continuously mobilized.

While not inherently negative, the reterritorialization of the University upon the body of capital has had more dire effects. Today we see the decomposition of the university into ever greater forms of surveillance and tracking, work in academia becoming more indistinguishable from grant writing, and universities and colleges being utilized more for conference organizing and as spaces for corporate advertising than for teaching and research. The implications of this shift in control requires focused political intervention, since much of the anti-oppressive educational project remains wedded to the ostensibly libratory goal of unfettering its subject. Problematically, while the forms of control documented by such radical pedagogues as the Marxian-inspired Paulo Freire have become outmoded, they continue to serve as the dominant mode of inquiry around which much critically engaged pedagogy revolves.

What is required for a political pedagogy today is a reinvigorated look at the reorganization of the social field at the end of modernity and the cessation of the *banking model of education* critiqued by Freire. It is via such an analytic re-launch that we might begin to cast suspicion on the new rhetorics of complexity and contradiction that have become synonymous with radical thought in contemporary educational theory. Simply, that capitalism thrives on the projects of *crisis, contradiction* and *complexity* lauded in much 'liberatory' curriculum thought has yet to be fully detected by anti-oppressive theorists in education. Concomitantly, the valorization of *incompleteness, process* and *life-long learning* in much arts-based and educational theorizing functions as an ideal corollary for a market economy no longer premised on enclosure, but rather, the production of an interminable *debt.* Put differently, neo-liberal market economics requires a subject that is always already in a process of seeking out new tastes, sensibilities, and images. For neo-liberal economics, the 'complete' subject is to be avoided 'at all costs', in so far as its sedimentation is

counterposed to perpetual marketing, self-styling, and the aesthetic sampling of popular 'tastes'. It is in response to the ways in which our conception of liberation has been reterritorialized in new tyrannies that this book aims to educe a genuine image of education and learning able to elude the grasp of the most readily available and acceptable conceptual tools at our disposal.

This task suggests the need to create new *grounds* (as a concept distinct from ready-made territories) for political action in education. Such a project might occur through the mobilization of new conceptual resources for a style of political thought capable of maximizing expressive potentials for a people not yet figured in the majoritarian (statistical, binaristic, transcendent) image of State thought – a sphere of existence that Deleuze and Guattari argue has not disappeared with the advance of capital, but rather merely become indistinguishable from everyday life and society as such.

Avoiding the capture of the State entails creating a unique style of political thought drawing from multiple fields, and further, the theorization of a politics drawing from creative philosophical, artistic and social *micromovements* alive today that have abandoned traditional party politics revolving around the Leninist pedagogical narrative of 'the one who knows' in favour of new transversally inspired forms of collective organization. This tactical shift is foregrounded in the political and philosophical work of Deleuze and Guattari, whose *oeuvre* is composed via a continuous non-philosophical approach to philosophizing. In this task, this book takes seriously those *minoritarian* forms of expression being created at the peripheries of standardized education, exploring the potential forms of non-integration, refusal and exodus alive in the social field today, adopting for education 'those revolutions going on elsewhere, in other domains, or those that are being prepared' (Deleuze, 2004, p. 138). As Deleuze states, 'there is no need to fear or hope, but only to look for new weapons' (1992, p. 4).

In an age marked by the increasing overdetermination of education in the image of instrumental thought and universal standardization, the Deleuzian and Guattarian notion of *singularity* assumes political significance. Originally employed in mathematics as a means of surveying the different ways in which a particular problem might be solved, the concept of singularity takes as its focus the notion of the problem *itself*. In educational terms, this development is significant in so far as it suggests that the contemporary image of education is but one of many. Taking the notion of singularity seriously, this book attends to not only the *actual* state of affairs in which contemporary education has become territorialized, but further, to those 'problem(s)' that the contemporary image of education attempts to resolve. It is hence towards such problems as how a

public is made, the organization of student desire, and the question of what it means to *learn* that this book is organized. In this commitment to the *problems* of education, however, this book aims to do more than pose solutions. As Deleuze (2004) writes, we have been led to believe that problems emerge *ready-made*, only to disappear through the formulation of responses or solutions. This illusion, Deleuze contends, suggests that *problems* emerge prior to solutions in causal relation. Rethinking this problem–solution binary, Deleuze argues that problems and solutions are concurrent – a position that does nothing but arouse suspicion at the prospects for success of new educational policy. As such we might understand the problems of contemporary education as immanent to the quality of solutions that have been projected upon it. In this vein, this book begins to introduce new problems for contemporary education – pedagogy being only as good as the problems it creates.

Following Deleuze's intent to conceive of philosophy and art as the creation of new pathways, we mean to use Deleuze's (1953) discussion of empiricism as a springboard to begin to counter the communicational compulsions and associated informational automatisms that have come to typify the institutionalized approach to education endemic to the control society. Specifically, this book challenges formal schooling's dominant mantra of skills and knowledge that relegates education to the mere acquisition of information and recitation of subjective presuppositions in the quest to overcome ignorance. Through focusing on Deleuze's work on empiricism and attendant reprioritization of experimentation we begin to think how education might inherently depend on new conceptual relations with objects and the world – both in terms of their use as a locus for the proliferation of desire, and also as a concomitant generator of new subjectivities. Instead of the transcendence inherent to the acquisition of skills and knowledge proffered by institutions, the empiricism of Deleuze inspires a trust and corresponding experimentation with this world that resituates ignorance as not only a productive force, but one essential to imagination and creative discovery. In other words, it is only through abandoning predictive and formulaic engagements with the world that new potentialities might appear. In our estimation, Deleuze's thought with regard to objects and the world, one that goes as far as to blur the line between the taken-for-granted separation between humans and non-humans, offers educational practitioners and researchers emerging pathways and linkages to begin to experiment and create new relationships with our surroundings.

Our intention is to generate work that seeks to replace the understanding of education as the institutionalized acquisition of information and skills with

one based on a new conceptual engagement with the world generated from contact with something outside the parameters of institutionally verified and compartmentalized forms of knowledge (Deleuze, 2000). We argue that these and other contemporary issues related to schooling, learning and teaching specifically necessitate an engagement with the political thought of Deleuze and Guattari. This collection of essays is not a call to become Deleuzian or Guattarian, but rather a call to think with and from their political thought in order to outmanoeuvre the modulating effects of the corporate subsumption of education and instigate new forms of institutional life and social organization.

References

Deleuze, G. (1953) *Empiricism and Subjectivity: An Essay on Hume's Theory of Human Nature.* New York: Columbia University Press.

—(1992) 'Postscript on the Societies of Control', *October* 59, pp. 3–7.

—(2000) *Proust and Signs: The Complete Text.* Minneapolis, MN: University of Minnesota Press.

—(2003) *Cinema 2: The Time Image.* Minneapolis, MN: University of Minnesota Press.

—(2004) *Desert Islands and Other Texts (1953–1974).* Cambridge, MA: MIT Press.

Raunig, G. (2013) *Factories of Knowledge Industries of Creativity.* New York: Semiotext(e).

Reynolds, William and Weaver, Julie (2002) *Expanding Curriculum Theory: Dis/positions and Lines of Flight.* Mahwah, NJ: LEA Publishers.

Roy, K. (2008) *Teachers in Nomadic Spaces.* New York: Peter Lang.

Semetsky, I. (2008) *Nomadic Education.* New York: Routledge.

1

Schizoanalysis and the Pedagogy of the Oppressed

Ian Buchanan

In *Nietzsche and Philosophy* (1983), Deleuze suggests that in order to understand a thinker properly one has to know who they were *against* (p. 162). In the case of Deleuze, both on his own and in collaboration with Guattari, the received wisdom is that he was against Hegel. In part this is because of the way in *Nietzsche and Philosophy* he positions Hegel as Nietzsche's enemy. But this 'meme', if you will, which is reproduced in the secondary literature on Deleuze and Guattari with such monotonous regularity it can justly be termed a cliché, obscures more than it reveals, giving us an image of thought (to use Deleuze and Guattari's own useful concept for clichéd thinking) in the place of what was actually thought. However, it is not just Deleuzians who are guilty of this. Hegel is frequently painted as a dark figure in French thought, particularly by the generation of thinkers loosely known as post-structuralists, e.g., Deleuze, Derrida, Foucault, and Lyotard. But this depiction of Hegel as a kind of a philosophical wrong turn overlooks the fact that he was also a profound inspiration to some of the keenest and most radical minds of the generation before the post-structuralists, such as Sartre and Beauvoir, and the many thinkers they inspired such as Fanon, Memmi, and the great Brazilian educationalist Paulo Freire. In other words, in the span of a single generation Hegel went from being the potent ally of politically-motivated philosophers to the arch enemy of the same, despite the fact that the later generation of philosophers were, politically speaking, largely in sympathy with their predecessors, sharing their concern for justice, equality and the need for critical thinking. This scission needs to be explained.

The key issue here, I will argue, is not, or not only, why were Deleuze and Guattari opposed to Hegel, but rather why were they opposed to Hegel at *this* particular moment in history? I tend to follow Perry Anderson (1976), one of

the most reliable guides to the history of Western Marxism, in thinking that contrasting 'Hegelian and anti-Hegelian schools is wholly inadequate to define the exact locations of the different schools within Western Marxism [in contrast to Anderson, though, I would very much include Deleuze and Guattari within the ambit of this history], or the inter-relations between them. The very multiplicity of the philosophical filiations [...] – including not only Hegel, but Kant, Schelling, Spinoza, Kierkegaard, Pascal, Schiller, Rousseau, Montesquieu and others – precludes any such polar alignment' (p. 73).

Against this point, though, I also agree with Jameson that anti-Hegelian assertions in this period were always something other than mere announcements of philosophical disagreements; rather, they were statements of position and of personal allegiance in a rather closeted post-war academy. I doubt Anderson would disagree with this in any case since he also makes the point that post-war Western Marxism was shockingly insular, compared to its first incarnation in the years before the First World War and more especially the Russian Revolution. He describes Adorno, Althusser, Colletti, Della Volpe, and Sartre, and many others too, as: 'utterly provincial and uninformed about the theoretical cultures of neighbouring countries. Astonishingly, within the entire corpus of Western Marxism, there is not one single serious appraisal or sustained critique of the work of one major theorist by another, revealing close textual knowledge or minimal analytic care in its treatment' (ibid., p. 69).

What one finds instead is a near constant search for 'worthy' philosophical precursors to Marx, which Anderson reasons became necessary when – as I'll explain below – Western Marxism jettisoned the practical dimension of Marxism in favour of its more purely theoretical dimension.

Interestingly, Anderson's observations hold true today, nearly four decades later: it is still the case that critical theorists of Deleuze's generation do an extremely poor job of reading each other's work, as is amply demonstrated by both Badiou's (2000) and Žižek's (2004) books on Deleuze (Deleuze's (1986) book on Foucault is no exception; it is simply partisan and partial in an affirmative rather than negative direction). And they are still obsessed with the question of the 'worthy' precursor, as the countless books on Deleuze can testify. Instead of trying to figure out what can be done with Deleuze and more especially what can be done with Deleuze and Guattari, the field of 'Deleuze studies' seems to be altogether stuck on the question of whether Deleuze was Bergsonian, Nietzschean, Spinozist, or, even more esoterically, whether

Deleuze and Guattari were inspired by or somehow rely on evolutionary biology, cognitive psychology, higher mathematics, and so on. Consequently, as Anderson put it speaking of Western Marxism, 'Deleuze studies' is in danger of becoming 'a prolonged and intricate Discourse on Method' (ibid., p. 53). The issue of whether Deleuze and Guattari are anti-Hegel is a part of this and for that reason the question should be refused in that form. To reorient the question in an historical way, in the manner I have suggested, is really to ask why in that particular period it seemed necessary to Deleuze and Guattari to *perform* anti-Hegelianism. And I use the term 'perform' here quite deliberately and not as a provocation. As many commentators have pointed out, there is no general critique of Hegel to be found anywhere in Deleuze and Guattari's writings. All we have to go on is the scant pages explaining why Nietzsche opposed Hegel in Deleuze's Nietzsche book and the various and far from coherent pronouncements they both made in interviews. Guattari was largely silent on the subject of Hegel, but Deleuze famously said he loathed dialectics because of its altogether too mechanical one-two simplicity. My point, though, is that this hardly constitutes a philosophical argument against Hegel. Nor does it even begin to do justice to the complexity of Hegel's thought.

In saying that Deleuze's anti-Hegelianism was a performance I am suggesting, with Jameson, that we should ask: Who or what did Hegel stand for in Deleuze's eyes? Fredric Jameson has proposed that for French thinkers of Deleuze's generation Hegel became a kind of code word for Stalin; it was a way for Marxists to use theoretical fights as a cover for deeper political disagreements. This certainly rings true for Althusser and the Althusserians, but I'm not so sure it holds for either Deleuze or Guattari because neither of them were all that interested or engaged in the internecine wars being played out on the French Left in the 1950s and 1960s. Neither were part of any recognized 'schools' and both were in any case quite scathing of such factionalism. The other obvious possible explanation is of course that Hegel was the 'arch' enemy of the Spinozists and that being anti-Hegelian was simply the flipside of being pro-Spinozist. But this is just factionalism of a different and possibly even meaner kind and for that reason should also be rejected. I think we have to look for an explanation elsewhere. This isn't to say, however, that Marxism doesn't provide an important clue, and not just because Spinoza was a beardless Marx according to Plekhanov, because I cannot but think we have to look in the direction of a political problematic rather than a philosophical

problematic in order to satisfactorily resolve this issue (ibid., p. 64 n20).[1] While I do think Hegel functions as a kind of code word for Deleuze and Guattari, as a particular kind of 'image' of thought, or performance, I don't think it is Stalin or any other factional figure that they have in their sights. I want to suggest rather that they saw the recourse to Hegel as a cul-de-sac in the road on the way to answering the key political and theoretical problem of the era. In responding to this theoretical problem, as I'll explain in what follows, Deleuze and Guattari reunite theory and practice, long since divorced according to Anderson.

In the 1950s and 1960s the key political problem for the Left was why hadn't the great socialist revolution Marx predicted taken place in Western Europe? According to classical Marxist theories, the socialist revolutions in China and Russia were historical anomalies because they were peasant-led revolutions and not proletarian-led as they were supposed to be. Marxist doctrine held that the revolution(s) should have taken place in France, England or Germany. The bigger problem though was that once the spark was lit in Russia the fire didn't spread west. This led Western Marxism as a whole to see itself, in Perry Anderson's words, as the 'product of *defeat*. The failure of the socialist revolution to spread outside Russia [...] is the common background to the entire theoretical tradition of this period. Its major works were, without exception, produced in situations of political isolation and despair' (ibid., p. 42). Paradoxically, the socialist victories in Russia and China, did not leaven this despair, nor energize Western Marxism as one might have expected, because they brought with them their own problems: first, in both Russia and China the needs of the Party were prioritized over and above all other considerations, with the effect that Marxism became in some circles synonymous with authoritarian bureaucracy (later as news of the Gulags became common knowledge this image soured further to the point where high-profile Marxists began to leave the party in protest – the so-called 'nouveau philosophes', despised by both Deleuze and Guattari, were only the most prominent); second, as the geographical axis of Marxism shifted from the West to the East, Marxism lost its meaning on the ground in its former strongholds in Paris and Berlin – where once it had been part of working-class culture, now it was simply an ideological cover for the Power of the Party (ibid., p. 43). In the process, Marxism became separated from mass struggle, and theory lost its mooring in praxis.

This situation created a problem that Marxists writing in the latter part of

[1] As tantalizing as it is, I do not think Deleuze's (1994, p. xxi) famous image of a philosophically bearded Hegel and a clean-shaven Marx as the ideal of philosophical commentary really points in this direction.

the twentieth century were largely unable to resolve. The Party steadily assumed the position of central organizing pole, thereby cornering Marxist theorists into having to decide whether to join or not. If they did, their prestige and authority was greatly enhanced, they gained a constituency, a body of readers who looked to them for guidance, but it came at a price. They had to accept the discipline and control of the party, which meant that in some circumstances they would have to remain silent about both the conduct and the actions of the Party. As Anderson states, 'No intellectual (or worker) within the mass Communist Party of this period, not integrated into its leadership, could make the smallest pronouncement on major political issues, except in the most oracular form' (ibid., p. 44). If they made the opposite choice and turned their back on the Party, the gain in freedom was more than offset by the corresponding loss of what Anderson usefully refers to as 'anchorage' in the very class of people who were supposed to benefit from their theorizing. Thus the great Marxist scholars of the 1950s and 1960s – Adorno, Marcuse, and Sartre, in particular – tended to be silent on the issues that had given Marxism its initial impetus, namely the study of economics, the analysis of political machinery, revolutionary strategy, and so on. It was under these conditions that so-called 'cultural Marxism' emerged and with it the dominance of philosophy as the primary area of interest (ibid.). Hegel's prominence in this period is a symptom of this fading away of the materialist side of Marxist thinking. This doesn't necessarily mean that Marxism thereby went into an idealist free-fall as many said at the time (Althusser and Colletti in particular), but it does point to a strange lacuna in a theory that at its outset chastised philosophy for merely trying to understand the world when the real point of such work was to try to change the world.

This failure of history to unfold according to script became even more perplexing for Western Marxists when they turned their eyes southwards and gave their attention to decolonization, which swept through Africa, Asia, and South America in the post-war years with varying effect. Most of the liberation movements were socialist inspired – e.g., Cuba, Indonesia, Kenya and Vietnam, to name just a few of the most important. These revolutions no doubt radicalized people in 'First World' countries, particularly students, some of whom went so far as to identify as Maoists (most notably Badiou and his circle). But for all its high points, and there were many (huge advances were made in the battle for gender and racial and sexual equality), 1960s radicalism didn't amount to much in the way of a revolution. The structures of power in the West survived unscathed and were in many cases strengthened because it created the perfect conditions for its naked expression. Indeed, on the bleakest

view of things, 1960s radicalism, in all its counterculture glory, simply paved the way for a still more complete capture of society as a whole by capitalism by setting aside all the social and cultural impediments that hitherto blocked its expansion.[2] Neo-liberalism is the result of these transformations. Government mishandling of various crises through the 1960s became the justification for the rolling back of the 'welfare state', i.e. the very idea that the state's primary purpose is to oversee the welfare of the people, and the subsequent privatization of services hitherto deemed the preserve of the state, such as healthcare, but also key infrastructure (roads, sewerage, telecommunications, water and so on), and even elements of both the military and the police.[3] Moreover, in the United States in particular, the state responded to the civil unrest generated by 1960s radicalism by declaring 'war' on its own people – the war on poverty saw the steamrolling of entire neighbourhoods deemed 'slums' only to be left as a vacant lots because the state lacked the resources to rebuild them; the war on drugs that followed was even more devastating because it resulted in extraordinarily high and utterly disproportionate levels of incarceration, particularly among the Black and Latino populations.[4]

There was no obvious historical answer to the problem of the failure to revolt in Western Europe. According to all the indicators Marxists generally relied on, the circumstances were in fact ripe for revolution. A large and well-organized working class existed at least until the early 1960s and although it had suffered several defeats, it was still more than willing to flex its muscles to obtain better conditions, as May 1968 demonstrated in Paris when more than 10 million blue-collar workers went on strike and brought the whole country to a standstill. This, for Marx at least, was the essential precondition for revolution and yet it had not happened. Why not? Western Marxism's answer to this rather perplexing problem, which it used Hegel to theorize, was that although the economic conditions were primed for revolution, the social and cultural conditions were not. The problem was that the people – understood in the broadest possible sense – lacked not just revolutionary spirit, but revolutionary consciousness, the sense that the position of the oppressed is in fact powerful. But more than that, it is the sense that it is in the people's interest to revolt. As Freire (1996) puts it, 'what characterizes the oppressed is their subordination to the consciousness of the master, as Hegel affirms', adding that 'true solidarity with the oppressed

[2] See Frank (1999).
[3] See Harvey (2005).
[4] See Wacquant (2009) and Parenti (1999).

means fighting at their side to transform the objective reality which has made them these "beings for another"' (p. 31).

Education is the royal road to revolutionary consciousness, according to Freire; not only that, it is also the springboard to a successful revolution, which is to say a revolution that endures beyond the initial storming of the barricades and the firing of the first shot. In Freire's view, it is the task of revolutionary leaders to begin critical education prior to the firing of the first shot so as to ensure the revolution's sustainability. Taking power is but a single moment, an event, albeit decisive, in the revolutionary process which is meant to transform both oppressor and oppressed (ibid., p. 117). In a brief essay on Lenin, Jameson (2007) makes the useful suggestion that one could even read event and process in this context in dialectical terms. The event is the moment of rupture in which power is taken, while the process is the accompanying long, often tedious, work of transforming a society so that the original revolution does not get forgotten, nor dwindle into a sad charade of power passing from one oppressing group to another (ibid., p. 68). This dialectic stands at the heart of Freire's entire enterprise. As Freire argues, utilizing a perfectly Hegelian logic, if oppressor and oppressed simply swap places then it cannot be counted as a genuine liberation. 'This, then, is the great humanistic and historical task of the oppressed: to liberate themselves and their oppressors as well' (p. 26). This task cannot be completed without education because it is the only way of ensuring that the newly empowered oppressed do not simply become oppressors themselves.

> Originating in objective conditions, revolution seeks to supersede the situation of the oppression by inaugurating a society of women and men in the process of continuing liberation. The educational, dialogical quality of revolution, which makes it a 'cultural revolution' as well, must be present in all its stages. This educational quality is one of the most effective instruments for keeping the revolution from becoming institutionalized and stratified in a counter-revolutionary bureaucracy; for counter-revolution is carried out by revolutionaries who become reactionary (ibid., p. 118).

Freire's educational philosophy is very straightforward and, perhaps surprisingly, completely consistent with Deleuze's. He specifies two kinds of education, or really two ways of thinking about education. The first kind, which he disapproves of, he calls 'narration' or 'banking'. On this model the educator 'deposits' knowledge in the minds of students, but does not listen to the students, so the knowledge they impart is lifeless and sterile, it does not waken the revolutionary consciousness.

The teacher talks about reality as if it were motionless, static, compartmentalized, and predictable. Or else he expounds on a topic completely alien to the existential experience of the students. His task is to 'fill' the students with the contents of his narration – contents which are detached from reality, disconnected from the totality that engendered them and could give them significance. Words are emptied of their concreteness and become a hollow, alienated and alienating verbosity (ibid., p. 52).

The 'banking' model of pedagogy has two main effects, both of which are deleterious in Freire's view. First, by spoon-feeding students information it actively discourages, one might even say 'starves', the critical consciousness, which for Freire is the ability to not only see reality for the way it really is, but more importantly to see reality's underlying causes; second, students who do not have to produce knowledge and understanding for themselves tend to see the world as fixed rather than malleable, as something they must adapt to instead of something they can transform. The 'banking' model thus serves the interests of the oppressing class by promoting the status quo as how things should be (ibid., p. 54).

In contrast, 'libertarian' education, as Freire calls it, 'consists in acts of cognition, not transferrals of information' (ibid., p. 60). It is facilitated via a process Freire refers to as problem-posing, which aims to turn the students into 'co-investigators', thereby eliminating the distinction between teachers as purveyors of knowledge-content and students as passive consumers of knowledge-content: 'The role of the problem-posing educator is to create, together with the students, the conditions under which knowledge at the level of the *doxa* is superseded by true knowledge, at the level of the *logos*' (ibid., p. 62). Whereas the 'banking' model renders students critically inert and fosters an adaptive response to objective reality, the problem-posing method compels the opposite attitude: students are positioned not merely as co-investigators in a project of finding out something they didn't know before, but as active agents in whose hands the shape of the world actually rests. The latter point is particularly crucial because the ultimate goal of consciousness-raising is not the acquisition of new knowledge as such, but a heightened awareness of one's class interests.

Problem-posing education affirms men and women as beings in the process of *becoming* – as unfinished, uncompleted beings in and with a likewise unfinished reality. [...] In this incompletion and this awareness lie the very roots of education as an exclusively human manifestation. The unfinished character

of human beings and the transformational character of reality necessitate that education be an ongoing activity (Freire, 1996, p. 65).

And though with Anderson we may question the degree to which Western Marxism's educators were in fact in solidarity with their students and the oppressed more generally, inasmuch that their personal situations had little in the way of common cause with the world's oppressed, the objective of Western Marxism as a whole was nevertheless perfectly consistent with Freire's: it, too, wanted to transform the consciousness of the people so that they in turn would begin the process of transforming their objective reality.

Given Freire's allegiance to a Hegelian world view, it is likely that Deleuze and Guattari would not have seen eye to eye with him. But what exactly would they have objected to? We can sharpen this question further by first of all noting that they actually have a lot in common. To begin with, Deleuze's (1994) own model of pedagogy, as he articulated it in a couple of fleeting passages in *Difference and Repetition*, is problem-posing. 'We learn nothing from those who say: "Do as I do." Our only teachers are those who tell us to "do with me", and are able to emit signs to be developed in heterogeneity rather than propose gestures for us to reproduce' (p. 23). This matches precisely Freire's image of student and teacher as co-investigators working side by side on problems and issues of mutual interest in all but one respect. It is a clear rejection, too, of the banking model of pedagogy. For Freire consciousness is consciousness *of* something pre-existing. It could be an object in the world or an object of thought (such as the fact of economic and political exploitation), whereas for Deleuze consciousness is the production of an object, which is necessarily an object of thought that does not pre-exist this moment of its production.

As we've seen, Freire's brand of Marxism depends on the idea of consciousness and Deleuze and Guattari reject this on what might be termed empirical grounds, or perhaps it would be better to say historical grounds, but also on theoretical grounds as I'll explain below. Basically, their position, which I will expand upon in what follows, is that consciousness-raising, the catch cry of the radical 1960s, did not work in the way Marxists thought it would. People became conscious of their oppression and more importantly their interests but did not rise up. No doubt this was in large part because in contrast to Freire's Latin America, people in the West generally did not see themselves as the oppressed, and in many ways they were not. For a start, they were vastly better off materially than at any other time in history. Thus the pedagogic task of Western Marxism's educators was doubly hard – before they could discuss the strategies and tactics of revolution

they had to convince their respective constituencies that a revolution was in fact required. This, despite the fact that it could readily be shown that a change to a socialist model of government such as Western Marxism envisaged was in the interest of the great majority of people (this line of thought persists in the recent treatises on Communism for our time by Badiou (2010), Bosteels (2011) and Deans (2012)). But as the 'Obamacare' case demonstrated all too well, interest is very far from self-evident to the majority of people.

This was undoubtedly Western Marxism's biggest stumbling block. How do you foster revolutionary consciousness in a population that has ceased to think of itself as 'the oppressed' and no longer thinks of its interest in collective terms? Marx thought that once people saw the true nature of their situation, their actual, objective reality, they would rise up against their oppressors and bring forth a new era of world socialism. But history didn't follow this script. At first it was thought that this was because the people were not fully aware of their situation and that with the proper education this could be changed. But it soon became clear, in the West at least, that the problem was different from and more pernicious than simple ignorance. The people were not unaware of their true situation – how could they not know? – and yet somehow they did not see that their interests would be better served by a change in the mode of production. In Freire's language, they adapted themselves to their oppressive environment. This latter position has come to be known as cynicism and for most contemporary Left critics (particularly Žižek who lifts the idea from Sloterdijk (1987)) it has replaced false consciousness as the standard explanation for the perennial problem of the oppressed's failure to revolt. But cynicism simply means the failure to see one's interests in collective terms. It is the view that allows one to recognize that the planet would be better off if climate change were halted or even reversed, but continue to prioritize one's self-interest, which would not be so well-served inasmuch as it would necessitate giving up certain key aspects of life as we presently know it.

From a Deleuzian perspective, the problem with both false consciousness and cynicism is that neither takes desire into account. In the case of false consciousness, it assumes that people have somehow been duped into wanting or tolerating something they would not otherwise wish for were they more clear-eyed about the true nature of their circumstances. But if one takes an extreme case like Nazism, can one really say the German people as a whole were deceived? Was fascism an unknown quantity they were unknowingly seduced into following without ever being fully aware of what it was? Did the millions of people who voted for the Nazis really have no idea what kind of

a regime they were electing? Did not the blood and iron flags, the torchlight marches, the operatic uniforms with death's head skulls on the collars not give them some inkling? Failing that, the undisguised brutality of the brownshirts, and more especially the ruthless way they were dealt with, must surely have been an indication. The 'following orders' argument which is generally used to explain how and why ordinary Germans became involved in mass exterminations in the later stages of the Nazis' short reign does not explain how the Nazi regime came into power in the first place. No one ordered the German people to vote for the Nazis; no one ordered them to join or support the Nazi Party. Hitler could well have remained a powerless nonentity if Germany's business barons hadn't got behind him in the 1920s. Thus, with Reich (1970), Deleuze and Guattari (1983) reject the thesis that the German people were duped and instead ask how and why they came to desire fascism. But unlike Reich they are not prepared to accept that the apparently dark desire for fascism is the product of mass irrationality on the part of the German people. On the contrary, they argue, 'the masses were not innocent dupes; at a certain point, under a certain set of conditions, they *wanted* fascism, and it is this perversion of the desire of the masses that needs to be accounted for' (p. 29).

Importantly, Deleuze and Guattari go on to argue that this principle, that fascism has to be accounted for affirmatively, as the desire for something known, rather than as the product of either a psychological aberration or deception, is in no way vitiated by the fact of social repression, not even social repression on the scale of Nazi Germany's infamously repressive state apparatus. Desire 'produces reality' they argue, which is to say, 'desiring-production is one and the same thing as social production. It is not possible to attribute a special form of existence to desire, a mental or psychic reality that is presumably different from the material reality of social production' (ibid., p. 30) So if something exists, it exists because it is desired; if a state of affairs exists, it exists because it is desired; if a certain kind behaviour exists, it exists because it is desired. Deleuze and Guattari test this principle against the age-old question of why people seem to fight for their own servitude (ibid., p. 29). Ultimately they reject this question as too simplistic, but it serves to open up the question of how desire functions. No one really desires servitude for itself, they concede, but there are many situations in which servitude of one kind or another is the direct result of one's desires. Putting it very crudely, every time we make use of pretrochemical products – and the number of such products is legion – we contribute to the reproduction of a global situation that literally and figuratively locks us all into a situation of actual servitude. And as the two Gulf Wars prove,

this is a situation 'we' are willing to fight to preserve. This example is only crude to the extent that we separate ourselves as individuals from what is happening all around us on a global scale. And that is precisely what cannot be done. I may not have the power as an individual to overturn the global hegemony of oil, but by my actions I contribute to its hegemony. That is the reality of the global political situation today. On this Deleuze and Guattari and classical Marxists agree. The problems start when we move onto the perhaps more pressing issue of what we can do to change things; or, rather, when we ask why we aren't really doing anything to change things. Marxism's answer that 'we' lack revolutionary consciousness is unsatisfactory in several ways, as I'll explain in what follows.

It isn't adequate, in Deleuze and Guattari's view, because it doesn't resolve the following problem, which is central to the paralysed state Western Marxism has found itself in since the middle of last century: 'why do many of those who have or should have an objective revolutionary interest maintain a preconscious investment of a reactionary type? And more rarely, how do certain people whose interest is objectively reactionary come to effect a preconscious revolutionary investment?' (ibid., p. 244). Here they do not so much answer the question as lay out the foundations of a problem and point the way to a new analytic model. Ultimately, what Deleuze and Guattari want to contend here is that there 'is an unconscious libidinal investment of desire that does not necessarily coincide with the preconscious investments of interest, and that explains how the latter can be perturbed and perverted' (ibid., p. 345). It explains the perversion of desire, its turn towards fascism for example, inasmuch that it offers a molecular model of desire capable of 'desiring' in several directions at once, including directions that are not only contradictory or mutually exclusive but also self-destructive: 'It is doubtless true that interests predispose us to a given libidinal investment, but they are not identical with this investment. Moreover, the unconscious libidinal investment is what causes us to look for our interest in one place rather than another, to fix our aims on a given path' (ibid.). In other words, consciousness-raising that aims only to make potential revolutionaries aware of where their true interests lie, which is in substance what Marxism aims to do, is bound to fail to a greater or less degree unless it comes to grips with the fact that it is desire itself that determines what one apprehends as one's interest.

And even then it is by no means certain of success: 'A revolutionary preconscious investment bears upon new aims, new social syntheses, a new power. But it could be that a part at least of the unconscious libido continues to invest the former body, the old form of power, its codes, and its flows' (ibid., p. 347). Freire was not unaware of this, as I've already pointed out. Liberation of the oppressed

was no liberation at all in his view if the oppressed simply became oppressors in turn, or more insidiously modelled their sense of what would constitute a victory on the oppressor's regime. But his solution was to appeal to the 'higher consciousness of humanization' and that is where he and Deleuze and Guattari do not see eye to eye (Freire, 1996, p. 26). Deleuze and Guattari point us in the opposite direction. Rather than aim for humanization through consciousness-raising, they encourage us to look at the complex way the conscious and unconscious operate to subvert the conscious and propel it in directions it would not otherwise want to go. The question we are left with then is what kind of pedagogy might be employed to ignite a revolutionary attitude, let's say, in such a situation? We have to move away from the representational model of knowledge, i.e., the model of knowledge that supposes in advance that there is something already formed to know, Deleuze argues, because it is 'modelled entirely upon propositions of consciousness which designate cases of solution, but those propositions by themselves give a completely inaccurate notion of the instances which engender them as cases, and which they resolve or conclude' (p. 192).

If interests are born of desire, then to 'change the world', as every revolutionary educationalist wants to do, it is desire that pedagogy must seek to address. Desire tends to elude the investigator because it is constantly moving, like a flow Deleuze and Guattari say. But perhaps that's how we deal with it, too, by developing a kind of hydraulic pedagogy that is capable of working with a fluid material.

References

Anderson, P. (1976) *Considerations on Western Marxism*. London: Verso.

Badiou, A. (2000) *Deleuze: The Clamour of Being*. Minnesota, MN: University of Minnesota Press.

—(2010) *The Communist Hypothesis*, trans. D. Macey and S. Corcoran. London: Verso.

Bosteels, B. (2011) *The Actuality of Communism*. London: Verso.

Deans, J. (2012) *The Communist Horizon*. London: Verso.

Deleuze, G. (1983) *Nietzsche and Philosophy*, trans. H Tomlinson. London: Athlone.

—(1986) *Foucault*. Paris: Editions de Menuit.

—(1994) *Difference and Repetition*, trans. P. Patton. London: Athlone.

Deleuze, G. & Guattari, F. (1983). *Anti-Oedipus: Capitalism and schizophrenia*. (trans. R. Hurley, M. Seem & H. R. Lane). Minneapolis, MN: University of Minnesota Press.

Frank, T. (1999) *The Conquest of Cool: Business Culture, Counterculture, and the Rise of Hip Consumerism*. Chicago: University of Chicago Press.

Freire, P. (1996) *Pedagogy of the Oppressed* (trans. M. Bergman Ramos). London: Penguin.

Harvey, D. (2005) *A Brief History of Neoliberalism*. Oxford: Oxford University Press.

Jameson, F. (2007) 'Lenin and Revisionism', in S. Budgen, S. Kouvelakis, and S. Žižek (eds) *Lenin Reloaded: Towards a Politics of Truth*. Durham, NC: Duke University Press, pp. 59–73.

Parenti, C. (1999) *Lockdown America: Police and Prisons in the Age of Crisis*. London: Verso.

Reich, W. (1970) *Mass Psychology of Fascism*. New York: Farrar, Straus and Giroux.

Sloteridijk, P. (1987) *Critique of Cynical Reason*. Minnesota, MN: University of Minnesota Press.

Wacquant, L. (2009) *Punishing the Poor: The Neoliberal Government of Social Insecurity*. Durham, NC: Duke University Press.

Žižek, S. (2004) *Organs Without Bodies: Deleuze and Consequences*. New York: Routledge.

On Cinema as Micropolitical Pedagogy

Is there an Elephant in the Classroom?

jan jagodzinski

The problematic

It may seem, at first, obvious when adopting a Deleuzian sensibility towards politics, especially when it comes to cinema, that Richard Rorty's charge in *Achieving Our Country: Leftist Thought in Twentieth-Century America* (1998) seems to hold sway in his claims. The academic Left, the likes of Foucault, Deleuze, Lyotard, Derrida, turned away from the actualities of 'progressive' political life, and instead turned to spectatorial 'cultural politics', making them powerless in effecting structural change.[1] This refrain has been taken up by others within the Left: Peter Hallward (2006) treats Deleuzian thought as being 'out of this world', especially the time-image that is a 'purely contemplative and essentially dematerialized or spiritual affair' (p. 116), while Badiou (2000), Deleuze's nemesis, maintains that subjective agency is dealt a decisive blow by such inactivism that places too much emphasis on the virtual realm. To this mix we might yet add, albeit in a different way, Brian Holmes (e.g. 2008), whose creative brilliance has been put foremost to advance Leftist artistic activism, drawing more on latter Guattarian developments than Deleuze's single-authored texts, especially not his cinema books, *The Movement-Image* (1986) and *The Time-Image* (1989) (*hereafter cited as simply (1986) and (1989), respectively*).

In relation to these developments, cinema seems to be the very apotheosis of this turn away from political action as a form of praxiology that has characterized 'critical theory' made paradigmatic by educators such as Paolo Freire, especially when the Hegelian dialectic continues to be so rigorously defended by Slavoj Žižek (2012) and Alain Badiou (2011). It is certainly a flight away

[1] Rorty's accusations have been answered by Paul Patton (2001).

from political economy as classily defined in terms of the circulation and production of commodities for profit, and the film industry most definitely belongs to the growing new forms of virtual capital brought on by the digital revolution (e.g., Beller, 2006). A film like *Avatar* attempts to make sure that all the bases are covered within the circuits of its production, the selection of its images and the timing and placing of its distribution to ensure that profit margins are met, not unlike a US Presidential campaign, which tries to leave very little to chance when convincing its electorate who they should vote for. Both are examples of a visual image regime that extends Deleuze's take on the 'psychological automation' of the movement-image namely a refined form of 'Leni Riefenstahl's propaganda machine' known as 'media spin' of representative democracy. Richard Grusin (2010) has cleverly called this a form of media 'premediation'. It is already pre-empted that the future is 'closed' for it. There is no 'Outside'. For many in a 'post-political climate' the rhetorical manipulation is far too obvious. Why vote when the choice is basically between two parties that in the end stalemate one another? Why pay 25 dollars for the large-screen viewing when we can wait for the cam recording? Are these forms of cynicism or resistance? It is hard to tell. A both|and logic persists – resistant cynicism perhaps.

There is a certain uneasiness, I must confess, in my own attempt to justify a 'micropolitical pedagogy' of cinema as culled from Deleuze's cinematic writings in the mid-1980s, especially as he developed this possibility in his time-image cinema book where the unthought and the unthinkable, the so-called 'spiritual automaton' of the non-dialectical cinematic machine, is given the task of performing such pedagogical work with the image. Pedagogy, it should be understood here, refers to a 'public education' that is not confined to schooling per se, given that cinema in its post-forms penetrates and 'informs' all segments of society. Like many other theorists of his generation (Derrida, Lyotard, Lacan) there is something in cinema that is 'more' than itself, which operates in *excess* of capitalist closure – like the *gift* and differ*a*nce in Derrida, the *figure* in Lyotard, the *objet a* in Lacan, or the *simulacrum* for Baudrillard. Conceptually, the Outside as a threshold, already developed in its nascent form by Maurice Blanchot's discussion of the Outside (*le dehors*) in literature, does the same work in being political economy's 'other,' a way out of a confined instrumentalism. It breaks with the Whole, as if there were a coherent world 'behind' the images that we see, and insists that transformative change must emerge from within the system itself through the singularities of *events*: to further 'difference' in such a way that is affirmative and creative, enabling

simultaneously the 'seeds' of its own *de*struction and well as its 'restruction'[2] in a never ending 'becoming'.

Cinematic politics does not refer simply to policy plans and political organizations that are being depicted (as in blatant political art), but to 'lines' of force and resistance (following Foucault) that are negotiated to sustain existence, namely the molar, molecular and a 'line of flight' of becoming. The molar line organizes representational thought via a 'binary machine' that stratifies society into segments, strata and identities. Representational politics is staged on this level, shaped by ideals that project a Utopian imaginary of justice, equality, freedom, human rights and multiculturalism – all of which have been used by both Left and Right to gain a moral high ground. It is, however, the micropolitics of the other two lines that cinema engages, where the more invisible molecular level of private thoughts can open up the molar system, eventually to 'lines of becoming' that crack the system open. This complex network of conscious and unconscious political activities that coexist with one another have their own inherent dangers. They can become totalitarian rigid lines of codification, fascist dreams of conquest and expansion, self-destructive flights of subjective destitution. There are no 'guarantees' when it comes to 'becoming'. The intensive processes that are put into motion are not always life affirming when thresholds are reached and transformations take place.

These three lines of forces and resistance seem to coincide with Lacan registers: molar (Symbolic order), molecular (Imaginary) and line of flight (Real). One should not readily dismiss these similarities and the productivity of an encounter between Lacan and Deleuze (Wilson, 2008; jagodzinski, 2012). Yet, as Wilson Scott (2008) put it, the shift from *jouissance* to Spinozian joy or Nietzschean laughter marks the movement from death to life – more specifically from the death-drive to *anorganic* life: death and *jouissance* are intimately tied together in the master-slave dialectic for what is at stake is the destiny of the signifier, playing a game of the limit. There is joy that lusts for life of the body in the face of death (e.g., the suicide bomber, the drug addict) as a total expenditure without reserve to achieve ecstatic pleasures that 'kill'. Deleuze and Guattari, in distinction, call on the affordances of life to become 'imperceptible', even though such life is paradoxically asexual, asubjective, anorganic, and aneconomic – pure immanence of and in itself characterized by 'desire as pure joy' (Deleuze and Parnet, 2002, p. 100).

[2] The use of this odd word (rather than reconstruction) is simply to refer to dynamic systems as a diagram of forces that can be brought to the 'edge of chaos' as in the work of Jeffrey Bell's (2006) take on Deleuze–Guattari.

As Deleuze notes, 'the life or afterlife of cinema depends upon its internal struggle with *informatics*' (1989, p. 270, emphasis added), and the time-image with its attendant sublimity as the unthought or the 'Outside' is forwarded as the way contemporary consciousness (of the new Left?) actualizes a resistance to molarity, to the field of stratification and smooth space of a plane of organization governed by capitalism's special, temporal, and perceptual orders that 'modulate' lived life to manage and assure the *accretion* of profit. The closing of the 'Outside' via work becoming play, exhausting desire via infinite possibilities (e.g. any pornographic fantasy can be fulfilled or found online), shapes the 'control society' where libidinal intensity is manipulated to make anything that one wants *possible* at a price.

The contemporary dominant molar visual regime of globalized media extends the psychological automaton of the movement-image and tempers it with the time-image to close off the Outside as much as possible. Those processes that disrupt and question our tacit sense of belonging to the world are constantly levelled and s(m)oothed over so that the full horror of military deployment in other countries appears acceptable, violent protests by students due to tuition hikes and the removal of 'Occupiers' from various sites around the world are seen as necessary to continue business as usual, the problems with municipal and government corruption is underplayed, while the global climate crisis is always deferred. Global stock markets become jittery and nervous when the world becomes unstable. The future is essentially closed off via a debt economy (Lazzarato, 2012), and resentment continues to be fuelled by the growing division between the haves and have-nots: the 99 per cent and the richest 1 per cent who control the economy and lobby all levels of governments.

A good example of this state of affairs is the co-option of amateur time-images of 9/11 that were quickly appropriated by sensorimotor schemas of mainstream media production (Ziegert, 2008). *Fox News* quickly turned the event into a melodrama where good and evil were clearly defined (Anker, 2005). Neurological pursuits have begun to harness the 'intrinsic body' of affect for more profit dollars, especially in advertising (Schmitt, 1999; Heath, 2005), which dovetail with the consumer industries that now market '*an* experience' rather than services. These 'experiences', like canned laughter, are managed to provide lifestyle 'kicks.' Given this bleak outlook, William Connolly has bravely argued for ways that should deepen the complexity of attachment to this world in answer to Deleuze's call for a 'belief in this world', and search out and name micropolitical strategies as '*countertechniques of cultural-corporeal infusion*'

(2006, p. 74, original emphasis). Attempts to expose the media of talk-show representation and news reporting through mimicry, parody and exaggeration (Stephen Colbert and Jon Stewart) are but one way. His is a call to 'press for pluralism, equality and ecological sensitivity' (2010, p. 197), noble, but difficult values to achieve.

Given this somewhat bleak account, can a cinematic micropolitical pedagogy be culled from Deleuze's cinema books, which offer a way to counter such accusations by theorists such as Rorty *et al.*? In *Cinema 2* (pp. 245–251) Deleuze develops a 'new pedagogy of the image', which, written in the 1980s, may seem dated given the innovations that 'modern cinema' has undergone in its 'post' cinematic phases of video and digital cinema to usher in perhaps a 'future cinema' that has already arrived.[3] Does it *still* have anything to offer? The question surrounding the reception of the 'time-image' has not gone away, but intensified in the way a continuous stream of media closes off the future by reducing the world to what is but a 'current' flow of information. As Lyotard (1991) once put it concerning the information age, 'What is already known cannot, in principle, be experienced as an *event*. […] [T]he present loses its privilege of being an *ungraspable point* from which, however, time should always distribute itself between the "not yet" of the future and the "no longer" of the past' (pp. 64–5, emphasis added). The event should be understood in its virtual incorporeal Deleuzian sense as never arriving or about to arrive, but never present.

Outside

Micropolitical pedagogy of time-image cinema concerns itself with 'belief in the world' (1989, p. 172), and the emotions that shape this belief in such a way that the foreclosure of the future (as potentiality) can be prevented by struggling with the paradoxes of time itself. '"The pure force of time" […] has always put the notion of truth into crisis' (p. 130). Cinematic narratives have the capacity to render inexplicable and undecidable what is true or false when they unfold in simultaneous presents or coexisting pasts. Such 'presents' and 'pasts' are 'incompossible', meaning that multiple worlds can coexist as distinct possibilities. However, not all presents are 'true' at the same time, and neither are there 'true

[3] Innovations that exploit the time-image can be found in the media environments of installation art but this is another discussion. See Murray (2008, 2010).

pasts' (1989, p. 131). Yet, pasts and presents are enfolded in such a way that the distinction between 'true' and 'false' no longer holds. This 'powers of the false', as Deleuze calls it (1989, pp. 130–1) enables the unthought to be confronted. For pedagogy this means a confrontation with a choice of a mode of existence that is only potentially available as explored by filmic scenarios. It means choosing to choose, adopting a way of living that allows a belief in the world's 'possibilities in movements and intensities to give birth once again to new modes of existence' (Deleuze and Guattari, 1994 (*hereafter cited as simply 1994*)), (p. 72; Bogue 2010, p. 129). This has major consequences for a micropolitical pedagogy: 'art' (cinema) constructs reality and intervenes in the existing archive, but does not 'represent' reality. Films fabulate. Fantasy and reality are not separate spheres, and hence can engender the 'creation of a people to come', opening up a future. For Deleuze, 'the people are missing' 'precisely because they exist in a condition of *minority*' (Smith, 1997, p. xlii, original emphasis), where minorities 'must be thought of as seeds or crystals of becoming whose value is to trigger uncontrollable movements within the mean or the minority' (ibid., xliii). What constitutes the object of micropolitical cinema for Deleuze is the 'intolerable [...] but permanent state of daily banality' (1989, p. 170). Its pedagogy must address such an 'intolerable' condition, '[t]o believe [...] in a link between man and world [...] otherwise I will suffocate', says Deleuze the optimist.

The potential for such a pedagogy emerges only when a disconnect between image, sound, and time via the irrational cut is made. This opens up an *'interstice between images'* (1989, p. 179), replacing the 'interval' of the movement-image. This induces not an *association* but *differentiation* between images, which can potentially produce something new. Deleuze maintains that a 'stratigraphic image emerges' (1989, p. 245), which can be '*read* at the same time it is seen. [...] Not in the sense that it used to be said: to perceive is to know, is to imagine, is to recall, but in the sense that reading is a function of the eye, a perception of perception, a perception which does not grasp perception without also grasping in reverse, imagination, memory, or knowledge' (1989, p. 245; see Conley, 2010). This 'pedagogy of perception' (Deleuze 1995, p. 70) instigates a thought that is alien to common-sense mentality, which is shaped by an 'outside' as is usually thought: as an externality and internality of space–time that are comfortably integrated and unified, which enable us to function in the world as it is. This pedagogy requires an alien thought that penetrates us at a level that 'shocks' us into thinking. Something has to touch us in a way that worries common sense, stumps the imagination, and solicits wonder. This is the 'pedagogy' that recognizes that it is the moment of 'failure' of thought

itself where thinking is activated. Deleuze identifies this 'failure' as 'unpower' (*impouvoir*) and 'impotence' (*impuissance*) (1989, p. 166). The *automaton* – the 'Mummy in us' (ibid.) is awakened. Its 'spirit' apprehends itself in relation to a Whole that our brain cannot grasp. We cannot think the W(*hole*).

Cinematic micropolitics, as a politics of perception, arises from an opening onto the 'Outside'. While this 'Outside' by definition cannot be represented, Deleuze suggests that it can nevertheless be intuitively felt. Such a break in the habituation of thought becomes a source of transformation, in so far as the forces and bodies that populate this Outside trouble conventional understandings of history and politics, calling into question the priority accorded to state, subject and security. In the second part of this chapter I suggest that this Outside is like 'an elephant in the room', as the expression goes. There are many 'elephants' that raise uncomfortable feelings and worries for us, yet we tend to ignore them.

Grasping difficultly

Conceptualizations such as 'spiritual automaton', the 'Outside', the 'unthought' are difficult and foreign terms for anyone who has not engaged in Deleuzian thought, and those who do are confronted with their difficulty. Such concepts can only 'figure' within a project that attempts to further radically decentre and deanthropomorphize Cartesian subjectivity that is shaped by representational thought that operates within chronological time, which is measurable, flexible and associated with memory and human agency. This is the dominant representational image of thought as characterized by metaphysical, metaphorical and dialectical forms of thinking. There is however another 'time' Deleuze refers to as Aion (after the Stoics) that plunges us into the sublime inhuman world that escapes our grasp, and sends a shudder as to its effects regarding our species situatedness within the cosmological forces that continually escape our perception. Deleuze and Guattari theorize the time of Aion as a phantasmic force of continuous materialization and dematerialization, taking place within the contexts of spaces, intensities, speeds and durations, a completely abstract and non-representational dimension. The time of Aion characterizes a 'pure' Outside or plane of immanence, which can be characterized as a 'virtual Real'. This is difference in and of itself – immanent and self-referential. Aion has this peculiar descriptor as a non-place as well as a non-time in the chronological sense, a bit like the phenomenon of 'dark matter' to grasp its cosmological

infinite sense. In terms of contemporary physics, it is a quantum world of 'immaterial' quarks, squarks, antiquarks, held together by the recent discovery of the 'God' particle, Higgs boson that makes space 'stricky' so that its mass can be 'experienced'.[4]

We can follow Lacan up to a certain point here by maintaining that this Real is a realm 'beyond' the image and symbolic language and is machinic in its functioning, below the level of consciousness. The Lacanian Real is closer to Deleuze's 'spiritual automaton' that 'thinks' as an alien 'other' 'in the back of our heads whose age is neither ours nor that of our childhood, but a little *time in a pure state*' (1989, p. 69, emphasis added). Again, the time of Aion is evoked. In Deleuzian terms it is a virtual realm of 'events', the singularities that are the threshold points that can transform a system. Such a transcendental plane is constructed through foldings or restrictions of this Outside so that the virtual transcendence of Ideas addresses the noosphere through 'events' that stand out. A global brain as a screen shifts the ground from 'Mechanosphere' to noosphere, 'the sphere of the noosign – an image which goes beyond itself towards something which can only be thought' (1989, p. 335), which is to say into a zone of nothingness: the unthought, an environment without bounds.

The virtual realm is articulated by Ideas or multiplicities, or ontologies of existence. Ideas are a set of differential elements and relations that structure the intensive processes that give rise to the way a system behaves. Lacan's 'missed encounter with the Real' *(tuché* in Seminar XI) is precisely the event in the heterogeneous time of Aion; Lacan's evocation of a *Wiederkehr* (return) rather than a *Wiederholung* (repetition) in the same seminar is very close to Nietzsche's Eternal Return, which Deleuze utilizes to great effect to 'think' the becoming of difference. The event is incorporeal, it is yet to come or already passed, but never present. It forms a 'clamour of Being' from which the ontology of becoming emerges as a chance event that actualizes Being, an act of genesis, creation seeming *ex nihilo*. Lacan uses the term *lamella* for this pulsing force of anorganic and impersonal life that becomes 'trapped' by assemblages of desire; that is, formations that temporally 'work' together within particular milieus. The difficulty of the term 'fold(ing)' as utilized differently by Deleuze, Merleau-Ponty, and Leibnitz emerges here (Coole, 2010), and perhaps the updating of these speculations of matter are now transposed into the eleven dimensions of 'string theory' that play with folding and unfoldings of matter as well. The

[4] Both Manuel Delanda and John Protevi have attempted to update Deleuze|Guttarian philosophical conceptualizations within the developments of complexity theory.

'virtual Real' is then this differentiated set of relations, a transcendental field, or 'surface' of this chaosmosis, made up of pre-individual and impersonal singularities (events), which have the capacity to organize themselves into a 'plane of consistency' so that singular beings are actualized that then continue to undergo their continued repetitions and differenciations. The 'Outside' then is not the opposite of inside, as would be commonly thought in representational thought, rather Outside for Deleuze is a chaosmos that is itself immanent. It is not a space that can be entered. It is an 'infinite whole' swarming with anorganic life.

Pedagogical worries

Cinema understood as a 'thought-machine' by Deleuze maintains that it has the capacity to transform thought through the very specificity of its own filmic ways of thinking. It 'thinks' with and through images and sound producing 'an image of thought'. Such an approach extends, clarifies and 'completes' Walter Benjamin's *early* enthusiasm and speculation that the 'kino eye', following Dziga Vertov, presents the world via this disembodied eye as a 'second nature' that might be 'translated' and 'read' given that we are confronted with a new spatio-temporal configuration of the world. Such 'visual literacy' was tied to the 'optical unconscious'; the virtuality of vision enabled by cinema and photography presented contexts that reconfigured human experience, opening up new realms of 'seeing'. The 'optical unconscious' becomes a non-human virtual dimension that was to be comprehended like the Freudian unconscious in its more formalist psychological pursuits.

The 'demonic side' to this development, as is well known, is the *politicization of perception* that emerged from being able to break down bodily movement visually (i.e., the photography of Eadwerd Muybridge) so as to analyse it and reconfigure it into more efficient action: to harness the body to conform to specified tasks via illustrated training manuals (e.g., August Sanders, Karl Blossfeld, Eugène Atget), and to apply time and motion studies of Taylorism to industry. The emergence of the advertising industry also began to exploit the virtual movement-image, and the ugliness of the eugenics movement that began its ethnic and racial classification systems led eventually to 'Hitler the filmker' as Deleuze put it, and the making of Fascist Man.

In Deleuze's case the 'optical unconscious' is given a renewed examination. What is of primary concern is that machinic vision produces automatic and autonomous images, which correspond directly to the machinic production of

thought itself – the automaton in us, our unconscious. Much of 'thought' is not subjective, belonging to the 'thinking ego' (*Cogito*) or I. It goes on below the level of consciousness by the 'intrinsic body,' as neurobiologists like Benjamin Libet have shown or via the culturally coded 'mirror neurons' discovered by Giacomo Rizzolatti, which enable us (and monkeys) to mimic the intentions of others before (below) the level of language and then install those tendencies in our body schemas. There is a 'half second delay' before there is a rational ordering of thought into the coded lines and hierarchies of sense that take place (language, affect, feeling, touch). This half second is the 'center [or zone] or indeterminacy'. It is precisely here that the delay between perception and action takes place; it lies at the heart of the imaginary being. This gap, as Deleuze maintained, is where the 'affection-image' bores into our brains (1986, p. 87), producing 'nooshocks'.

'Thinking' is shaped by common sense that generates an 'image of thought' on an immanent plane of consistency. In Lacanian terms, as developed in S XI, we can call this common-sensical image of thought the hegemony of a gaze that positions one 'in the picture', that frames one's place in the Social Order so that there is a consistency between movement, action, belief and emotion ('sensory motor unity'). While this gaze is ephemeral, like the time of Aion, its power to instil order, a molar consistent image of thought, is 'captured' (folded) and coveted by those who claim to have or are transferred the power of authority and Law through the many microcircuits of everyday life. This gaze can only function because 'the virtual is real' in the Deleuzian sense (1994, p. 208). A particular image of thought already 'governs' in our screen cultures. Virtuality works in our minds via our memories, fantasies and imagination as past layers of images. It forms our collective consciousness. This image of thought is conditioned by the belief systems and the emotional attachments that are in place, and that are constantly challenged by what lies Outside of it, by that which has yet to be thought – the unthought. Thought and its Outside are thus coexistent with each other. The Outside of thought, pure difference, cannot be assimilated into something we know, yet it does exist, like Lacan's gaze as 'light' itself, as that which enables perceptions to form.

In Lacanian terms, an 'encounter with the Real' is an encounter with the Outside, with the sublime where the rational faculties no longer hold together. Thinking is produced through such an encounter; in art's case such an encounter enables the creation of new affects and percepts to grapple with the 'formlessness' that the 'spiritual automaton' of our brain encounters. As Deleuze says, "Something in the world forces us to think' (1994, p. 139). Cinema offers an encounter between an image of thought and the cinematic image, but it

does so through its link with neurology and the brain. 'Thought is molecular. Molecular speeds make up the slow beings that we are. [...]. Cinema, precisely because it puts the image in motion, or rather endows the image with self-motion, never stops tracing the circuits of the brain' (Deleuze 2000, p. 366). The 'brain as a screen' becomes a way to think the post-human. As Gregg Lambert (2000) reminds us: 'It is the brain that thinks and not man – the latter being only a cerebral crystallization' (p. 287).

The cinematic image produces automatic and autonomous movement that is machinic, which correlates with automatism of thinking that goes below the level of consciousness as processed by the neurocircuits of the brain as the bodily sensations that are being continually processed. The flow of images, manipulated at various speeds, does not allow time for contemplation and critical distance, unless one reviews the film over and over again. Then the bodily affect is likely to change. The surprises are levelled. A more 'rational' look is possible. A scene is no longer horrifying by being repeated forwards and backwards with the use of a remote control. On most accounts, however, the images act immediately on a pre-reflexive, pre-linguistic level of thought capable 'of producing a shock to thought, communicating vibrations to the cortex, touching the nervous and cerebral system directly' (1989, p. 156).

Spiritual automaton

The automatism of cinematic thinking is correlated at yet another level aside from its unconscious affects. The 'spiritual automaton', is also a formal aesthetic order of the cinema, the way cinematic images are perceived, thought, and edited and then put to 'work' on our intellect at a supra-conscious level. Within such a 'machinic' ontology, there is no definitive break between sentient and non-sentient entities, that is material and spiritual phenomena. Hence, what appears as an oxymoron, 'spiritual automata', is also a way to identify cinema's powers to animate, stimulate and engender 'real' effects. Spiritual automaton as Deleuze incorporates it, draws its inspiration from Spinoza, who maintains the question of free will is a fundamental illusion of consciousness. The ideas one has are less *in* oneself than the ideas that are *affirmed* in oneself. More eloquently put by Deleuze in his lectures on Spinoza, 'it is less we who have ideas than ideas are "*in*" us'. In other words the 'cause' of an Idea resides in its power of 'subjectivizing' our spiritual automata. It is not the singular power of an individual subject but the power (*puissance*) of a mode of thought or an entire

cinematic assemblage. The spiritual automaton 'is not something limited to the embodiment in humans on the screen, but rather, a function distributed across a given film through its gaps as well as a function generated within spectators when the film succeeds in meeting its ends' (Bogue 2010, pp. 126–7).

Cinema's spiritual automaton produces a circuit that enables 'thinking' to enter and 'be' with the film. It 'holds' our fascination within this established circuit. In such a circuit the viewer becomes part of the desire of the machinic assemblage that its spiritual automaton 'wroughts' on us, which can activate a 'nooshock' to our brains. 'It is as if cinema were telling us: with me, with the movement-image, you can't escape the shock, *which arouses the thinker in you*. A subjective and collective automaton for an automatic movement: the art of the "masses"' (1989, p. 156, emphasis added). Cinema works on the viewer on both levels: on the intellectual and the unconscious affective bodily level, resulting in nooshocks. This is precisely the mind–body interconnection that is opened up via the time-image through the irrational cut or interstice that creates a 'delirium' or a fracture, crack or fissure in the I, 'a hole in appearances' (1989, p. 167).

Eisenstein, Artaud, Godard

Cinema's automaton – its unconscious and conscious effects are explored by Deleuze through the two well-established images of thought: the movement-image and the time-image. Each introduces its own specificity of time, which is crucial to grasping the importance of the potential for a micropolitical pedagogy of the cinema, given that the movement-assemblage produces a *psychological* automaton, whereas the time-assemblage produces a *spiritual* automaton. As commented by many, the movement-image refers to classical cinema where the continuity of the linear narrative, interval and montage is maintained by overcoming the cuts and gaps that occur through 'bad' editing to ensure fluid movement from one image to another, by following the 180-degree rule, co-ordinating diegetic sound, attending to action and reaction as cause and effect, utilizing metaphorical images and so on to create a representation of the world. Time is derived from the succession of shots that show a linear progression towards an 'ending'. Through movement, time is represented indirectly and quantitatively. Classical cinema has had its fill of ideological and psychoanalytic critique as forms of Benjamin's call for 'visual literacy'.

For Deleuze, it was Serge Eisenstein, 'the cinematic Hegelian', who developed one of the most sophisticated approaches to this visual regime where its spiritual

automaton becomes a dialectic machine: two shots are brought into conflict with one another, resulting in the audience having to 'think' their synthesis within a predefined 'Whole', as Deleuze puts it. Eisenstein creates an 'action-image' where concept and image are one, enabling 'dramatic, pragmatic, praxis, or action thought' (1989, p. 161). The dialectical unity or truth produces a non-ambiguous concept or idea within the viewer in relation to the image of the Whole of the film, and this is done via the 'shock' effect of opposition putting political pedagogy to work to create 'Revolutionary Subjects,' a more sophisticated form of the psychological automaton being put in the service of dialectal reason and revolutionary zeal, addressed to the intellect.

Deleuze turns to Antonin Artaud to think through the radical potential of the time-image. The schizophrenia of Artaud, who neglected to confirm the established limits of literature, common sense and the body, opens up the world of fixed objects and idealistic categories through processes of unpredictable production. Artaud's brief infatuation with cinema, his poetics and 'theatre of cruelty' provide Deleuze with a way to forward cinema's spiritual automaton of the time-image as mobilizing thought in relation to and contact with the Outside, subverting the relation between image and reality, an un-hinging and de-association between the two. It was Artaud who maintained that cinema was powerless to think the Whole and to think oneself. Thought had to think on its own fracture and powerlessness, its *inability* to be represented. The nooshock of the cinema for Artaud was pure 'neuro-physiological vibration' brought on by the movement and speed of images, closer to automatic writing that exposed the *aporias* of thought. It 'is the shock wave or the nervous vibration which means we can no longer say "I see, I hear", but I FEEL' (1989, p. 158).

The spiritual automaton created by the time cinema no longer correlates redemptive and affective intensities with logical expectations. The image becomes disruptive, powerful, beautiful and intolerable for the mind to grasp; a sublime dimension overwhelms thought. Cinema becomes an *aporia* machine. It is this gap in thought, which reveals that we are not thinking; it brings us to a point of 'thought without image' (Deleuze) – the Outside, synonymously the Real, the W(hole) as Aion, a continuous open set of transformation, difference in itself.

The time-image introduces the irrational cut that separates sound from image and introduces a 'pedagogy of perception' (Deleuze 1995), a new approach to the image. Godard is Deleuze's most important exponent here. Montage now becomes 'montrage'[5] of time as a play with the 'before and the

[5] The showing of images in duration, optical, sonority. From *montre*, French for 'to show'.

after [of becoming] in the characters that constitutes the real' (1989, p. 154). The image is 'purified' of any speech that would rationalize it, which then allows the visual image and the sound image to reach their own subsequent limits; each is purified as it were – the audible is 'free' of the seen and visual is 'free' of the word. The image is thus cut loose, becoming legible and autonomous. What is said and what is seen have no rational relationship. This sets into motion new ways of deframing the world via 'thought and the light source' (1989, p. 176). 'Depth of field' in classical cinema would simply conceal or reveal objects, whereas in time-image cinema it is their 'opacity' in 'relation to light which makes us see being and objects' (1989, p. 176), that enables us to feel synaesthetically their place within the spaces occupied. The cinematic apparatus mediates the pure light of the gaze of the world on us, a gaze (following Lacan) that is radically de-anthropomorphized.

Powers of the false

To think the unthinkable becomes a 'pedagogical' task via cinema that fabricates a virtual world and opens up a subject yet 'to come'. Time-image cinema with its heterogeneous disconnected spaces, autonomous images and sounds, and sheets of time recreates an 'object' that is purely cinematic in its logic. It is the 'power of the false' that exposes ambiguities, irrationalities and uncertainties that are in play, which escape representational thought. The Outside as W(hole), as an open system, and no longer simply an interiority/exteriority binary, now becomes a non-totalizable order of Time as Aion. The political pedagogical potential emerges through Deleuze's (1989, pp. 175–6) distinction between a 'theorematic' (or axiomatic) and 'problematic regime' of filmic thought that repeats his distinction of a minor mathematics that sets itself apart from axiomatic set theory (such as Alain Badiou) (see Smith, 2003). The problematic consists of transcendental Ideas; they mark out a field of problems that cannot be empirically known; they can only be 'thought' since representation fails here. Ideas are therefore *aporias* immanent in thought itself. Cinema is an *aporia* machine that explores transcendental Ideas. What we never know lies at the heart of thought – as the unthought, which is precisely the problem that must be thought.

The nooetic power of cinema is to confront this aleatory 'point of the outside' (1989, p. 176) by creating ways to *counteractualize* 'events' of chance that are untimely and disruptive to everyday life. They help to shape questions and

imperatives stemming from the virtual transcendental Ideas (the multiplicities). These structure and restructure the virtual-actual. Virtual events are creative new patterns and thresholds, while Ideas extend concepts that help us 'think' the world to a virtual point beyond. Further, Ideas 'animate ideal problems determining their relations and singularities' (Deleuze 1994, p. 283). This is the place, so to speak, where cinematic light cannot shine, a 'dark hole' whose denseness dares to be explored.

The *impotence* of cinema (or any human endeavour), its very failure to represent, and by fiat, the impotence of thinking itself, emerges so that the immensity of our failure to see 'the thing or the image in its entirety' (1986, p. 19) forces us to think the unthought so that the 'unbearable' can break through representation. Pedagogy to mean anything must struggle on this level. Two 'brains' meet, so to speak and superimpose on one another: the human 'brain as a screen' meets the cinematic 'screen as a brain,' which composes an image of thought which is 'false'. Real and imaginary give way to a virtual world as a zone of indiscernibility, as perception is stymied or suspended. This is the making of a schizoanalysis.

Such a problematic is capable of producing a new image of thought (new conceptualizations, new percepts and affects) through the confrontation with the unthought, which plunges us into the sublime dimensions of inhuman life that 'nooshocks' us into thinking. '[T]he problematic deduction puts the unthought into thought' (1989, p. 176). Deleuze (2003, pp. 70–93) sums what is at stake concerning 'thinking' by drawing on Foucault's struggles via Blanchot with the Outside in terms of boundaries and limits. Pál Pelbart (2010) sums this up as '(1) The task of thought is to liberate the forces that come from the outside; (2) the outside is always openness unto a future; (3) the thought of the outside is a thought of resistance (to a state of affairs); and (4) the force of the outside is Life' (p. 206).

Post-cinematic concerns

The question is how would such a cinematic pedagogy take place given that Godard's 'pedagogical' approach seems somewhat exhausted within a post-cinematic context of television and virtual cinematography in the twenty-first century? Many of the time-image 'signs' have become ubiquitous throughout television and post-cinematic techniques. In his 'conclusions' to the *Time-Image* (pp. 262–80), when addressing the development of video and digitalization

as the 'new electronic automaton', Deleuze says that '[t]he new images no longer have an [O]utside (out of field), any more than they are internalized in a whole. [...] They are the object of a perpetual reorganization, in which a new image can arise from any point whatever of the preceding image' (1989, p. 265). Does this then change the approach to the Outside as the cinematograph is replaced by the electrograph? Does the 'brain as a screen' in terms of the brain patterns produced no longer continue the dangers of 'Hitler and Hollywood'? Film theorists like Steven Shaviro (2010), Sean Cubitt (2004), Patricia Pisters (2012) and Garrett Stewart (2010), who have dealt extensively with post-cinema, continue to see the significance of the two cinema books for contemporary thought. Stewart writes, 'Deleuze anticipates everything the current spectator must contend with' (2010, p. 337). He brilliantly shows the structural parallels between the films since Deleuze's death in 1995 and the cinematic concepts he developed. Sean Cubitt (2004) concludes his book on post-cinema by maintaining that the '[a]utonomous affects, percepts, and sensations "independent of a state of those who experience them" [Deleuze and Guattari, 1994, p. 164] are not simply commodities that cinema makes available for purchase' (p. 362). This still holds for the post-cinematic developments. They escape being recoded by the state.

Given the body–brain implications of neurobiology, Deleuze's 'the brain in a screen' continues to be important for grasping productive desire in relation to the Outside, pulling thought beyond the limits of subjectivity by encountering the Real of an *event* – its navel, its dark spot, its horror, its incomprehensibility, its emptiness, its death-striking beauty – so that it may be *counteractualized* via cinema, changing the virtual-actual dynamic so that one cannot go back to 'seeing-feeling' as before. New actualizatons can take place as new becomings emerge. We might call this, following Timothy Morton (2010), encountering the inhuman 'hyperobject' that is just too immense and incomprehensible to grasp, but which shakes the foundations of our very being. Patricia Pisters (2012) concludes her work on the 'neurological image' with an equally provocative challenge: 'Films of the twenty-first century show brain-worlds, brain-cities, architectures of the mind. We no longer look through characters' eyes: we experience their minds' (p. 306). Calling on Deleuze's 'third synthesis of time', the contingent time where the new is created as the no-place of the Outside in the time of Aion; where the 'future' is the becoming of the eternal return of difference, Pisters maintains that the contemporary neuro-image takes 'the absolute internalism of the schizophrenic hallucinations as one pole of the brain-screen and the absolute externalism of cosmic space as the other pole,

the brain-screen is always situated at some point between these poles, shifting and sliding between them, inducing epistemological probability and belief *as a zero degree of knowledge*' (p. 306, emphasis added). This is a call, as Deleuze would have it, for the renewal of cinema in two directions at once, a 'dualism which corresponds to the two aspects of the time-image: a cinema of the body, which puts all the weight [tiredness and neurosis] of the past into the body [...] but also a cinema of the brain, which reveals the creativity of the world ...' (1989, p. 205). Gregg Lambert and Greg Flaxman (2005), following Deleuze, put it this way: '[t]he renewal of the cinema must be able to move in both directions at once: toward an outside composed of new possibilities for the body and what it can do, and at the same time, toward the direction of an inside that is created by new actualizations of the brain, or by the multiplication of new artificial brains (chemical, electronic, silicon-based, etc.)' (p. 126). Important to note here is that the field forces of the Outside, in their nth power, are able to reformulate an assemblage into the new, which has profound political and ethical implications as to how we live life.

The heteronomy of the Outside has to be reconnected with poesis (fiction, fabulation, to fabricate, to create), a productive engagement with the world in the context of a particular historical moment.[6] The 'I' must be 'fractured' by the virtual Idea or problem that are 'the imperatives of Being' (1994, pp. 199–200). As in the case of the time-image, the Outside permeates the image in varying degrees, from intensities that seep into shocks that explode, where the eyes remain shut so as to screen the sensation and 'save' the body and intellect from pondering that which disturbs us too deeply – paranoid reactions to overcode leaking cracks.

A micropolitical pedagogy of cinema as a spiritual-electronic automaton should focus on the problematic of the numerous 'elephants' that are stomping on the earth so that we, after Deleuze, emerge with a new image of thought. The elephant is the Outside that 'insists' or 'subsists' from the 'absolute out-of-field' of *durée* – invisible but ever present (Bogue 2003, p. 44). To invoke that sense that something is uncomfortably worrying and disquieting is the encounter with 'difference' of an *incorporeal* event, the sublime virtual Real or void once the interval or interstice between mind and body is opened up both intellectually and aesthetically in political fashion, at the level of the neurological 'body

6 'One "fictions" history starting from a political reality which makes it true, one "fictions" a politics which does not yet exist starting from a historical truth' (Foucault 1980, p. 193). Experience, therefore, in both of its senses, is something that emerges from a necessarily perilous encounter with the world – or with the strange and the foreign.

without organs'[7] – the point of imperceptibility is reached (see Žukauskaitė, 2012). Imperceptibility is therefore the moment when the image without thought emerges, when one 'thinks'.

Pedagogically, I believe, these are moments only reached when a new dimension opens up for the participant-spectator. A spark of wonder has to be struck for the dialogue to begin, as Cubitt (2004) says regarding the spectator-participant: 'Such autonomy that audiences may have opens the option of moving from absorption to dialogue, not with one another, not yet with the creative mind somehow "behind" the film, but with the system-cinema as an *intelligence other than human*' (p. 363, emphasis added). This statement hinges on the interactive cyborgian potential that the electronic automaton can engender. But this only happens when affection, action and relations no longer hold; when the common-sense perception that is held together via feeling, intensity and quality falls apart; when affection is no longer linked with action; or when we can no longer respond in a habitual way to the image; these are affirmative moments when the Outside is let in. This Outside is not a void, a hard kernel of the Real in the Lacanian literature, but the multiplicity of incompossible virtual worlds that are at 'ebb' and 'flow' with and through time, including the chatter that our own species contributes to this never-ending cosmic flow.

Elephants

With these concerns in mind, the film *Elephant,* directed and written by Gus Van Sant (2003) offers an insight as to how a Deleuzean 'cinematic micro-politics' enables *events* to reveal themselves 'otherwise' through this opening to a W(hole) made possible by the cinematic 'spiritual/electronic automaton'. It is an example of the *interiority* of the Outside, the psychotic mind–body that rages against the Symbolic Order as a crisis of disbelief where all identities are derealized, all empathy vanquished. In this case, the event that is given such an alternative treatment is the shooting spree by Eric and Alex at Watt High School in Portland, Oregon, in 1999, as a simulacrum of the actual event at Columbine

[7] As Eric Aliez (2004) would have it: 'It is less an aesthetic truth than the truth as pure sensible, the intensive truth of the Body without Organs which *embodies* aesthetics as *aisthesis = sensation*. Logic of Sensation means that any true immanence is *aesthetic – and that it is the work of art to express it in a politics of sensation, constructing a block of sensation that stands alone*' (emphasis in the original).

High School by Eric Harris and Dylan Klebold.[8] The approach by the media is predictably the same, with emphasis on 'why' and 'how' this could reoccur, and especially the mourning and the loss of innocent victims.

The state institution is the school; the subject is the psychotic body, and security – an impossibility to maintain. The unthought that haunts *Elephant* is precisely the impossibility of ever knowing just who might be susceptible to a psychotic breakdown in the institutionalized school setting where so much crisis of identity goes on. The primary interpretation of the Eric and Dylan school shootings was not only their affiliation with the so-called Trench gang mafia, but Harris's neo-Nazi leanings and the playing of violent video games: *Doom* to be specific. The usual slate of TV psychologists and reporters furthered these interpretations both to sensationalize the killing spree and to aid in helping a nation mourn for such 'senseless' acts. It is for this reason alternative perceptions become necessary, perspectives that aim to see something that cannot appear in the normal course of politically charged events whose claims to the 'truthful' representation must always remain under suspicion. For instance, Robert Steinhäuser's ('Steiny' – or Rocky) shooting spree in the Gutenberg Gymnasium in Erfurt had Gerhardt Schröder, Germany's Chancellor at the time, and several of his ministers attributing the cause of the killings to video game violence and the band Slipknot, thereby gaining valuable publicity points by a public baffled and searching for easy explanatory answers. While these partial explanations may well contribute to desensitization to raise the intensity of the threshold to kill, they always fall short of grasping the larger forces that are at work. In these cases the killing sprees are both a symptom of the school as an institution and a synecdoche for the larger question of the perceived increase of violence and bullying in schools, and the pervasiveness of structural violence in general.

Viewed from the context of cinematic micropolitics, such violence cannot be understood simply as a symptom of the failure to resolve conflicted student psyches by the school administration and its internalized rules and regulations that are supposed to inhibit such behaviour – like stress management, bully programmes and other discursive forms such as self-assertion training and so on. Frustration with such programmes has certain US politicians and legislators calling for arming teachers with guns, zero tolerance, and an increase in surveillance and 'lock-down' drills, blurring schooling with incarceration. Such

[8] At the time of this writing, yet another 'shooting spree' had taken place in Newport, Connecticut, even more tragic, if that is possible, given that the victims were mostly children aged from five to ten.

violence points towards the workings of 'something' that is in excess of the law, the state, the subject or representation. Cinematic politics in this Deleuzian sense charts an alternative both to the realist notions of analysis based on state politics and their accompanying ideological apparatuses (including public media), and the discursive notions of an analysis based on representational politics where the discussion turns to class, gender, race, disabilities, ethnic differences and the like. These are precisely the clichés Van Sant questions through his time-image approach to *Elephant*.

Van Sant's problematic is to 'stage' this incomprehensible sublime event and have an audience face and endure its unthought. It is the banality of everyday high school structural violence that stalks the institution which pervades throughout the ecology of the film. It is this sense of foreboding and impending danger that Van Sant is able to sustain via the discord of the soundtrack and the visual images that disorientate the viewer. The first part of the film, prior to the shooting spree, is shot in natural or low-key light, while during the shooting spree a sinister feeling is achieved through intense colour saturation making the audience 'feel' the haecceity of the one 'day' that is being projected. To explore the event, he provides a crystalline description of this killing spree where description is no longer a representation of the object, but 'constitutes the sole decomposed and multiplied object' (1989, p. 126) through sheets of de-actualized presents and one sheet of the past, the day before the shooting when Eric sleeps over at Alex's house before they gear up and drive to school. The event of the killing spree was edited as it happened in one day – although the actual shooting script took two weeks.

Optically, Van Sant shoots the day as a simultaneous criss-crossing of time with various speeds. Some scenes are shot in slow motion, as when he pans across Alex's basement bedroom while he is playing Beethoven's sonata No. 2, the day before the shooting. This slow motion sweep is homologous with Alex's apparent calmness. Yet underneath that calm exterior, anger is boiling, signalled by an abrupt chord struck as he fails to follow a difficult passage on the sheet music, stopping his progress. Slow motion at times is used to show the awkward gait of some of the teenagers. Boomer the dog swinging in the air is also filmed in slow motion, conveying the lingering moment of wanting to watch a pet perform a trick – over and over again in fascination. In another very long slow-motion sequence (in terms of actual film time), a cloudy night sky, filtered through a blue-green lens to give it a bile acidic feeling, begins to churn into a dark brooding storm with sounds of distant thunder being heard while Alex and Eric sleep before their day of reckoning. The storm and its sounds adumbrate

both their shooting spree as well as their unconscious dreams that reach the limit of representation by the cinematic apparatus – the black screen which the storm eventually turns into as the camera pans over the sleeping bodies of Alex and Eric. In opposition to this, Van Sant uses time-lapse of the sky at the beginning of the film to show the quick passing of the day to night, when everything is over before you know it through inattention, and when Michelle looks up into the sky to signal her desire that time passes quickly only when she is outside the school building – free to move at her own pace.

Van Sant presents us with one déjà-vu scene as a peep into the future when Alex is going over the plans as to how exactly he and Eric intend to storm the school, which entrance they will take, where they will gear up, when the bombs are to explode, scattering students towards them, and so on. Each time Alex talks and points to the map, Van Sant cuts to the scene that will have already happened – the future anterior. The planning scene and its attendant cuts to an adumbrating future is another sheet of memory that belongs to the virtual memory of the event itself. The scene exposes the present as immediate doubling, as an actual present perception and a virtual memory of the present. It is presented here as an exposed 'mirror image' made possible by the insertion of future anterior cuts of the killing spree as Alex points to specific places on the map. This is usually an 'objective illusion' of a real doubling in which the virtual and actual are distinct but unassignable moments that meet as a point of indiscernibility. Here we are given privilege to their splitting. However, even the so-called rational plan that Alex provides ends up going wrong, showing us that the future is always open to the Outside.

Van Sant's rendering of the Columbine event is a fine example of the 'powers of the false' – a suspension and dispersal of truth in various directions, which form the shards of the crystalline structure. In a very particular way, Van Sant presents a Deleuzian notion of a desubjectivized body void of any 'subjectivity'; a mode of corporeality that escapes structures of identity and subjectivity, the students are like the 'Mummy' mentioned earlier, habituated in their everyday life, yet this depiction is not an implicit return to the abstractions of philosophical idealism that relegates the body to some fleshy, contaminated world of substance. Such body materiality turns out to be a corporeal 'something' that returns as a form of resistance, refusal, singularity and radical particularity. This 'body' is presented as if we, as viewers, know little or nothing of students, or student life. They are all ambiguous figures, seemingly empty, placed in an environment that is isolating and pregnant with an impending doom. No rack focus shots are used to subjectivize one student from another in a crowd. These

students are *minoritarian figures* of the school. Dislocated, their wandering appears aimless, but they are always on the move as if in a constant transition, caught perpetually between two points, in the liminal spaces of the school – corridors, empty gyms, empty classrooms and washrooms.

Shooting the characters with a telephoto lens enhances the feeling of a crisis situation and make them more isolating figures. These shots tend to flatten the foreground and background; the figures become lost, absorbed, and isolated within the setting. At other times, Van Sant resorts to a wide-angle lens, which elongates and skews space so that the figure of Michelle is engulfed by the cavernous space of the gymnasium she crosses; her diminutive size within it matches her uncomfortableness and awkwardness of taking part in gym class, never good enough, never fitting in. Van Sant situates his cameras in ways where the periphery of the film frame is disallowed or cut-off, a strategy of deframing (*décadrage*). The camera is placed in a position that appears in the non-place of the Outside; while not a God's eye view, it is 'an unsettling angle of framing that suggests a non-narrative motivation' (Bogue 2003, p. 43). It has to be 'read' or 'interpreted'. As Deleuze says, 'this is a cinema of the seer and no longer the agent' (1989, p. 126). More often used in horror films, the deframing techniques incite anxiety in the viewer since the figures become vulnerable and potential victims.

Shot in a square format 1:33:1 aspect ratio, the projection forces the audience to move up closer to it, rather than sitting farther way in the cinema. This adds to the claustrophobic effect of not having space to breathe. The interior and exterior of the school at times appear to vanish, becoming a labyrinth of hallways. Sound is often kept at a threshold level of understanding, also forcing the audience to come 'into' the screen. (I found that the movie is most force-fully experienced with headphones on, in private rather than in a cinema.) The soundtrack is purposefully composed of conversational fragments, which, as viewers, we are not fully privy to. 'What speech utters is also the invisible that sight sees only through clairvoyance; and what sight sees is the unutterable uttered by speech' (1986, p. 260). This is a good example of 'free indirect discourse', for these dialogical exchanges are examples of conversations that take place as the spontaneous inventions by students lying somewhere between fact and fiction – neither totally dictated by the script nor totally spontaneous, yet informed by a particular historical memory each body carries. Narration, as the correlate of illustration, cannot slip into the space between these figures in order to animate an illustrated story. These are fragments of stories that do not quite add up. They are filled with gaps of nonsense that make it impossible to

follow completely. Gus Van Sant purposefully cast non-acting students for their ability to improvise conversations. In all instances, their Christian names were used. There were no pseudonyms to protect participants as in some forms of ethnographic documentary.

Van Sant emphasizes this decentred subjectivity through the body of Elias, who is the school's photographer. Elias is a recorder in machinic motion, capturing what he accidentally stumbles upon – a Goth couple in the park, John caught in the hallway. He even takes a snapshot of Alex before he is shot in the school's library – the warehouse of knowledge where symbolically the first killing take place (as was the case with Klebold and Harris), with Michelle being their first victim, the least likely person to be condemned to death if revenge is posited as motive for such action. She is, after all, yet another abjected creature of the school. We have no idea of John's relation to his father (Mr. McFarland), as to why he is an alcoholic; all we know is that John suffers and cares for him. We know nothing of Benny, except as a body that is called by the noise and attracted to the violence. He is simply shot by Alex. We know nothing of Eric in particular, except that he is Alex's friend, and certainly not the 'brains' of the operation. He has trouble identifying the figure of Hitler in an afternoon documentary, dashing popular journalist assumptions. He is more physical … an accompanying grunt whom Alex unemotionally shoots during the spree perhaps for his jibing remark that Alex may catch herpes from the cup he is drinking from. We know nothing of Michelle, except that she is uncomfortable with her body, persecuted by other girls and nagged by her physical education teacher for not wearing shorts to gym class as she is supposed to. We know nothing about the school jock Nathan, other than he is a womanizer. We know nothing about any of this student body, and like psychosis itself, they are presented often as 'backs' moving throughout the long corridors, reminiscent of René Magritte's thought-provoking surrealist painting of 1937 *La Reproduction Interdite* (Reproduction Forbidden), where there is no reflection in the mirror, no stable ego identity. The mirror is a 'reflection' of the back of the head and shoulders of the person (Edward James) standing in front of it, offering many possible explanations.

Van Sant echoes both Deleuze and Lacan's mistrust of imaginary represen-tation, each on different grounds. Representation is conceptual, transversing the distance between the image and its referent. Image, in contrast, is perceptual, visceral and experiential. Perception simply confronts the image and does not connect it to anything else. This mode of perception suspends the action of conceptualization – as the denial of the viewer knowing who these characters

truly 'are' makes them non-referential images. Still shots, close-ups and extreme-long shots isolate the figures even more. Each student body is introduced by a first name (no surname) on a black screen, which presents the limit of the irrational cut that marks the time-image. These are figural bodies, not figurative, icons isolated in/to their own sites. Such minimalism enhances the unknowability of each body, and reminds us that any student body's name could just as easily appear there – fated by death or by an escape from it. In Deleuze's terms, each body is simply a simulacrum rather than an image of its referent. We find out that each body is persecuted within the school in a particular way. Alex and Eric, who commit the killing spree, seem to be regular kids. Alex in particular is sensitive, artistic, plays the piano, a nerdy kid who exteriorizes his suffering and humiliation in school through his suicidal act. These bodies are constructed in such a way that they are not so easily judged. The setting, the school as an institution, in effect produces the event. All the student bodies presented are ticking time bombs that can explode at any given moment. While Alex and Eric shed bullets, Brittany, Jordon and Nicole shed vomit in properly bulimic fashion, while John sheds uncontrollable tears. Michelle can only run to find her bodily release. The shooting spree for Alex and Eric is just another 'day' at school to have 'fun', as they put it, meaning that it will be the first day that their 'work' will be suspended and they will be recognized – subjectivated. As John Protevi's (2009) Deleuzian analysis of Klebold and Harris maintains, it is all about 'judgment', 'having been judged and found wanting their whole lives, Klebold and Harris became judges on the spot. [...] In "control society," it is a matter of constant checking and modulation, of dispersed self-enforced surveillance and improvement' (p. 161).

The hodological space (Lewin, 1938), that is the paths that tie people together or distance them apart, or – put more simply – the various directions to and fro, is disrupted in the labyrinthine hallways of the school. The anomalies of movement as students walk these corridors are presented as multiple sheets of simultaneous time, as chance meetings, yet mutually exclusive occurrences, as *peaks of the present* of the event. Time is a W(*hole*) of these enfolded presents, open to the Outside. The moment of conjunction between bodies is what makes space, it ceases to be hodological and chartable. For example, Van Sant presents us with three *simultaneous* views of Elias's exchange with John with Michelle in the background. These three sheets of 'time' appear at different chronological moments within the narrative.

The sensory-motor schema is especially collapsed by long tracking shots where bodies do not seem to do much else but walk along trajected paths,

occasionally meeting contingently other bodies in the labyrinthine corridors of the school, where brief conversations take place. The corridors become almost dark alleyways as natural light is lost in the corners. These minoritarian bodies inhabit only liminal spaces. Gus Van Sant spends more time filming in the corridors, washrooms, cafeteria and outside of the school building than in any actual classroom. The two exceptions to this are a Gay–Straight alliance meeting where a circle of students forms a discussion group, and another to show how Alex is being gobbed by classmates as he sits in the back row of a science class. The teacher is oblivious to this ongoing ridicule. Van Sant, an outed gay director, obviously has an interest in presenting the Gay–Straight alliance meeting, but even here the talk about gay bodies is reduced to a question of appearances, while the infamous kiss between Alex and Eric, which takes place while they shower before heading to school for the kill, is staged in such a way that the homoerotic overture acknowledges and seals the pact between them. When Eric asks Alex, 'I have never kissed anybody, have you?' the exchange is one of love between blood brothers, soldiers who are about to die together; their heightened eroticism anticipated by their killings is adumbrated by their kiss.

School space becomes especially alienating, as when Michelle, a young woman who is uncomfortable with her body in school, but free when outside it, walks across the gym floor. It is a space she absolutely detests, a space that overwhelms her, which is foreign and alien territory for her; it becomes a crystalline space despite the 'actuality' that basketball and the gym floor as a whole is usually considered to be the pulse and centre of a school's identity as represented by its myriad sport teams, pep rallies, speeches, dramatic presentations and so on (see Figure 2.1). We can also see in this scene how depth of field enables the image itself to convey the thought of alienated space, having replaced the shot–reverse shot of classical cinema of the movement-image. This alienating parabolic space shot with a wide-angle camera lens is contrasted to Michelle's feelings outside the school in open spaces, like the football field she runs across in an earlier scene. Rather than gawking at the football player like some love-struck cheer leader, here she hesitates, content merely to smell the fresh cold autumn air and look at the wide blue sky that is fleetingly passing her (we see the sky through time-lapse photography) for she must return to the building (see Figure 2.2).

The school hallways, despite being the apotheosis of Euclidean space that direct bodies in and out of classrooms when buzzers go, have also become estranged, uncanny, labyrinthine, endless, rhizomatic, empty and amorphous

spaces, losing all their Euclidean coordinates. The fields of force, which usually define this hodological space, have been suspended. No buzzers are ever heard, and when they are, they become muffled siren calls during the shooting spree. Often these hallways are strangely empty, isolated tunnels, as if they have become the bowels of the school; the intestines where all the shit between bodies is processed through quick glances, gossip, hesitations and outright stares. In them, the movement of the student bodies almost tends to zero in

Figure 2.1: *Elephant* film still

Figure 2.2: *Elephant* film still

the way they seem to wonder aimlessly throughout these corridors … as if they were going nowhere in particular, often without purpose or goal, loitering as meaningless movement. Van Sant even has Nathan wearing a white Lifeguard Cross on the back of his red hoodie, which is reminiscent of the cross-hairs of a gun as if he is being followed by a first-person shooter – the camera, tightly focused, as if walking down a pipe where all peripheral vision has been cut away, raising the audience's anxiety (see e.g. Figure 2.3).

Perhaps, Benny, the last body to be shown, best exemplifies this. Benny is attracted to the fire and the noise … the sensory-motor situation of the shooting spree has now given way to a pure optical and sound situation, like those coming to gawk at an accident scene and become mesmerized by the gore and destruction, as in Andy Warhol's accident series. The camera follows Benny each cautious step of the way until he comes up to Erik who is pointing a gun at Principal Luce. Erik simply turns around and shoots him … and says 'shit' (almost as if he did not intentionally wish to kill Benny, a black student who was obviously cool and 'hip', but the point is that there was no intention meant. Benny was simply another target). As Protevi (2009) points out, 'since everyone [in a control society] falls away from the norm (that is, everyone has a 'becoming-minority') all Klebord and Harris had to do was simply look at their victims to identify their weaknesses; they were able to find a failure everywhere – you're black, you're Christian, you're fat, you've got glasses' (p. 161).

Figure 2.3: *Elephant* film still

When it comes to the killing scenes, we hear the sounds of birds and crickets chirping, buzzing insects, as if the school hallways have turned into an open field that seems to be engulfing Alex as he walks through the corridors, stalking for prey … perhaps an allusion to *Apocalypse Now, redux* where Colonel Walter E. Kurtz also hears heightened jungle sounds as he plunges further and further into psychosis. These sounds become disembodied, existing on some Outside, which cannot be identified subjectively or objectively. Yet, it must be added, these sounds are paradoxically both freeing (birds chirping, open field) and shrilling. Van Sant mixes sound as Alex and Eric continually look for prey. Protevi (2009) provides some insight here when he discusses the neurological relation between rage and predation. The Columbine killers, 'although they were in some ordinary sense rageful and hateful, were indeed hunting when roaming the library looking for victims' (p. 145). They were able to sustain this state for about sixteen minutes before they committed suicide. The soundtrack offsets the images of killing during this section of the film. Hildegard Westerkamp's composition *Beneath the Forest Floor* is an example of *musique concrète*. She is famous for her compositions that use everyday sounds as part of her musical scores. The soundtrack is a combination of familiar schoolyard sounds of children playing, crickets chirping, train departure announcements, running water, and bird sounds that are all electronically digitalized and distorted.

Unlike a film such as *Run Lola Run,* where it becomes obvious that narration ceases any claim to truth, forwarding only falsifiability by presenting the simultaneity of 'incompossible presents' (Leibnitz's term for a view of parallel futures or worlds that can never collide), or the coexistence of 'not-necessarily true pasts' (1989, p. 131), Van Sant presents the simultaneity of school life as one of constant crisis, and leaves us with the hint that the Elephant is ready to rumble at any given time. When the true and the false become blurred, when there is a collapse between the real and the imaginary – the actual and the virtual – as to what is placed in doubt, it seems that there are many 'schooled bodies' who are troubled by the institution and the desperate lives led within it and at home. (The opening scene has Mr. McFarland, John's drunken father, driving him to school, side-swiping cars along the way and nearly hitting a biker. The parents of Alex, filmed mostly with their heads cropped, have no emotional attachment to the boys, except to acknowledge another routine day; Principal Luce is more interested in school rules than the lives of his students.) Van Sant's micropolitical cinema demonstrates how the powers of the false 'shatter the system of judgment'. It becomes more and more difficult to condemn even the psychotic killing spree brought on by the stresses of school life. As witnesses to the

crystalline event, we are positioned in the nowhere place of the Outside, gazing at the incomprehensibility, as if our viewpoint was now placed at the zero point of time itself, realizing that the identification of characters is never found in the truth of the ego. As Deleuze puts it, 'the power of the false cannot be separated from the irreducible multiplicity. "I is another" has replaced Ego=Ego' (1989, p. 133). It is as if each body in that school shares a conflict of identity like Eric and Alex, but only veiled … yet subject to potential explosion when the veil is dropped if the conditions for constituting such a psychotic body politic to negotiate the intensity of the act of killing are met. As Protevi (2009) puts it: 'the question, "how" rather than the question "why"' (p. 143).

Van Sant is not interested necessarily in the questions of 'how' or 'why' but to throw a micropolitical 'punch' at the audience via his combination of affects and percepts so that they face their own questions around such an event; so that they can counteractualize ('dialogue') the problematic that surrounds it. In this way Van Sant presents the 'unthought' body of these students. The audience is forced to think beyond that which is not contained in the image, yet carried by the soundtrack. Simultaneously it is that very terror that evades the sound, which is secreted by the image. The perception of this student body is micropolitical in so far as it demands a transformed thought, a transformed relation to the orders and logic of state-thought as regulated by school Law and mandatory attendance. The state as a system produces spatial relations and regulates these relations between individuals and the space of the state. In this framework the political centrality of movement becomes apparent. The state mediates the relations between individuals and places through the regulation and control of movement and property.

To think the Outside of the state, we need to think not only of bodies without subjects but bodies without places or locations, which is what Alex and Eric are – not BwOs but OwB, Organs without Body with no place in the symbolic order, caught by dislocation within a 'judgment machine' – they have become all *too* perceptible. The other students waver between two extremes, to recall Patricia Pisters, between a psychosis as the closure of the Outside within the deepest interiority of the self, or a 'pure' escape into exteriority, the freedom of the Outside in its infinite openness of cosmological wonder, perhaps like Michelle who finds no solace anywhere, only in 'dreams of escape' – perhaps two forms of psychosis that the 'control society' produces?

Alex and Eric have become 'war machines' that disrupt the smooth ordering of place, with no identity, as OwBs, ambivalent figures where becoming a war machine and becoming dead are not distinguishable in their case. In terms of

the micropolitics of the body, Alex and Eric bring into perception something that cannot be, 'warring machines' that are not defined and delimited by their opposition of being abjected. Both Michelle and Benny are their victims with no differentiations made. Protevi (2009) again: '"to be done with judgment of God" is a profound Deleuzian wish' (p. 161).

<p style="text-align:center">* * *</p>

Alex has found Nathan, the school jock, and his latest girlfriend, Carrie, in a meat refrigerated room, part of the cafeteria, a space that is frozen and dead, never meant to be inhabited by human beings – strung with slabs of cow carcasses – allusions to the great works of Rembrandt and Francis Bacon. The camera frames Alex as a close up as he moves his rifle back and forth from Nathan to Carrie as to who he will kill first. Alex starts to repeat a racist poem that, in effect, says that he will spare one of them their fate. 'Eeeny … meeny … miny mo, catch a Nigger by the toe, if he hollers let him go … eeeny … meeny … miny mo'. As he continues to recite the verse, the camera pulls back and the scene fades into the same blue-green brooding sky as before, and then into credits. No shot is ever heard.

This scene raises the Deleuzian question of 'contingent futures' and the paradox of time, the way that the 'pure force of time [and not its content] always puts truth into crisis' (p. 130). Without the concept of the 'compossible' the situation becomes irritatingly paradoxical and frustrating. If it is true that Nathan *may* be shot first in the next instant, then how can the paradox of the following two *true* consequences concerning time be avoided? Either the impossible proceeds from the possible – if Nathan is killed first and not his girlfriend Carrie, it is no longer possible that his killing may not have taken place; that is to say, the future has already been decided and the impossible cannot emerge; or the past is not necessarily *true*. Nathan may not have been shot so that the impossible can emerge and the future is open. After all, Alex is wavering between them, not saying which one he will kill, or even if he will indeed let one go as his racist rhyme seems to indicate. As viewers, we are left suspended by his hesitation as his rifle drifts back and forth. Again, no shot is heard after the fade to a brooding and moody blue-green filtered cloudy sky moving in hyper-time. Deleuze's point is that this paradox 'shows the difficulty of conceiving a direct relation between truth and a form of time', obliging '*us to keep the true away from the existent*, in the eternal or in what imitates the eternal' (p. 130).

A film such as this, which does such an amazing job of 'keeping the true away from the existent', generates the kind of micropolitical pedagogy the

public should be confronted with. I have on many occasions called this a pedagogy of self-refleXion, the capital X being a grapheme that denotes the importance of the Outside when it comes to thinking. This should be the job of the artist, to continue to create the new that offers challenges and interventions into the stupidities of common-sense thought. Artists are teachers as teachers are artists.

References

Anker, E. (2005) 'Villains, victims and heroes: melodrama, media, and September 11', *Journal of Communication* 55, (1) (March): 22–37.

Badiou, A. (2000) *The Clamor of Being*, trans. Louise Burchill. London and Minneapolis, MN: University of Minnesota Press.

—(2011) *The Rational Kernel of the Hegelian Dialectic*, ed. and trans. Tzuchien Tho. Melbourne: re.press.

Bell, J. (2006) *Philosophy at the Edge of Chaos: Gilles Deleuze and the Philosophy of Difference*. Toronto: University of Toronto Press.

Beller, J. (2006) *The Cinematic Mode of Production: Attention Economy and the Society of the Spectacle*. Hanover and London: University Press of New England.

Bogue, R. (2003) *Deleuze on Cinema*. London and New York: Routledge.

—(2010) 'To Choose to Choose – To Believe in This world', in D. N. Rodowick (ed.), *Afterimages of Gilles Deleuze's Film Philosophy*. London and Minneapolis: University of Minnesota Press, pp. 115–34.

Conley, T. (2010) 'The Strategist and the Sratigrapher', in D. N. Rodowick (ed.) *Afterimages of Gilles Deleuze's Film Philosophy*. London and Minneapolis: University of Minnesota Press, pp. 193–212.

Connolly, W. E. (2006) 'Experience and Experiment', *Daedalus* 135, 67–75.

Coole, D. (2010) 'The Inertia of Matter and *Creativity of Flesh*', in Diana Coole and Samantha Frost (eds), *New Materialisms: Ontology, Agency, and Politics*. Durham, NC and London: Duke University Press, pp. 92–115.

Cubitt, S. (2004) *The Cinema Effect*. London and Cambridge, MA: MIT Press.

Deleuze, G. (1986) *Cinema 1: The Movement-Image*, trans. Hugh Tomlinson and Barbara Habberjam. London and Minneapolis: University of Minnesota Press (cited as 1986).

—(1989) *Cinema 2: The Time-Image*, trans. Hugh Tomlinson and Robert Galeta. London and Minneapolis: University of Minnesota Press. (cited as 1989).

—(1994) *Difference and Repetition*, trans. Paul Patton. New York: Columbia University Press.

—(1995) 'Letter to Serge Daney: Optimism, Pessimism, and Travel', in *Negotiations, 1972–1990*, trans. Martin Joughin. New York: Columbia University Press, pp. 68–79.

—(2000) 'The Brain is the Screen: An Interview with Gilles Deleuze', in Gregory Flaxman (ed.), *The Brain is the Screen*. London and Minneapolis: University of Minnesota Press, pp. 365–74.

—(2003) *Foucault,* trans. Sean Hand. London and Minneapolis: University of Minnesota Press.

Deleuze, G. and Guattari, F. (1994) *What is Philosophy?*, trans. G. Burchell and H. Tomlinson. London and New York: Verso (cited as 1994).

Deleuze, G. and Parnet, C. (2002) *Dialogues II*, trans. H. Tomlinson and B. Habberjam. London and New York: Continuum.

Foucault, M. (1980) 'The History of Sexuality', in C. Gordon (ed.), *Power/Knowledge*. New York: Pantheon Books.

Grusin, R. (2010) *Premediation: Affect and Mediality After 9/11*. London and New York: Palgrave Macmillan.

Hallward, P. (2006) *Deleuze and the Philosophy of Creation: Out of this World*. London and New York: Verso.

Heath, R. (2005) *The Hidden Power of Advertising*. Henley-on-Thames: Admap Publications.

Holmes, B. (2008) *Unleashing the Collective Phantoms: Essays in Reverse Imagineering*. Brooklyn, NY: Autonomedia.

jagodzinski, j. (2012) *Psychoanalyzing Cinema: Productive Encounters with Lacan, Deleuze and Žižek*. London and New York: Palgrave Macmillan.

Lambert, G. (2000) 'Cinema and the Outside', in Gregory Flaxman (ed.), *The Brain is a Screen: Deleuze and the Philosophy of Cinema*. London and Minneapolis: University of Minnesota Press, pp. 253–92.

Lambert, G. and Flaxman G. (2005) Ten Propositions on Cinema and the Brain', *Pli: Warwick Journal of Philosophy*, 16: 114–128.

Lazzarato, M. (2012) *The Making of Indebted Man*, trans. Joshua David Jordan. Los Angeles, California: Semiot(e).

Lewin, K. (1938) *The Conceptual Representation and the Measurement of Psychological Forces: Contributions to Psychological Theory*. Durham, NC: Duke University Press.

Lyotard, J. F. (1991) *The Inhuman: Reflections on Time*, trans. Geoffrey Bennington and Rachel Bowlby. Stanford, CA: Stanford University Press.

Mercer, K. (1998) '"1968": Periodizing Politics and Identity', in Lawrence Grossberg, Cary Nelson, and Paul Treichler (eds), *Cultural Studies.*. New York: Routledge, pp. 424–49.

Morton, T. (2010) *Ecology Thought*. Boston: Harvard University Press.

Murray, T. (2008) *Digital Baroque: New Media Art and Cinematic Folds*. London and Minneapolis: University of Minnesota Press.

—(2010) 'Time @ Cinema's Future: New Media Art and Thought of Temporality', in D. N. Rodowick (ed.), *Afterimages of Gilles Deleuze's Film Philosophy*. London and Minneapolis: University of Minnesota Press, pp. 351–73.

Pál Pebert, P. (2010) 'The Thought of the Outside, the Outside of Thought', *Angelaki: Journal of the Theoretical Humanities*, 5 (2): 201–9.

Patton, P. (2001) 'Redescriptive Philosophy: Deleuze and Guattari's Critical Pragmatism', in Patricia Pisters (ed.), *Micropolitics of Media Culture: Reading the Rhizomes of Deleuze and Guattari*. Amsterdam University Press, pp. 29–42.

Pisters, P. (2012) *The Neuro-Image: A Deleuzian Film-Philosophy of Digital Screen Culture*. Stanford, CA: Stanford University Press.

Protevi, J. (2009) *Political Affect: Connecting the Social and the Somatic*. London and Minneapolis: University of Minnesota Press.

Rodowick, D. N. (1997) *Gilles Deleuze's Time Machine*. Durham, NC: Duke University Press.

Rorty, R. (1998) *Achieving Our Country: Leftist Thought in Twentieth-Century America*. Boston: Harvard University Press.

Shaviro, S. (2010) *Post Cinematic Affect*. Winchester: Zer0 books.

Schmitt, B. (1999) *Experiential Marketing: How to get Customers to Sense, Feel, Think, Act and Relate*. New York: The Free Press.

Smith, D. (1997) 'Introduction', in Gilles Deleuze, *Essays Critical and Clinical*, trans. D. Smith and M. A. Greco. Minneapolis: University of Minnesota Press.

—(2003) 'Mathematics and the Theories of Multiplicities: Badiou and Deleuze revisited', *Southern Journal of Philosophy*, 41 (3): 411–49.

Stewart, G. (2010) 'Cimnemonics versus Digitime', in D. N. Rodowick (ed.) *Afterimages of Gilles Deleuze's Film Philosophy*. London and Minneapolis: University of Minnesota Press, pp. 327–50.

Van Sant, Gus (2003). *Elephant*. Fine Line Features.

Wilson, S. (2008) *The Order of Joy: Beyond the Cultural Politics of Enjoyment*. New York: SUNY Press.

Ziegert, D. (2008) 'Radical Measures: 9/11 and as Deleuze's Time-Image', *Rhizomes* 16. Available at: http://www.rhizomes.net/files/masthead.html (accessed 4 September 2013).

Žižek, S. (2012) *Less than Nothing: Hegel and the Shadow of Dialectical Materialism*. London and New York: Verso.

Žukauskaitė, A. (2012) 'Potentiality as a Life: Deleuze, Agamben, Beckett', *Deleuze Studies*, 6 (4): 628–37.

Deleuze, Guattari, and Environmental Pedagogy and Politics

Ritournelles for a Planet-Yet-To-Come

Petra Hroch

What becomings pass through us today?
Gilles Deleuze and Félix Guattari, 1994, p. 113

Introduction: A people-yet-to-come and becoming now-here

Deleuze and Guattari's invocation for a 'people-yet-to-come' leads us to ask: *what* are the people-yet-to-come? Or rather, *who* are the people-yet-to-come? Or perhaps, *where* are the people-yet-to-come? Or even, *when* are the people-yet-to-come? Early twentieth-century avant-garde artist Paul Klee made a similar plea, seeking 'a people' in his 1924 lecture 'On Modern Art': Klee lamented that 'the people' present in his milieu 'are not with [them]' – the modernist artists at the Bauhaus school of design (1964, p. 55).[1] His remarks in this famous lecture and elsewhere in his diaries and notebooks suggest he thought that the art audiences of his era were not ready to release artists from the representationalist paradigms of traditional art and embrace modern art-making as the creation of the new (in other words, art audiences were not prepared to embrace a new notion of art and design as *presentation* rather than *re-presentation*). Klee, too, sought a people-yet-to-come – an art audience hospitable to new concepts. His ideas were, indeed, *avant-garde*: in one sense they were perfectly *of* their time, arising out of the context of a specific historical moment and surroundings; but, in the sense that his work was experimental, innovative and even deemed radical, his ideas were also *untimely*, out-of-step with time, and, we might even

[1] Paul Klee writes, 'the people are not with us ... But we seek a people. We began over there in the Bauhaus. We began there with a community to which each of us gave what he had. More we cannot do' ('On Modern Art', 1964, p. 55).

say, *ahead* of their time (especially given the significant influence of his work on later thinkers and artists such as Walter Benjamin, Deleuze and Guattari, CoBrA and others). His theories about art and art-making were *too* new – too 'modern' – for the people in his milieu, not to mention their social and political representatives. Those who formed the conservative and majoritarian Weimar Germany, famously condemned Bauhaus art as 'degenerate', and eventually closed down the school. Deleuze and Guattari's concept of a 'people-yet-to-come', though it echoes Klee's call in its pedagogical and political implications, is less a historical lament and more an expression of an ontological concept. Deleuze and Guattari's plea for a 'people-yet-to-come' does not presume that the pedagogical or political process of transformation at work is one through which a pre-existing (though not-yet-existing) 'people' will come to adopt a pre-existing 'idea' over time. Rather, they understand the people present *in the present* as *already* the 'people-yet-to-come'. That is, for Deleuze and Guattari, we are always already people-in-becoming and thus the concept of a 'people-yet-to-come' expresses the perpetual potentiality of becoming-other inherent to the present. This more mundane – and yet more radical – understanding of people-in-becoming *as* the 'people-yet-to-come' is crucial for rethinking concepts of environmental 'sustainability' and practices of environmental pedagogy and politics. Deleuze and Guattari's notion of a 'people-yet-to-come' as people-in-becoming is more *mundane* because for them the 'people-yet-to-come' are the people who are already here (rather than an *other* radical people who are waiting in an *other* future time and place). And it is also yet more *radical* because rather than locate potentiality in far-off futures, Deleuze and Guattari ask us to see potentiality in what is immanent, in the already-existing processes of becoming around us and indeed, throughout us, *here* and *now*.

Rather than simply hold out hope for a different future, we, in our constant becoming-other, our on-going yet-to-come-ness, are recognized by Deleuze and Guattari as agents with the potential capacity to bring such futures about. Deleuze and Guattari's concept of a 'people-yet-to-come' can thus be understood as what Rosi Braidotti describes as an affirmative expression of a futurity (2006, p. 209) in that it locates futurity in the potential for change inherent in our immanent and material present rather than in a transcendent or possible future. A 'people-yet-to-come' as an image of thought anchors the utopian-sounding summoning of a people in a futurity-oriented *now-here* rather than in a future *no-where* (Samuel Butler, quoted in Deleuze and Guattari 1994, p. 100). As a result, this concept, especially when articulated in terms of a more ecological notion of subjectivity, can be used to promote transformative

re-conceptualizations of current ways of thinking and/as practices of doing environmental 'sustainability' in pedagogy and in politics.[2]

In this chapter-to-come, I connect the concept of a 'people-yet-to-come' to what we might call a 'planet-yet-to-come' in order to highlight some of the ways in which Deleuze and Guattari's materialist, post-humanist and ecological reconfiguration of subjectivity helps us learn to think in critical and creative new ways about 'sustainability' – a term that is taken-for-granted as having a clear meaning, a meme that is perhaps even becoming a cliché, and indeed, as Adrian Parr argues in *Hijacking Sustainability* (2009), a notion that is often highly problematic in its conceptualization and practice. I propose that we think sustainability differently – namely, through the concept of the 'refrain' and its process of differentiation – in order to critique, complicate and re-conceptualize the term.[3] This requires that we not take the term 'sustainability' for granted as a good or as a goal. As Parr observes, 'the meaning and value of sustainability is contested, produced, and exercised' (2009, p. 3). For Parr, sustainability is 'an instrument of knowledge formation' that engages the 'energies' that propel 'new and emerging social values' as well as 'more traditional values and conventions' and the 'habits and stereotypes underscoring these' (2009, p. 3). In so far as the term 'sustainability' serves as a banner for ecological awareness gaining cultural, social and political recognition, it provides the terrain for conversations and contestations about environmental relations, and currently encapsulates approaches that are problematic as well as many that are promising. It is a concept, then, worth thinking about critically and creatively rethinking.

I suggest that practices of sustainability are – or ought to be – intimately linked to pedagogy and politics in so far as they require *transformation* in habitual modes of thinking and practice. In this era of neo-liberal governmentality, global capital flows, and cascading economic, ecological and social crises, environmental education must engage with notions of 'sustainability' that

[2] Thinking ought to be included in our conception of action – not to mention included in the habits under consideration here. Ian Pindar and Paul Sutton, translators of *The Three Ecologies*, point out that although the 'concept of "praxis" (from the Greek for "doing") originated in Karl Marx's early writings' and 'suggests action rather than philosophical speculation', Guattari did not oppose thought to action but understood praxis more broadly as 'effective practices of experimentation' (2008, p. 85 n. 16). Following this line of thought, in *The Ecological Thought* Timothy Morton ponders the thought/action distinction and defines ecological thought not only as thinking *about* ecology but, equally importantly, as 'a thinking that is ecological' to which he adds that ecological thinking is: 'a contemplating that is a doing. Reframing our world, our problems, and ourselves is part of the ecological project. This is what *praxis* means – action that is thoughtful and thought that is active. Aristotle asserted that the highest form of praxis was contemplation' (2010, pp. 8–9).

[3] I thank Dianne Chisholm for her thoughtful feedback on this chapter. I am grateful, in particular, for her insights regarding the paradox of sustainability as sustaining what is versus as sustaining difference and suggesting the 'refrain' as a way of thinking differently about this problematic.

exceed the confines of individualized and individualizing actions and responses to issues that remain circumscribed in consumerism or oriented towards extracting profit. What is required is a more radical change in habitual ways of thinking about ourselves as separate from other human and non-human, living and non-living others. Focusing on the work of Deleuze and Guattari on capitalist economies (1983, 1987) and ecologies (Guattari 2008), this chapter connects concepts such as geophilosophy, habit, the new, nomadism and the refrain in order to ask: What does it mean – if we think with Deleuze and Guattari – to think 'sustainably'? How can we conceptualize 'sustainable relations'? What is to be 'sustained'? I argue that focusing on *intensities, different connectivities* and an expanded understanding of *communities* in the work of Deleuze and Guattari offers a critical response to the individualist and consum-erist neo-liberal notions of sustainability being promulgated today and informs new directions for creative environmental pedagogy and politics. I demonstrate how thinking sustainability through the concept of the 'refrain' or '*la ritour-nelle*' (1987, p. 312) is vital for the kind of environmental pedagogy and politics needed *in* the present *for* a future of our planet.

Geophilosophy: A people-yet-to-come and a planet-yet-to-come

Remapping the concept of a people-yet-to-come onto the becoming of a people-in-the-present prompts us to ask ourselves: So *what* are we, *who* are we, *where* are we, and *when* are we here and now? It also leads us to be concerned with the question: How is the concept of a 'people-yet-to-come' connected to what we might call a *planet-yet-to-come*? Deleuze and Guattari's concept of 'geophi-losophy' is one of the ways in which they express the connection between people and the planet in their work (1994, p. 85). Their writing on geophilosophy calls attention to the terrestrial contingencies that bring a particular way of thinking into expression in a particular place and time. They call attention to the fact that, for instance, Greek philosophy was more a product of its geographical milieu than the sign of the natural origin of philosophical thought belonging to the 'Greek territory' and, by extension, to the 'Western earth' (1994, p. 95). Moreover, they propose that just as Greek philosophy was an immanent and contingent expression of its earthly place–time, the philosophical challenge for us today is not to seek to return to an origin, a point of departure, a philo-sophical home to which we may (or may never) have belonged (and to which

we certainly no longer belong) but instead to create concepts that express where, when, and how we are living here and now. As Dianne Chisholm elucidates in her editorial introduction to the special issue of the e-journal *Rhizomes* devoted to Deleuze and Guattari's ecosophical expressions:

> Modern European philosophy, notably German philosophy, colonizes (or reterritorializes upon) Greek philosophy while overlooking and misconstruing the immanence and contingencies of its own territorial assemblage. To recover the philosophy of ancient Greece is an unrealistic option for a really innovative philosophy, a philosophy that is alive to the here and now of creative, geographic and demographic evolution, and to its own place in this process. Instead, Deleuze and Guattari urge that philosophy – and affiliated arts that share geophilosophy's desire to uproot the exhausted ground of thought – tune into earth's flows and forces from where they are, and that, with sympathetic intuition, they articulate the concepts and affects of a most becoming territorial refrain.
>
> Chisholm, 2007

In Deleuze and Guattari's analysis, philosophy emerged in Greece 'as a result of contingency rather than necessity, as a result of an ambience or milieu rather than an origin, of a becoming rather than a history, of a geography rather than a historiography, of a grace rather than a nature' (1994, pp. 96–97). Subtracting 'nature' and adding 'earth', removing the inherent and replacing it with the contingent, turning history into geohistory, and reorienting philosophy into a geophilosophy invites us not only to wonder 'Why philosophy in Greece at that moment?' (1994, pp. 95), but also challenges us to ask: How do we make a connection between thinking today and the present-day earth that provides the context for our thinking? Indeed, for Deleuze and Guattari, the only thing that ought to remain the same across the different and constantly differing locations of thought is the *creative* function of philosophy: what is consistent about philosophy across varied times and places is that its function is 'to create concepts' (1994, p. 136). Our task today, then, is to ask: What kinds of thinking 'habits' are adequate for today's habitats? How do we create concepts that are contingent upon and connected to the planet we inhabit and that inhabits us today? How do we cultivate the joint becoming of a 'people-to-come' and the 'new earth' or *planet-yet-to-come* (1994, p. 109)?

The ecological dimension of what Deleuze and Guattari called 'geophilosophy' is not lost on these thinkers when they propose that we pose philosophical questions that relate to 'the Now' (1994, p. 112). For them, the objective of philosophy is not 'to contemplate the eternal or to reflect history' but rather 'to

diagnose our actual becomings' (1994, p. 112). Moreover, Deleuze and Guattari themselves not only present, but also perform, an ecologically and economically engaged philosophy – a philosophy connected to the *oikos*, our habitat and, indeed, our home (1994, p. 112).[4] It is in the context of the ecological and economic issues central to Deleuze and Guattari as well as the crises of our current ecological and economic climes that they call for creativity when they remark: 'We do not lack communication. On the contrary, we have too much of it. We lack creation. *We lack resistance to the present.* The creation of concepts in itself calls for a future form, for a new earth and people that do not yet exist' (1994, p. 108). For Deleuze and Guattari, this call for the creation of new concepts, a new earth and new people has an important ontological, pedagogical and political dimension that cannot be underscored enough: the call for a new earth and a new people is at once an affirmation of and an invitation to the people in the here and now to be creative in thinking and practices concerning their earthly existence so that they can become-other. This immanent and affirmative kind of thinking and/as practice is itself what brings about the existence of a new people together with a new earth. In other words, while a people-yet-to-come might already be here now, their task is to forge a critical resistance towards taken-for-granted and worn-out ideas, foster a creative betrayal of the categories of thought to which they have been tethered, and create new concepts adequate to the complexities of new contexts.[5]

Deleuze and Guattari focus on art and philosophy as engines of creation when they explain, 'Art and philosophy converge at this point: the constitution of an earth and a people that are lacking as the correlate of creation' (1994, p. 108). Indeed, as I have argued here, sustainability has much to do with not only doing 'sustainable' things but also learning to become more 'sustainable' thinkers – that is to say, we need to understand *thinking as also a kind of doing* and understand 'sustainable' thinking as learning to think differently about ourselves, our becomings and, indeed, about 'sustainability' as a concept. Just as a 'people-yet-to-come' can be conceptualized as a critique of molar (or common-sense) categories of thought, so too must 'sustainability' be critically re-examined, creatively re-conceptualized and freed from its common-sense understanding: the simple reproduction of the status quo. Thus, 'sustainability' should not be thought of in terms of sustaining what is (the people as they are,

[4] As Guattari notes, the Greek word, *oikos*, from which the word *ecology* and *economy* derives, means 'house, domestic property, habitat, natural milieu' (2008, p. 95 n. 52) and denotes a location where 'interactions and encounters take place' (Herzogenrath, 2009, p. 5).

[5] I thank Jason Wallin and Matt Carlin, the co-editors of this volume, for emphasizing this point.

the earth as it is, and the pre-existing interconnectedness of things as they are) but rather as the sustaining of intensities, the generative drivers of becoming-other, to create and test new and different connections (heterogenesis) for how they work and what they do. Let us begin this process of sustainable thinking, then, precisely *by thinking differently* about sustainability. This will lead us to shift the ground upon which we think sustainability from the repetition of the same to the process of generating difference through deterritorializing refrains – or what Deleuze and Guattari call '*ritournelles*' (1987, p. 312).

'Thinking differently': The pedagogy and politics of learning

Several authors have recently focused on the ways we think about pressing earth-matters and have proposed various ways of 'thinking differently' as a response to current ecological crises.[6] In *The Three Ecologies*, Guattari describes thinking ecologically as 'thinking about interconnectedness' or thinking 'trans-versally' (2008, p. 29).[7] Learning to think differently is both a political and a pedagogical project since both pedagogy and politics involve processes of change and transformation. Indeed, change and transformation are critical in the area of environmental education and environmental politics, both of which, in their attempt to create connections between us 'in here' and the environment 'out there' presume and reinstate a separation between what constitutes 'us' and the 'environment'. Guattari registered this criticism when he accused 'political groupings and executive authorities' to be:

> totally incapable of understanding the full implications of these issues. Despite having recently initiated a partial realization of the most obvious dangers that threaten the natural environment of our societies, they are generally content to simply tackle industrial pollution and then from purely technocratic perspective, whereas only an ethico-political articulation – which I call *ecosophy* – between the three ecological registers (the environment, social relations and human subjectivity) would be likely to clarify these questions.
>
> 2008, pp. 19–20

[6] Gregory Bateson proposes thinking in terms of an 'ecology of ideas' in *Steps to an Ecology of Mind* (1972), a related concept finds expression in Guattari's later work on 'mental ecology', especially in *The Three Ecologies* (2008), and, more recently, Timothy Morton elucidates what he calls thinking about 'ecology without nature' (2009) and 'the ecological thought' (2010).

[7] Guattari writes: 'Now more than ever, nature cannot be separated from culture; in order to comprehend the interactions between ecosystems, the mechanosphere and the social and individual Universes of reference, we must learn to think 'transversally' (2008, p. 29).

Not unlike what Guattari calls the limited perspectives of politicians and policy-makers, most approaches to ecology do not include what Guattari identified as 'mental', 'social', and 'environmental' ecologies. I would like, then, to follow Chisholm's invitation to think in terms of a geophilosophy that includes not only us as humans but also other non-human, living and non-living entities and imagines new ways to inhabit the earth and co-habit the earth with others:

> "Geophilosophy" and the various "plateaus" of *A Thousand Plateaus* describe and prescribe the becoming-earth of philosophy and art, bearing in mind the first principle of ecology: namely, that all things assemble with other things in hetero-geneous composites. [But g]eophilosophy offers more than just a description of these matters and forces; it articulates an ontology of ecological consistency that maps for us a rhizome – or symbiotic network of matter-energy flow – that we can either block with environmental damage or extend so as to increase the functional and expressive health of machinic assemblages (couplings of earth and *socius*). As such, geophilosophy is more ecological than ecology, the discipline of which is restricted to the quantifying analytics of ecosystem dynamics, ecosite constituencies, and population stability and sustainability. (Chisholm, 2007)

Learning to think differently requires the formation of new thinking habits that break free of the confined and restrictive ways in which we think about ourselves as individuals separate from other human and non-human, living and non-living others in such a way that even these categories become confounded. A more materialist, post-humanist and ecological way of thinking about subjec-tivity such as the one Deleuze and Guattari present in their joint work, and Guattari presents also in his later projects,[8] opens us up to the ability to craft creative responses that are not limited to individualized and individualizing actions and, indeed, to think differently about 'sustainability'.[9]

In one of the few articles to date that deals explicitly with learning in relation to sustainability, Adam Douglas Henry states that scholars in sustain-ability science 'generally agree that learning is a critical hinge for sustainability'

[8] Guattari further describes his ecosophical project as 'a reconstruction of social and individual practices which I shall classify under three complementary headings, all of which come under the ethico-aesthetic aegis of an ecosophy: social ecology, mental ecology and environmental ecology' (2008, p. 28).

[9] The concept of the 'new' and that of 'habits' might initially seem a paradox; however, I read Deleuze and Guattari's work on 'habit' (like their work on other concepts such as 'the new') as not necessarily suggesting that habits are necessarily 'good' or 'bad', but rather that they could be either (depending on what they do). That is, a good habit is a habit that does not repeat, but rather refrains, generating creativity, experimentation and difference. Good thinking habits are ways of thinking – or 'images of thought' that imagine thought to be the work of ongoing experimentation aiming at sustaining intensities and the creation of concepts rather than those that routinize life. In this way, good habits are habits of resisting repetitive habits – habits that refuse to solidify into common-sense ways of thinking and routine ways of doing.

(2009, p. 131). Henry defines problems of sustainability as 'those that involve conflicts between enhancing the well-being of humans, protecting the integrity of ecological systems, and balancing these often conflicting goals in the long term' (2009, p. 133). Although Henry's study acknowledges that understanding learning as 'the accumulation of truthful knowledge about the world is an overly constraining and narrow definition, and leads to a smaller class of model than is needed to address problems of sustainability' (2009, p. 133), a critical issue to which I will return, he nevertheless reproduces an understanding of the human as separate from the environment and pits these 'conflicting' interests against one another. Further, this study goes only so far as to suggest that sustainability is about 'complex and uncertain problems' (2009, p. 131) without proposing new ways of thinking about what sustainability might be and stopping short at the suggestion that sustainability simply 'means different things to different people' (2009, p. 133). I argue that Deleuze and Guattari offer useful cartographies as well as suggest new routes for thinking about subjectivity and the problems of sustainability in the face of such complexity, uncertainty and difference. Rather than define sustainability on an extensive plane of sameness, or make a relativist argument about what sustainability means, Deleuze and Guattari's approach helps us to focus on how sustainability is always about complexity, uncertainty (as Deleuze and Guattari write, paraphrasing Spinoza, 'we do not know what a body can do'), intensity, becoming-other, and transversal relations (1983, p. 39).

First, the task of critical environmental education is to think of 'students' as people-to-come, which, as Henry suggests, means moving beyond education's reductive focus on accumulation and exchange of information wherein what is sustained is a habituated circulation of knowledge (and thereby the status quo). Thinking about students as a 'people-to-come' means valuing learning as a process of transformation, the process of students' coming to think differently, thereby becoming-other in the process, and supporting thinking differently from the norm, producing a diverse range of critical and creative ideas, and experiencing the joy of expressing one's capacities.

Second, contemporary ecologies of education ought to take cues not only from thinking of students as a 'people-to-come' but also for a 'people-to-come' to be understood as existing in connection with a spatial and temporal milieu – in other words, we need to think more geophilosophically about the notion of subjectivity and move beyond an unquestioning acceptance of liberal humanist views of subjects as discrete individuals, but rather, approach environmental education using approaches that understand subjects as ecological

entities. Opening up of the notion of subjectivity means that our relations to our environs – the earthly environment, as well as the social, cultural, and political ecology – are open to question, critical interrogation and creative re-conceptualization. What is at stake in having the courage to examine our habits of thought is the possibility to experiment with creative new ways to inhabit this earth and co-habit this earth with human and non-human, living and non-living others. This more 'eco-sophical' notion of subjectivity is also grounded in a way of thinking about humans that underscores our connection to others. Such connections are often stifled, or even severed, in contemporary educational contexts that focus on competition between rather than cooperation among so-called 'individuals', and perpetuate the ideologically-inflected notion that 'nature' works via competition rather than co-production – rather than revealing this notion to be a reflection of the way neo-liberal capitalist logics have become naturalized. An educational system that relies on liberal accounts of subjectivity and reproduces rather than radically interrogates capitalist logics of competitive rather than cooperative, collaborative, co-productive relations reinforces a broken socius, recapitulates unchecked economic practices, and repeats ecological bad habits that contribute to the destruction of the planet. We need to think differently about the next generation of thinkers – a people-yet-to-come already here – in order to build the capacity to generate new ideas, and to regenerate ideas that sustain the intensities of our living planet.

The pressing issues of our milieu are no doubt the earthly issues of our habitat, our habits, and the ways we inhabit our home (*oikos*) – ecological, economic, and social sustainability. In light of cascading ecological and economic crises such as environmentally damaging resource extraction, climate change and toxic contamination of the earth from e-waste, nuclear waste, oil spills and other refuse that we dump and yet that refuse to disappear, not to mention debt-fuelled, profit-driven, bubbling and collapsing financial markets, we must ask: What kind of transformation in thinking is needed for our changing habitat? And how do we change our thinking habits?

In the next section I bring together Deleuze and Guattari's concept of geophilosophy as a philosophy that connects a people and a planet with their concept of people as 'habits' and the planet as habitat. These are conceptual tools to help us cultivate new ways of contemplating ourselves, the earth, and how to inhabit both and co-habitat the earth with others. The way in which Deleuze and Guattari think about people and planet addresses thinking as a habit (and indeed, habit as 'contemplation') and activates a kind of thinking that results in 'a transformation not only of our schemes of thought, but also

our ways of inhabiting the world' (Braidotti, 2006, p. 8). The pedagogical and political project of breaking unsustainable thinking habits and ways of living in the world inheres in activating the potential of the 'people-yet-to-come'.

Habits and habitats: 'I' as a habit and 'me' as 'milieu'

To initiate this shift in our thinking habits in the hope of learning new ways to think about subjectivity, let's begin by considering the connection between individuals and their habits and habitats or, in other words, on the concept of 'me' in relation to 'milieu' in the work of Deleuze and Guattari. The word 'milieu' in French means not only the 'environment', but also the 'middle' – I invite us to start, then, in the middle of matters by thinking differently about the 'I' by de-centering 'I' as an individualistic identity (Braidotti, 2006, p. 262) and by enmeshing the 'I' in relation to its environment – as a habit, interaction, intra-action, or habitual encounter with habitat.

Deleuze and Guattari's shifting of the terrain of subjectivity in a way that takes habits and habitats more seriously means that subjectivity is understood as simultaneously material (though not essentialist) *and* constructed (materially, socially, and in other ways) and thus subject to change. Indeed, for materialists like Deleuze and Guattari, the 'natural' and the 'socially constructed' world are not opposing binary categories; rather, both are expressions of underlying material forces and flows. Habit is a crucial concept for understanding our own subjectivity in the context of the complex forces at work in the world beyond 'us'. Deleuze and Guattari connect thinking to being-as-becoming in their writing about habit. In their words, we are all 'contemplations, and therefore habits. *I* is a habit. Wherever there are habits there are concepts, and habits are developed and given up on the plane of immanence a radical experience: they are "conventions"' (1994, p. 105).

Influenced by the work of Gilbert Simondon (2009) and Jakob von Uexküll (2010), Deleuze and Guattari challenge the notion of a stable subject as an individual agent in their more materialist and post-humanist account of subjectivity by situating the subject in the middle, *en milieu*, of an environment and arguing that it is this 'milieu' that composes a 'me'.[10] For Deleuze and Guattari,

[10] For Simondon, the process of individuation makes visible 'not only the individual, but the pair individual–environment' (2009, p. 5) and we can think of the relations that are 'interior and exterior to the individual as "participation"' (2009, p. 8). For von Uexküll, 'every subject spins out, like the spider's threads, its relations to certain qualities of things and weaves them into a solid web, which carries its existence' (2010, p. 53).

whether it is what/who/where/when we are or how we think about what/where/when/we are, the 'contemplations' that make our 'selves', the terms 'subject and object', are inaccurate descriptors that 'give a poor approximation of thought' (1994, p. 85). Indeed, not only are 'subject and object' excessively blunt distinctions, the terms 'human' and 'non-human', 'living' and 'non-living', become similarly troublesome when we consider the ways in which the living, human 'me' is inextricably connected to, and reliant upon, the non-human, living and non-living in the midst of human 'milieus', surroundings or environments. Just as we become most aware of a part of a body or a part of a machine at the moment when it breaks down, we become most aware of our material imbrication in our milieu – the connection between what we think of as 'outside us' and what we think of as 'comprising us' – in instances where the connections between what was presumed to be a clear-cut 'inside' and 'outside' is marked by an identifiable 'breakdown' of connections or 'breach' across them. For instance, environmental crises such as land contamination, viruses or oil spills not only reveal the lack of separation between the 'human' and 'non-human' but also the 'living' and 'non-living', and indeed, 'organic' and 'inorganic'. The lack of a 'line' or boundary between 'us' and our 'environs' is perhaps most explicit in how quickly we are implicated in and affected by the spread of any so-called 'contagion'. We are always already made of (as well as un-made by) our milieu. Indeed, as Michel Serres observes in his work on 'the parasite' (2007) or as Myra J. Hird observes in her work on bacteria and microbial life (2009, 2010), contagions, parasites or symbionts reveal the ways we are nested entities, to use Donna Haraway's words, 'all the way down' (in Schneider, 2005, p. 140). As Timothy Morton writes, 'At a microlevel, it becomes impossible to tell whether the mishmash of replicating entities are rebels or parasites: inside–outside distinctions break down. The more we know, the less self-contained we are' (2010, p. 36). Materialist accounts that trouble the distinction between the human and non-human as well as extensive evidence of anthropogenic effects the so-called 'non-human' environment lend support to Bateson's observation that 'the unit of survival is organism plus environment. We are learning by bitter experience that the organism which destroys its environment destroys itself' (1972, p. 484).

Deleuze and Guattari suggest that just as subjects and so-called 'objects' or 'surroundings' are materially implicated, so too is the way in which we think about them (and about thinking): 'Thinking is neither a line drawn between subject and object nor a revolving of one around the other. Rather, thinking takes place in the relationship of territory and the earth' (1994, p. 85). This more material and post-humanist reading of subjectivity de-centres identity

questions of 'who' we are by re-positioning the subject in the middle – *en milieu*, thereby accounting for the 'who' through a 'what, where and when' we are. We are reminded here of Deleuze and Guattari's description of Greek philosophy as linked to a particular habitat, and as a particular way of thinking consisting of particular habits. In their grounded – and yet fluid and creative – conception of habits, Deleuze and Guattari explain that:

> habits are taken on by contemplating and by contracting that which is contemplated. *Habit is creative.* The plant contemplates water, earth, nitrogen, carbon, chlorides, and sulphates, and it contracts them in order to acquire its own concept and fill itself with it (enjoyment). The concept is a habit acquired by contemplating the elements from which we come.
>
> 1994, p. 105, my emphasis

Describing ourselves as 'habits' or patterns of difference and repetition, Deleuze and Guattari write that we are made up of 'contractions' consisting of 'passive syntheses' that constitute 'our habit of living, our expectation that "it" [us, our "life"] will continue ... thereby assuring the perpetuation of our *case*' (1994, p. 74). Habit, Deleuze argues, 'concerns not only the sensory-motor habits that we have' but also, 'before these, the primary habits that we are; the thousands of passive syntheses of which we are organically composed' (1994, p. 75).

There is no 'self' called 'I', no identity, no subject apart from the 'continuity' formed from 'our thousands of component habits'. In this way, we as humans are not unlike 'wheat' – 'a contraction of the earth and humidity' (Deleuze, 1994, pp. 76–8). Indeed, Deleuze asks,

> What organism is not made of elements and cases of repetition, of contemplated and contracted water, nitrogen, carbon, chlorides and sulphates, thereby intertwining all the habits of which it is composed? ... [E]verything is contemplation, even rocks and woods, animals and men, even Actaeon and the stag, Narcissus and the flower, even our actions and our needs. ...
>
> 1994, pp. 76–8

For Deleuze, the subject is a contraction, contemplation, or composition of nested agencies, agential materialities, actions, responses, and witnesses that interact with no origin, no centre, no 'I', only a cooperation among many little so-called 'selves':

> Underneath the self which acts are little selves which contemplate and which render possible both the action and the active subject. We speak of our 'self' only in virtue of these thousands of little witnesses which contemplate within us: it is always a third party who says 'me'.
>
> 1994, pp. 76–8

What Deleuze calls the 'self' within this dynamic milieu is itself 'by no means simple'; indeed, as Deleuze points out, it is 'not enough to relativise or pluralise the self, all the while retaining for it a simple attenuated form': 'Selves are larval subjects; the world of passive syntheses constitutes the system of the self, under conditions yet to be determined, but it is the system of a dissolved self' (*Difference and Repetition*, 1994, p. 78).

The work of Deleuze and Guattari is concerned not with determining 'identities' but rather with how things work – their philosophical focus is not what something *is*, but what something *does*. Their work functions to de-essentialize and yet at the same time emphasize an entity's material realities, especially an entity's emergent capacities *in relation* to – and as a condition of a relation to – other entities. Deleuze and Guattari's iterative oeuvre creates concepts, demonstrates ways of thinking, and produces vocabularies that enable new projects to continue to mobilize connections – their work acknowledges the force of material limits and actualities while at the same time emphasizing that these always coexist with virtual potentialities.

'Facing the outside' and creating sustainable connections

Deleuze/Guattarian theorist and feminist philosopher Rosi Braidotti is, alongside Adrian Parr, one of the foremost scholars concerned with connecting Deleuze and Guattari's oeuvre with concepts of sustainability. For Braidotti, so-called 'subjects' are 'ecological entities' (2006, p. 41). She emphasizes that our way of thinking about subjectivity should be brought up-to-date with the material and environmental underpinnings of our subjectivity. Braidotti argues that our conception of subjectivity should reflect the openness of the subject to his/her milieu when she calls our attention to the crucial importance of 'reversing the subject to face the outside' (2006, p. 262). If '*I* is a habit' or a contraction of a territory, then if we reverse our view, we see that that same 'I' functions as a kind of collection and connection – a machinic part of its milieu. As Bernd Herzogenrath puts it, 'While deep ecology subjectifies and shallow ecologies objectify nature, Deleuze's flat eco*logics* intensify it, by opening up the "philosophical subject" to the realm of non-human machines, affects, *haecceities*' (2009, p. 11). This shift in thinking about subjectivity from thinking about habits *as something someone does* to thinking about habits *as something that 'does' someone* offers a better account for what Braidotti argues are 'the kinds of subjects we have already become' – that is to say, the kinds of entities

we have not only become but are also always in the process of becoming (2006, p. 40).

In *The Three Ecologies* Guattari expands the notion of ecology beyond environmental concerns to include 'the whole of subjectivity and capitalistic power formations' (Guattari, 2008, p. 35). He takes the idea that individuals are 'captured' by their 'environment, by ideas, tastes, models, ways of being', and argues that, just as it is difficult to know where we begin and end relative to the molecules of our milieu, 'it is difficult to know where, or rather who "we" are' – particularly in the ecology provided by the dominant refrains of the milieus produced by what he critically calls 'Integrated World Capitalism' (Pindar and Sutton, 2008, p. 5). Guattari's central concern in outlining the social, mental and environmental ecologies is to ask how we can learn to use the fits and starts, differences and repetitions, haecceities and momenti of habit to propel ourselves from one kind of habit to another (or, more specifically, towards the habit of non-habit, or becoming-other). As Pindar and Sutton note, in *Chaosmosis*, Guattari describes a psychological patient who finds himself 'stuck in a rut, going round and round in circles' until

> One day, on the spur of the moment, he decides to take up driving again. As he does so he immediately activates an existentializing refrain that opens up 'new fields of virtuality' for him. He renews contact with old friends, drives to familiar spots, and regains his self-confidence.
>
> <div align="right">Guattari quoted in 2008, pp. 6–7</div>

Habits have a centrifocal force, concentrating forces in routines, reterritorializations and representations, but perhaps we can use their other *centripetal* force to propel ourselves into new non-routines, deterritorializing refrains, and creative productions – after all, we are reminded by Deleuze that habit, while having a tendency toward redundancy, is also '*creative*' (1994, p. 105). Indeed, the refrain, in this case, can also have '*re-creative* influence' (Guattari quoted in Pindar and Sutton, 2008, p. 7).

We are indeed creatures of habit, which is to say, contractions of habit, and indeed inhabited by our habitat just as we inhabit our habitat. It seems to me that the question of our becoming-other is dependent upon this recognition of our selves as porous, open, in-becoming subjects and thus necessarily interested in our environment as an integral part of our own self-interest (indeed, when the 'self' is configured in this open way, the false opposition of 'selflessness' and 'selfishness' becomes nonsensical; instead, the aim becomes, as Bateson suggested, the sustainability of the 'self' plus its 'environment').

What is sustained in this more open concept of the self–other relation is not a static status quo, nor an oppositional relation to it, but rather the sustaining of intensities, a mutual becoming-other and the creation of a new and different assemblages. Deleuze and Guattari famously give the example of the mutual becoming-other of the wasp and the orchid:

> How could movements of deterritorialization and processes of reterritorialization not be relative, always connected, caught up in one another? The orchid deterritorializes by forming an image, a tracing of a wasp; but the wasp reterritorializes on that image. The wasp is nevertheless deterritorialized, becoming a piece in the orchid's reproductive apparatus. But it reterritorializes the orchid by transporting its pollen. Wasp and orchid, as heterogeneous elements, form a rhizome. It could be said that the orchid imitates the wasp, reproducing its image in a signifying fashion (mimesis, mimicry, lure, etc.). But this is true only on the level of the strata-a parallelism between two strata such that a plant organization on one imitates an animal organization on the other. At the same time, something else entirely is going on: not imitation at all but a capture of code, surplus value of code, an increase in valence, a veritable becoming, a becoming-wasp of the orchid and a becoming-orchid of the wasp. Each of these becomings brings about the deterritorialization of one term and the reterritorialization of the other; the two becomings interlink and form relays in a circulation of intensities pushing the deterritorialization ever further.
>
> 1987, p. 10

In *Deleuze, Guattari and Ecology*, Herzogenrath writes, 'If the eminent eco-socialist Barry Commoner's "First Law of Ecology: Everything is Connected to Everything Else"' meets with Deleuze and Guattari's idea that 'what makes a machine, to be precise, are connections' then, he argues, we can think of nature as an abstract machine composed of multiple assemblages of "interconnected relations"' (Deleuze and Guattari quoted in Herzogenrath, p. 5). Following what Chisholm also calls ecology's first principle of 'generative interconnectivity', the key concern of a 'clinical ecology' is the promotion of the vitality of these connections (2007).

In Braidotti's view, the question of sustainability is intimately related to what one connects to – and the cultivation of 'good' and 'bad' habits.[11] Although the Deleuze and Guattarian oeuvre, following Friedrich Nietzsche's, is often hostile to the idea of habits and more hospitable to the notion of 'the new', this is largely

[11] I thank Rosi Braidotti and Anneke Smelik for their lucid elaboration upon the concept of 'good' and 'bad' habits in the seminar on 'Gilles Deleuze and Cultural Studies' they co-taught at the Centre for the Humanities at Utrecht University in the fall of 2010.

due to the naturalized authority that habits have in dictating the 'normal' and their role in holding to historical and conservative patterns of thought.[12] Upon closer examination, however, we discover that for Deleuze and Guattari, habits are, in and of themselves, neither 'good' nor 'bad'. Indeed, even Nietzsche's ethic of an eternal return – or the Deleuze and Guattarian refrain – is what one might call the cultivation of a 'good' or un-habitual habit. Guattari writes that we need to 'kick the habit' of sedative discourse, particularly the '"fix" of television', in order to learn to 'apprehend the world through the interchangeable lenses or points of view of the three ecologies' (2008, p. 28). In effect, he argues that we need to kick one – unsustainable – habit in order to learn another – more sustainable – one. Guattari stresses that all things must be 'continually reinvented, started again from scratch, otherwise the processes become trapped in a cycle of deathly repetition' (2008, p. 27). This reinvention is an example of a 'good' habit that can also promote more sustainable (or, to put it differently, 'refrain'-able) modes of becoming. A 'good' habit is composed of sustainable or 'good' connections or connections that 'work' by sustaining intensities through generating difference. A 'bad' habit, on the other hand, eradicates differences, creates monotonies and monopolies, and diminishes intensities – the potential to further regenerate by generating difference.

We can think of 'sustainable habits' as habits that work like Deleuze and Guattari's concept of the 'refrain' or the '*ritournelle*'. Deleuze and Guattari invite us to recall 'Nietzsche's idea of the eternal return as a little ditty, a refrain, but which captures the mute and unthinkable forces of the Cosmos' (1987, p. 343). For Nietzsche, the eternal return is an ontological concept as well as ethical challenge. For him, because the world works through a repetition of difference, we need to *amor fati* or love our fate; we should, in other words, affirm the world as it is and want the world to be no other way than this repetition of difference, and difference via repetition.[13] For Deleuze and Guattari, the refrain, this pattern of difference via repetition, or repetition via difference, 'fabricates time' (1987, p. 349). It is what gives what we consider the 'given'. But within this 'given'

[12] Braidotti adds that habits are 'socially enforced' and thereby 'legal' types of addiction. They are cumulated toxins that by sheer uncreative repetition engender forms of behaviour that can be socially accepted as 'normal' or even 'natural'. The undue credit that is granted to accumulation of habits lends exaggerated authority to past experiences'. Her goal in *Transpositions* is to grapple with 'the question of which forces, desires or aspirations are likely to propel us out of traditional habits, so that one is actually yearning for changes in a positive and creative manner' (2006, p. 9).

[13] In a section entitled 'Why I Am So Clever' in his autobiography, *Ecce Homo*, Friedrich Nietzsche extols the virtues of loving our fate: 'My formula for greatness in a human being is amor fati: that one wants nothing to be other than it is, not in the future, not in the past, not in all eternity. Not merely to endure that which happens of necessity, still less to dissemble it – all idealism is untruthfulness in the face of necessity – but to love it …' (*The Nietzsche Reader* 2006, p. 509).

there is a lot at play – the tempos, rhythms, can be territorialized or deterritorialized, habituated or de-habituated, repetitive or experimental. For Deleuze and Guattari, territorializing refrains are not 'opposite' those that deterritorialize, but rather, compose different movements. Deterritorializing refrains may even rely on territorializing refrains. Deleuze writes,

> It is odd how music does not eliminate the bad or mediocre refrain, or the bad usage of a refrain, but on the contrary carries it along, or uses it as a springboard … a musician requires a *first type* of refrain, a territorial or assemblage refrain, in order to transform it from within, deterritiorialise it, producing a refrain of the *second type* as the final end of music: the cosmic refrain of a sound machine.
>
> 1987, p. 349

For Deleuze and Guattari, 'producing a deterritorialized refrain' is paramount to 'building a new system' (1987, p. 350). The habituated pattern can be the basis of a new habit – that is, *a habit of non-habit*, or experimentation. For Deleuze and Guattari, these are not opposites, since 'one was already present in the other; the cosmic force was already present in the material, the great refrain in the little refrains, the great maneuver in the little maneuver'. The movement of experimentation is what should be sustained. Thus, recasting the imperative 'to sustain' as the desire 'to refrain' is to think sustainability not as prescribed system or pre-known end-goal, but rather an experimental process. As Deleuze and Guattari write, 'we have no system, only lines and movements' (1987, p. 350).

If we take seriously Bateson's observation that there can be 'an ecology of bad ideas, just as there is an ecology of weeds' (1972, p. 19), we can say that Braidotti, inspired by the work of Deleuze and Guattari, takes up the task of vigorous conceptual weeding by testing the 'pretentious belief that only a liberal and humanistic view of the subject can guarantee basic elements of human decency: moral and political agency and ethical probity' (2006, p. 11). After pulling up the habits of thought that suffocate the potential for more sustainable connections, Braidotti plants new thought-seedlings that she hopes will take hold as roots of new 'habits'. In place of the belief that, as she writes, has 'little more than long-standing habits and inertia of tradition on its side' (2006, p. 11), Braidotti posits what she calls 'nomadic subjectivity', a materialist and post-humanistic way of understanding the subject of becoming 'as an alternative conceptual framework, in the service of a sustainable future' (2006, p. 3–4). In the next section I focus on 'nomadic subjectivity' as a different way of thinking, as a rhizome that can lead to better connections, and as a way of thinking about subjective relations

among habits and habitats that can lead to more sustainable – or rather, refrainable – habits.

Nomadic subjectivity: 'We' are wanderings

Contemporary flows of capital and the forced migration of workers and 'climate refugees' due to economic and ecological crises begs the question: surely *this* is not the kind of nomadism Deleuze and Guattari would have championed? What, if not an image of a wanderer walking through a landscape is the relationship of the nomadic subject to his or her habitat? The nomadic subject, I argue, is not an expression of *an entity moving through a milieu*; rather, it is an expression *of a milieu moving through an entity*. Indeed, this re-conceptualization of the way in which we habitually think of the nomad as a conceptual persona connects us to more sustainable ways of thinking about subjectivity that may lead us to adopt more sustainable habits as people that inhabit this planet.

Nomadic thinking is central to Rosi Braidotti's conception of doing philosophy and, indeed, to thinking ethically. Influenced by the concept of 'nomadism' in the work of Deleuze and Guattari, Braidotti argues that we are all 'nomadic subjects' in multiple senses. Important for her rethinking of social, economic and political subjectivities, Braidotti points out that many of us are nomadic subjects in so far as we might relate to multiple gender, sexual, ethnic, racial, class and national identities. Similarly important for her thinking about our ecological and ethical subjectivities, she brings a meta-perspective to life and stresses that we, like all living entities, live on what she calls 'borrowed time' (2006, p. 210). For Braidotti, life is a force that runs through us that, although it may find expression in our existence, does not 'belong' to any entity (human or non-human) for more than its lifetime. Accordingly, since 'life' traverses entities for the time of their existence, Braidotti shares the view with other Deleuze and Guattari theorists as well as other post-humanist and new materialist feminist thinkers that material forces and flows circulate and confound stark distinctions among 'human' and 'non-human', 'living' and 'non-living' things and thus '[t]he life in "me" is not only human' (2006, p. 236). This recognition radically reconfigures our relations and results in at least two associated ethical consequences: first, it involves the 'dissolution of the self, the individual ego, as the necessary premise' (Braidotti 2006, p. 253); and second, it assumes that our existence is 'bound up with things that existed before and after us' (2006, p. 238). The dissolution of the self or 'death of the subject' is, she argues, an ethical gesture

that affirms the extension of the self toward a spatially and temporally broader 'eco-philosophy of the subject' (2006, p. 204).

This nomadic entity is not the nomad of neo-liberalism, always in search of newness, so that it can cumulate and accumulate. Although a superficial reading of Deleuze and Guattari's work, especially their focus on concepts such as the new and the nomadic, might be read as providing some sort of skewed legitimacy to capitalist logics, this kind of reading is a mistake. Although, as Braidotti notes, the 'polycentred, multiple and complex political economy of late postmodernity' is also 'nomadic' in that it lubricates the exchange of capital and commodities, this is not an example of the kind of nomadic ethics she, or Deleuze and Guattari, advocates (2006, p. 8). Indeed, Deleuze and Guattari's warning in *A Thousand Plateaus* to '[n]ever believe that a smooth space is enough to save us', in conjunction with the insistence on sustaining potential that underlies their thought, suggests that we ought to read what they mean by the 'new' and the 'nomadic' more *intensively* and with more *complexity* (1987, p. 500). In *Difference and Repetition*, Deleuze draws upon Nietzsche's distinction between the creation of new values and the recognition of established values and emphasizes that these

> should not be understood in a historically relative manner, as though the estab-
> lished values were new in their time and the new values simply needed time to
> become established. In fact it concerns a difference which is both formal and
> in kind. The new, with its power of beginning and beginning again, remains
> forever new, just as the established was always established from the outset, even
> if a certain amount of empirical time was necessary for this to be recognized.
> What becomes established with the new is precisely not the new. For the new –
> in other words, difference – calls forth forces in thought which are not the forces
> of recognition, today or tomorrow, but the powers of a completely other model,
> from an unrecognized and unrecognizable *terra incognita*.
>
> 1994, pp. 137–8

Rosi Braidotti orients this critique of the 'new' squarely at capitalism when she argues that

> The much-celebrated phenomenon of globalization and its technologies
> accomplishes a magician's trick: it combines the euphoric celebration of *new*
> technologies, *new* generations of both human and technological gadgets, *new*
> wars and *new* weapons with the complete rejection of social change and trans-
> formation. In a totally schizophrenic double pull the consumerist and socially
> enhanced faith in the *new* is supposed not only to fit in with, but also actively to

induce, the rejection of in-depth changes. The potentially innovative, de-terri-torializing impact of the new technologies is hampered and tuned down by the reassertion of the gravitational pull of old and established values.

2006, p. 2

The notion of nomadism that Deleuze and Guattari describe, and that Braidotti advocates, does not flow through life colonizing, owning and leaving. Rather, life flows through this nomad in a way that confounds any notion of acqui-sition, individualism or identity, ownership, property, profit and yet also is not in the business of abandonment. Braidotti's nomadic subject is, conversely, what she calls a 'not-for-profit' entity that recognizes its dependence upon the environment in which it is situated and participates in its forces and flows. As she explains, 'this does not mean that one is not productive or useful to society, but simply that one refuses to accumulate', and instead 'gives itself away' in a 'web' of 'becomings and complex interactions' (Braidotti 2006, p. 215).

If we think of this version of a nomadic subject as the conceptual persona of a sustainable way of connecting the 'habit' that is a human with its 'habitat' composed of human and non-human, living and non-living entities, the question that remains is 'what exactly do we aim to sustain'? In the next section, as I move to conclude, I argue that focusing on sustainable *intensities, different connections* and an expanded understanding of *communities* in the work of Deleuze and Guattari offers a critical and creative response to the individu-alist and consumerist neo-liberal notions of sustainability being promulgated today and informs new directions for environmental education vital for a *planet-yet-to-come*.

Nomadism as voyaging in place: Sustaining intensities, connectivities and communities

In ecology, sustainability is defined as the capacity to endure and describes how biological systems remain diverse and productive over time. For us as humans, sustainability is understood as the potential for long-term maintenance of well-being, which has environmental, economic and social dimensions. It is upon these related planes of immanence – that of the earth and that of human existence – that I would like to make connections between sustainability and Deleuze and Guattari's concept of intensity.

If sustainability is 'the capacity to endure', then it would seem that, for

Deleuze, the principal task for sustainable existence is the modulation of intensities.[14] As Manuel DeLanda argues in *Intensive Science and Virtual Philosophy*, the crucial function of intensities in Deleuze's ontology is the 'productive role which differences play in the driving of fluxes' as well as the capacity to 'further *differentiate differences*' in the ongoing, divergently evolving, processes of becoming (2002, p. 73). The question of intensity, then, is tied to the question of sustainability in terms of defining the limits of what an entity can endure – in other words, modulating instances of high speeds with periods of slow burn – and in terms of the ongoing creation of the conditions of possibility for further endurance. Sustainability is both an extensive and an intensive concept; and yet, intensity is an overlooked dimension of conventional ways of conceptualizing it.

Following Deleuze and Guattari's concept of intensity means rethinking ecological sustainability defined as diversity and ongoing productivity as ends in themselves, since these are both extensive measures. Rather, for Deleuze and Guattari, what must be sustained is the potentiality (what Deleuze and Guattari call 'intensity' or 'difference') that creates diversity, or, in other words, the potential of difference to continue producing differences via generative connections. As I have argued elsewhere, when we move from understandings of sustainability in strictly ecological terms to an understanding of sustainability that also includes economic and social dimensions, an emphasis on diversity or productivity is not a sufficient criterion for the creation of sustainable systems.[15] As Braidotti, points out, capitalism, too, with its 'entropic power of hybridization', promotes the 'proliferation of differences' for the homogenizing, hegemonizing, monotonizing and monopolizing 'sake of profit' (2006, pp. 275–6). It is not enough simply to 'diversify' – we have to think about the kinds of diversifications. It is not enough simply to 'produce' – we have to think about the purpose of the production. The concept of sustainability thought

[14] In *Difference and Repetition,* Deleuze describes extensities – 'everything which happens and everything which appears' as the products of intensities, the 'differential processes that generate extensive properties or qualities' (1994, p. 222): 'Intensity is [thus] the determinant in the process of actualization' (1994, p. 245). Differences of intensity, which, as Deleuze points out, is a tautological expression since 'every intensity is differential, by itself a difference', include differences of level, temperature, pressure, tension, [and] potential' (*Difference and Repetition*, 1994, p. 222).

[15] In a previous paper, I argued that diversity and productivity, though they may be sufficient principles for ecological sustainability, are problematic when applied to economic sustainability in a global and so-called 'free-market' capitalist system (Hroch, 2011). The current contraction of ecological and economic crises in such phenomena as peak oil, climate change, food crises, financial crises, and the destruction of habitats and communities strongly suggest that ecological sustainability is at serious odds with economic sustainability as it is currently configured. While ecological sustainability aims at sustaining diversity and productivity so that intensity is maintained and potential can continue to flow, economic sustainability as it is currently configured is at odds in so far as, as Braidotti points out, capitalism 'proliferat[es] … difference for the sake of [producing] profit' (2006, p. 276).

with intensity as the plateau – the generative ground – of endurance suggests that keeping intensive forces connectively flowing is paramount to what or how much is produced (although diversity and productivity as extensities will determine the conditions of possibility for perpetuating the flows of forces or intensive magnitudes). Sustainability is about the ability to create and keep up generative connections – connections that arise out of differential relations and maintain the intensity to continue to generate difference.

If potentiality is that which needs to be sustained, this is precisely what the current configuration of capitalism drastically diminishes.[16] If we consider, for example, industrialized, globalized farming practices, we find a system based entirely on oil-derived chemical fertilizers, a system under threat not only because of the inevitability of 'peak oil' but also because it is based on uniform monocultures, and therefore more easily threatened than traditional agriculture by 'climate change, to which it has contributed, and to diseases and pests' (Shiva, 2008). The alternative farming practices advocated by Vandana Shiva in *Soil Not Oil* (2008) are based on a principle of cultivating the productive capacity of the soil rather than a focusing on what the soil can produce – in other words, she argues that farming practices should be in the business of cultivating potential as much as, if not more than, agricultural products. Shiva's work provides a rich example of the importance of sustaining intensities and regenerating difference.

I would like to close by thinking about nomadism in Deleuze and Guattari's work in relation to the notion of cultivating potentiality as demonstrated by 'soil-not-oil' focused farming practices – practices that, in the process of producing more diverse products, and producing more product, enhance rather than destroy the *potential* of regional (cultural, social, economic and ecological) systems. 'Soil-not-oil' focused farming practices aim at maintaining (if not augmenting) the intensity inherent in the soil by making connections that work – by reorganizing the flows of energies, food, waste, inputs and outputs, sinks and yields in the ecologies, economies and communities they sustain and that sustain them. These practices demonstrate what Braidotti has called a form of gratuitousness based on principles of non-reciprocity that do not follow the 'logic of recognition' but rather, the 'logic of mutual specification' by specifying

[16] How can you sustain the earth when it is profit that capital seeks to sustain? When diversity and productivity are its extensities with a diminishing, increasingly indebted, potentiality as the underlying force? Although economic theories may be influenced by selective ecological presumptions or 'laws of nature' such as competition, the stark difference between ecologies and capitalist economies is that the goal of capitalist production is accumulation. Indeed, with the production of so-called 'products' such as derivatives and various other debt instruments, even the destruction of potential is configured in such a way as to be for-profit.

what a body can do. They couple the time-spans that often present a tension between economic and ecological goals of sustainability and take the long view – treating ecological sustainability as what Braidotti calls an 'experiment in inter-generational justice' and demonstrating that economic sustainability can exist at an intensity that is in step with ecology.[17] They demonstrate a kind of nomadism that is not exemplified in the persona of the indebted farmer, exploited worker or climate refugee who is forced to move to greener pastures to follow the flows of capital, leaving an exhausted earth behind, but rather, in a kind of nomadism that cultivates intensities and connectivities, and participates in an expanded understanding of communities by being 'nomadic in place' (Deleuze and Guattari 1987, p. 482). In *A Thousand Plateaus*, Deleuze and Guattari describe this kind of rooted nomadism that is intensive, *in situ* and interested in sustaining a milieu:

> The nomad distributes himself in a smooth space; he occupies, inhabits, holds that space; that is his territorial principle. It is therefore false to define the nomad by movement. Toynbee is profoundly right to suggest that the nomad is on the contrary *he who does not move*. Whereas the migrant leaves behind a milieu that has become amorphous or hostile, the nomad is one who does not depart, does not want to depart, who clings to the smooth space left by the receding forest, where the steppe or the desert advances, and who invents nomadism as a response to this challenge.
>
> 1987, p. 381

This nomad is not attuned and adaptive for the sake of ongoing learning in the service of neo-liberal competition, but rather is attuned and adaptive for the sake of staying and sustaining its surroundings in the spirit of cooperation. The question for this nomad is not how quickly you can ride the wave to get to where you are going but how well you can be more hospitable to the flows that run through you and the connections that augment rather than diminish your local and global milieu by producing deterritorializing refrains that sustain earthly intensities. The nomadic subjects that Deleuze and Guattari describe are interested in sustaining the intensity of the ground that sustains them, 'They are nomads by dint of not moving, not migrating, of holding a smooth space that they refuse to leave. Voyage in place: that is the name of all intensities, even if they develop also in extension' (1987, p. 482).

[17] These are quotes from my notes from a seminar on 'Gilles Deleuze and Cultural Studies' jointly led by Rosi Braidotti and Anneke Smelik at the Centre for the Humanities at Utrecht University the in Fall 2010.

Conclusion: The people-yet-to-come, the planet-yet-to-come, pedagogy and politics

To think is to voyage ...
> Deleuze and Guattari in *A Thousand Plateaus*, 1987, p. 482

Thinking differently about our subjectivities – namely, thinking about the connected and collective becoming of the 'people-yet-to-come' and the 'planet-yet-to-come' – in the service of sustainability is a political and pedagogical project not only because it is concerned with transformation and becoming, but also because it is concerned with boundaries between so-called 'subjects' or so-called 'objects' and their 'surroundings' and 'environments'. As Haraway remarked in her work on 'situated knowledges', 'objects are boundary projects' (1991, p. 201) and, as the work of Deleuze and Guattari and theorists inspired by their work such as Braidotti demonstrate, in a world wherein 'subjects' and 'objects' are so co-constitutive, or indeed, as Barad argues: 'intra-acting' (2007, p. 33) decisions around where we draw boundaries among 'subjects' and 'objects' are primarily political decisions – that is to say, they are decisions that are made real based on their desired effects – their inclusions and exclusions – rather than decisions grounded in a reality that we can call 'truth'. Although Deleuze and Guattari's more material and post-humanist reconfiguration of subjectivity may not provide ready-made solutions to the problem of ecological, economic and social sustainability, their work reconsiders these boundaries, and opens up new ways to approach the problem of sustainability in both the pedagogical and the political realm. Indeed, perhaps the most 'sustainable' kind of thinking is not the kind that searches for a ready-made solution but is rather what Guattari advocated as a 'work in progress' or the 'continuous development' of adequate philosophical and, indeed, pedagogical and political 'practices' that are attuned to the question: what does this do? (2008, p. 27).[18] Indeed, if we are 'contemplations', then let us 'voyage in place' (1987, p. 482) by learning to think more intensively and in more complex ways about the wanderings that we are in order to become more hospitable to the human and non-human, living and non-living forces that sustain us.

[18] Guattari writes, 'Similarly, every care organization, or aid agency, every educational institution, and every individual or course of treatment ought to have as its primary concern the continuous development of its practices as much as its theoretical scaffolding' (2008, p. 27).

References

Barad, K. M. (2007) *Meeting the Universe Halfway: Quantum Physics and the Entanglement of Matter and Meaning.* Durham, NC: Duke University Press.

Bateson, G. (1972) *Steps to an Ecology of Mind.* New York: Ballantine.

Braidotti, R. (2006) *Transpositions: On Nomadic Ethics.* Cambridge: Polity Press.

Chisholm, D. (2007) 'Rhizome, Ecology, Geophilosophy (A Map to this Issue)'. *Rhizomes*, 15 (Winter). Available at http://www.rhizomes.net/issue15/chisholm.html (accesed 15 June 2010).

DeLanda, M. (2002) *Intensive Science and Virtual Philosophy.* London and New York: Continuum.

Deleuze, G. (1994) *Difference and Repetition*, trans. Paul Patton. New York: Columbia University Press.

—(1995) *Negotiations 1972–1990*, trans. Martin Joughin. New York: Columbia University Press.

Deleuze, G. and Guattari, F. (1983) *Anti-Oedipus: Capitalism and Schizophrenia*, trans. Robert Hurley, Mark Seem, and Helen R. Lane. Minneapolis: University of Minnesota Press.

—(1987) *A Thousand Plateaus: Capitalism and Schizophrenia*, trans. Brian Massumi. London: Athlone Press.

—(1994) *What is Philosophy?*, trans. Hugh Tomlinson and Graham Burchell. New York: Columbia University Press.

Guattari, F. (2008) *The Three Ecologies*, trans. Ian Pindar and Paul Sutton. London: Continuum.

Haraway, D. J. (1991) 'Situated Knowledges: The Science Question in Feminism and the Privilege of Partial Perspective', in *Simians, Cyborgs and Women: The Reinvention of Nature.* New York: Routledge: 183–202.

Henry, A. D. (2009) 'The Challenge of Learning for Sustainability: A Prolegomenon to Theory', *Human Ecology Review*, 16 (2): 131–40.

Herzogenrath, B. (ed.) (2009) *Deleuze, Guattari and Ecology.* Basingstoke: Palgrave Macmillan.

Hird, M. J. (2009) *The Origins of Sociable Life: Evolution After Science Studies.* London: Palgrave Macmillan.

—(2010) 'Meeting with the Microcosmos', *Environment and Planning D: Society and Space*, 28 (1): 36–39.

Hroch, P. (2011) 'Sustainable Concepts: Deleuze and Guattari's Economies, Ecologies and Communities'. Paper presented at the *Fourth International Deleuze Studies Conference: Creation, Crisis, Critique*, 27–29 July.

Klee, P. (1964) 'On Modern Art', trans. Paul Findlay, in Robert L. Herbert (ed.), *Modern Artists on Art: Ten Unabridged Essays.* Englewood Cliffs, NJ: Prentice-Hall: 102–15

Morton, T. B. (2009) *Ecology Without Nature: Rethinking Environmental Aesthetics.* Cambridge, MA: Harvard University Press.

—(2010) *The Ecological Thought*. Cambridge: Harvard University Press.

Nietzsche, F. W. (2006) *The Nietzsche Reader*, ed. Keith Ansell Pearson and Duncan Large.Oxford: Blackwell.

Parr, A. (2009) *Hijacking Sustainability*. Cambridge, MA: MIT Press.

Pindar, I. and Sutton, P. (2008) Translators' Introduction to *The Three Ecologies*, by Félix Guattari, London: Continuum.

Schneider, J. (2005) *Donna Haraway: Live Theory*. New York: Continuum.

Serres, M. (2007) *The Parasite*, trans. Lawrence R. Schehr. Minneapolis: University of Minnesota Press.

Shiva, V. (2008) *Soil Not Oil: Environmental Justice in an Age of Climate Crisis*. New York: South End Press.

Simondon, G. (2009) 'The Position of the Problem of Ontogenesis', trans. Gregory Flanders. *Parrhesial*, (7): 4–16.

von Uexküll, J. (2010) *A Foray into the Worlds of Animals and Humans*, trans. Joseph D. O'Neill. Minneapolis: University of Minnesota Press.

Inter-collapse ...

Educational Nomadology for a Future Generation

David R. Cole

Transversality is, at heart, nothing but nomadism ...

Félix Guattari, 2009, p. 147

Introduction

This writing suggests that one has to overcome dualism in education before one moves to the implementation of nomadism. The main issue that this chapter addresses is: How do we reconcile the philosophical overcoming of dualism with educational nomadology?

There is a bad film called *Good* (Taylor and Wrathall, 2008) that coincidentally encapsulates a good idea. In the film, the central character is an academic called John Halder. The film starts as Halder grapples with and lectures on challenging literature such as Proust, Joyce, D. H. Lawrence and Thomas Mann. Meanwhile, the Nazi Party have come to power and the lecturer has to decide either to continue with his liberal arts education or to choose the Party. Halder has a Jewish friend that he is forced into dispute with as a tide of anti-Jewish sentiment sweeps through Germany. The academic had written a bad novel about euthanasia that the Party seized upon and used to promote their ideals. Halder has a hellish domestic life with his mad mother, bedraggled wife, and wayward children hovering around the home like ghosts. At the same time, an attractive, young blonde student solicits Halder. The paths are clear, either stay with his previous struggling existence to explain complex literature to uncaring masses along with the accompanying and boorish domestic servitude, or take the new path, the vivacious blonde, the Party and fascist line, limitless power. Halder chooses the second path, and in a fittingly dreadful scene, cloaks up to

take on the masses in a night of riots. He looks in the mirror and sees himself, freshly dressed in a leather SS uniform. His 'Rhine-maiden' is in a position of adoring fellatio, willing to do anything to keep the man-warrior-hero by her side.

The writing of this chapter will use the film *Good* as a device to understand the contemporary politics of duality in education and the subsequent 'inter-collapse' into nomadology. On one side of the equation are the influences of the most recent developments in capitalism, and how we might understand these in education. Everything that one produces and learns should be market-ready, able to be cast into the melting pot of post-industrial digital production – including teachers and knowledge. On the other side are the intense thought processes necessary to grasp the potential of a non-representative politics – as advocated by Deleuze and Guattari (1988). The writing of this chapter suggests that to understand and implement the second option, one should draw on the analysis of process in Deleuze and Guattari's (1988) *nomadology*. This is because the ways in which nomadology is conceptualized offers an escape route from the dualisms of educative choice by continually offering 'multiple third options' as machinic objects.

Decision-making in education (duality)

It is not straightforward to deny the 'either-or' of decision-making in education. This is because the 'either-or' in contemporary education is reinforced and struc-turally determined by many of the dualistic processes that involve knowledge, the truth, language and the philosophical edifices of thought from a Western perspective (see Rogers, 1980). The fact remains that the 'either-or' lies at the heart of propositional logic, is lodged within the divisions between good and evil, and is often considered as the 'natural' outcome of moral training. One can choose, so one is taught at school, between right and wrong, one can do the 'right' thing – if one really wants to. This simple logic is foundational to much educational ideology, and is the connecting device between education and the formation of civil society based on decision-dependent rules (see Habermas, 1987). The point of this writing is not that nomadology challenges the authority of the 'either-or' statement – or that Deleuze and Guattari (1988) came up with a new type of logic, but that there *is* another option, 'either-or' is not definitive, there isn't always the 'road not taken' (however multiple). Deleuze (1990, 1994) explored the philosophical arguments for the third option, which

could be bracketed as 'beyond the either-or' in the philosophy of *Difference and Repetition* and *The Logic of Sense*. Guattari explored the consequences of duality in education through his practical work and machinic materialism in the community with psychiatric patients and minority activism, which I will term here *après* Deleuze and Guattari (1988) as immanent materialism. I suggest that the philosophical project of working out a way around the 'either-or', and the practical work on the ground to help escape the logic of 'either-or' are best drawn out through nomadology. This is because nomadology deploys the conceptual resources of philosophical argumentation whilst being applicable to the complexity of real life situations. The situations that we are engaging with in this chapter are in schools, colleges and universities.

Halder followed the path of the Party, and the conformism of fascist ideology. In hindsight, and from a perspective that opposes the Nazi Party, one might consider this decision to be wrong. However, such a simplistic judgement does nothing to help understand the forces at work through the character of Halder, or the specific historical moment that was at play. The truth is that the decision was not a momentary one, but came over time, and through the ways in which the university was being reorganized during the 1930s. In the present situation, academics are choosing to abandon universities due to the influence of free-market neo-liberalism on thought, scholastic endeavour and intellectual integrity. Confluent with the 1930s, the impact of market economics has not happened suddenly, but has come about due to the rise of trade over the past five hundred years (see Braudel, 1967). It is therefore impossible to impose a definitive, timeless, 'either-or' on such decisions made by Halder or academics opposed to neo-liberalism. Rather, one should look at the ways in which identity and character have been shaped through education, and at the consequences of this shaping in terms of duality and 'the will' to do otherwise. Nietzsche expressed this idea (1982) in *Daybreak*:

> The surest way to corrupt a youth is to instruct him to hold in higher esteem those who think alike than those who think differently.
>
> <div align="right">p. 202</div>

Halder was corrupted by the historical circumstances, and the takeover of the university system by the Nazis, or 'those who think alike'. One could argue that we, as academics and teachers, are corrupting the youth if we instruct them to blindly copy neo-liberal mores, customs and modes of thought. The difficulty with this argument, and by degrees the nomadic political project (cf. Holland, 2011), is that capitalism precisely demands difference and thinking 'outside of

the box'. So, by questioning neo-liberalism, one is setting into motion one of neo-liberalism's most characteristic and necessary moves, i.e. opening up the space for market expansion and growth (see Seltzer and Bentley, 1999). The dilemma for contemporary teachers and academics is clear. Either reinforce neo-liberalism through intellectual work that effectively reduces education to vocational studies and closes down other possibilities for thought, or deny neo-liberalism, and shut down the difference that neo-liberalism makes in the world through market expansion. The idea behind this chapter is that there is a third (multiple) way, lodged between these two options as a machinic object. This third way can be expressed through the concept of 'educational nomadology', which retains the power to think through problems to their deepest philosophical levels (for example, the construction of the Western self), whilst simultaneously initiating practical measures to change matters on the ground. Therefore, decisions in education should not be reduced to a dualism about deploying neo-liberalism or in denying its use value by imagining a space outside of market influence. Furthermore, duality in education cannot be characterized by a lack that is produced when decision-making goes wrong – i.e. the effect of non-choice or the affect of indecision. Rather, educational nomad-ology supports any means to revolutionize neo-liberal market economics, and does not uncritically follow its tenets. Additionally:

> Irit Rogoff (2008) notes that the discussions of academics and cultural profes-sionals tend to constitute an 'eternal lament of how bad things are – how bureaucratised, how homogenised, how understaffed and underfunded'. Though 'not without its justifications … this voice of endless complaint serves to box education into the confines of a small community'. How can education become more, Rogoff (2008) asks, 'than this site of shrinkage and disappointment?' Part of her answer involves thinking about 'the principles we cherish in the education process' – in particular attentiveness to the complexities of meaning-making, desire and curiosity, intellectual challenge.
>
> Jones, 2010, pp. 797–8

Educational nomadology could be summarized through such attentiveness. The voice of endless complaint characterized above is dealt with through the Spinozism of nomadology, in that one henceforth affects and is affected through duality in education, and therefore acts immanently (see Cole, 2011). Furthermore, the smooth space through which the nomad may move concep-tually and intellectually to sidestep the confines of small community decries the tendency to sit only on the negative side of the educational equation (married to the disadvantaged). Educational nomadology in teaching and learning deploys

a vitalist conception of time (see Bergson, 1994), and involves the construction of a plane through which affect, vitalist time and the ontological grounding of difference work together in practical situations (see Freinet examples below). Educational nomadology is not restricted to local situations, yet this is where the impact of educational nomadology will be at its most intense. This impact comes about because the nomad opens up subjectivity and group action, by putting into play the conceptions of space associated with sedentary existence. One could argue that nomadism could be aligned with a type of management strategy (e.g. Fisher, 2009) in that nomad space is not restrictive in terms of sedentary influence or entrapment. It is true that managers of institutions and companies may want to deploy a nomadic form of surveying their employee performance – often through electronic means. Conjointly, educational nomadology includes a roving consciousness or 'probe-head', but does not attempt to manage others through top-down strategies, but encourages the movement of others through Deleuze and Guattari's (1988) immanent materialism (see Cole, 2012a). This movement importantly involves non-organic life. Immanent materialism includes engagement with the ways in which capital flows through education as non-organic life, and this structuration feature creates duality in terms of favoured pedagogy, hierarchies of resourcing, and spheres of educational influence. Nomads in education are not unrelated 'others' to the capital flows as they currently exist, but work ceaselessly to divert and expose sedentary empire building that may extend to the material organization of the institutions within which nomads now work.

Nomads in capital space

Educational nomadology defines a new way to think about capital flows in education. In Halder's period, capital flows were incorporated into Nazi Party ideology (fascism) as the state took over universities, industry, government and commerce and effectively abandoned free-market capitalism. In the contemporary period, capital flows are directed around the globe by automated investment mechanisms run by computer programs (see Yochai, 2006). One could cogently ask about the political motives or human agency involved with such capital flows given the automation and speed of the processes. Yet the outcomes are predictable, capital begets capital – the rich thrive on the free movement of their money through electronic circuits and integrated investment strategies. The point here is that educational nomadology cannot directly

challenge such processes, or deny their existence. Educational nomadology encourages a following of material flows through immanent materialism, both in terms of actual and virtual money transactions, and in the desire that the global manipulation of capital produces. There is a double system at work through the markets, one constituted by the dynamism of capital manipulation, and one that results from the desires, imaginings, thought processes and politics that these transactions encourage. Deleuze and Guattari (1984) critiqued capitalist desire in *Anti-Oedipus* – educational nomadology gives one the opportunity to take this critique further, and to effectively analyse the situation of the double bind, which can be positioned as a development from critical pedagogy – parallel to Abraham DeLeon's (2010) discussion:

> Although critical pedagogy has included calls for teachers to resist in certain ways, sabotage as a 'method' rings more clearly and urgently than similar positions in critical pedagogy, while also providing a more activist framework for engendering social change. This approach supports the notion that social change will have to occur both within and outside established institutional structures, echoing Jean Anyon's (2005) call for economic change to accompany urban educational revitalization.
>
> DeLeon, 2010, p. 3

Critics have described the nomadology of Deleuze and Guattari (1988) as a form of 'anarcho-communism' (e.g. Martin, 2006). However, this characterization belies the non-representative depth of the political manoeuvrings that Deleuze and Guattari (1988) executed in *A Thousand Plateaus*. Nomadology is not restricted to one political outcome or perspective, but wraps political ideologies unto itself in the deterritorialization and exploitation of non-sedentary space. This makes educational nomadology an immanent political movement – one that creates acts of resistance and sabotage, as DeLeon (2010) describes, but in terms of affective attack and stealth-cloaked strategies. With relation to the capital flows that besiege and riddle teaching and learning, and define duality in education, educational nomadology adds stealth factors with respect to critical pedagogy. Critical pedagogy can become caught in reactive oscillations between capitalism and anti-capitalism, thus defining its range and sphere of influence (see Darder *et al.*, 2009). Educational nomadology utilizes capitalism to work against itself, from within the system, as immanent materialism suggests. This is because the nomadism of capitalism precisely defines the breakout points and surges into new markets that are necessary for growth. These points and movements, as Marx (1976) noted, will spell the ultimate break-up and end of capitalism.

Educational nomadology posits nomads in capital space. This is because the reality of present-day capitalism presents an overwhelming system that cannot be directly opposed, but must be subverted and objurgated. An example to illustrate this point of the argument in education comes in the form of the cyberpunk movement (see Cole, 2005). The cyberpunks need to master electronic circuitry to make their political points, and such 'cyber-events' can be achieved through hacking, electronic irony, or Net sabotage. The cyberpunk wages warfare against mainstream conformity and banality, and the tedious commercial exploitation of Net space. The recent uprisings in the Middle East and the organization of protests against educational cuts in the United Kingdom, Canada and Chile have shown how the deployment of social media can represent a new form of cyberpunk (see Liu, 2004). This is because social media is a suitable host through which to transmit subversive and anti-conformist messages. Yet even here, the contradictions and pulsations exist between surging towards new societies in the Middle East that are freed from tyranny, and the reality of intervention by liberal democracies that practise free-market economics. If the new educational institutions in the Middle East are to stay clear of privatization, they must build a sense of public ownership in tandem with their identities and law (see Ball, 2007). Educational nomadology supports public ownership in education to the extent that it creates a space beyond free-market intervention in the movement of thought. This idea, of ring-fencing education beyond the free market, points to new forms of educational organization, which will be explored in terms of the pros and cons of nomadology.

The pros and cons of nomadology

The most prevalent 'pro' of nomadology is that it can be pushed to the limit, or the nth degree (the multiple third way as a machinic object), and in education, this means a complete reorganization of systems and forms. Curriculum theory is an exemplar of nomadic thought, as the heterogeneous nature of knowledge, knowledge acquisition and knowledge dispersal, makes it a prime candidate for the nomadic in education (see Doll and Gough, 2002). One could argue that the penetration of nomadology, which has previously worked on a discursive and conceptual level, has largely not been drilled into the habits and context of teaching and learning situations where teachers and students interact. This is because the ways that educational transactions happen embody a huge amount of sedentary energy, and is an intensive field, in contrast to curriculum theories,

which are often only surveyed by interested intellectuals. Nomadology should not stop at the intellectualization of the curriculum, but seep into curriculum execution, timetabling, teacher education, cohort organization, assessment, school design, and the integration of ICTs (information and communication technologies) with teaching and learning. However, in order to do this, nomadology has to overcome perhaps its most devastating 'con', and this is contained in the history of civilization. One could argue that since human beings ceased being hunters and gatherers and moved into sedentary cities, the defence of those cities has been inbuilt into the structures and forms of socialization that take place within the city walls. Education is at the forefront of these modes of socialization, and has functioned as a means to normalization for sedentary lifestyles (see Deleuze and Guattari, 1988, p. 129). The question that the pros and cons of nomadology delimit, and which is crucial to this argument, is: How can we loosen the hold of sedentary power on education? The answer might come from a surprising perspective:

> One response to such a 'polyminimalist' position – favoured in this post – is to promote the greatest possible loosening of a key hyperstitional concept: that of *carriers*. At one extreme, carriers are well-articulated fictions able to convey a plausible sense of integrity and thus mimic a range of 'hoax-type' effects. At the other extreme, proposed as a norm here, they are units of systematic relativisation that function as sinks for 'eccentric agendas'. The term 'eccentric agenda' is being coined technically here, to cover an immense terrain, namely: every hypothesis, belief, emotion or commitment that can be evacuated from the principles of hyperstitional activity. The elementary function of carriers is to eliminate extraneous norms from hyperstitional practice. Carriers are the tools of hyperstitional 'autodisindoctrinization'.
>
> <div align="right">Unknown, 2005, online</div>

The hyperstition blog has been advocating a form of educational nomadology for a number of years. In the quote above, educational nomadology works through the carriers, defined as the range from 'hoax-types' to 'eccentric agendas'. The internet gives new impetus to these carriers, as subjectivity is not ascribed to an author, group or institution as being responsible for the carriers – hyperstition is a 'non-group' or point of dispersed implosion. Rather, the carriers work as a form of asymmetrical warfare, which has an extraordinary ability to reorganize and attack sedentary forms of life in new and unforeseen ways. Contrast this to, for example, the tendency to name oneself as a pedagogue, and to work creatively, practically and intellectually to change the educational system (see Daignault, 2008). Such a focus and will to educate could lead to the evolution

of alternative schooling methods and new places of teaching and learning if one may gain the social support for one's plans. Yet how can one, as a pedagogue, sidestep the tendency to reinstitute new methods and alternative educative locations within the context of sedentary conditioning?

Hyperstition gives us a clue as to how to solve the ineluctable riddle of sedentary functioning, and this solution is parallel to the position of nomads in capital space. The answer lies in the reality of the pedagogue going about the business of constructing alternative means to education in the context of sedentary conditioning without incorporating the sedentary means to power into their world view (see Rose, 1999). Rather, educational nomadology works from within to reconstruct nodes of learning intensity as 'matter flows of life'. For example, schools may be redesigned as the tents of nomads. Curriculum structures can be delivered and received as 'nomad-flexi-nodules'. The normative structures of teacher education can be delivered through (de)instructional means (see Becker, 2001). The important political question to consider is: How will nomadic changes to educational practice be received in communities dominated by sedentary mores? We are searching for a workable politics to accompany educational nomadology, and one that will not be derailed by the reactivity of sedentary communality. This search takes us back to overcoming dualism and decision-making in education, and to fundamental questions that relate to the practical and political in teaching and learning.

The good, the bad and the nomad-ugly

The education system in Finland has been heralded as one of the best in the world through the gamut of OECD testing regimes that examine the learning efficiencies of subjects such as literacy, mathematics, science and the humanities (see OECD, 2006). The French educator Célestin Freinet (1896–1966) profoundly influenced the design of the system in Finland. Freinet was also an influence on Guattari's (1995) experimentation with group dynamics, and the ways in which working with group dynamics can relieve psychiatric patients of neurosis and schizophrenia. There is therefore an interconnection between the current educational provision in Finland and the material dynamics of nomadology or immanent materialism. In other words, there is an evidence-based convergence between the macro-economic, social and political funding of the Finnish education system, and the micro group processes of dealing with neurosis through transversal experimentation (nomadism). The point here

is that this convergence takes us further in understanding how to implement educational nomadology and how to construct a workable nomadic politics on a practical level. The Finnish system tries to rigorously take out the stress of teaching and learning – and to relieve teachers of the potentially stultifying entrapments of subjectivity (as *the* teacher) by giving them an autonomous position in society, whereby they can act through the particular dynamics and speeds contained in group contexts. In Finland, education is ring-fenced against free-market economics. Finland is not a utopia, but does show how educational nomadology could be implemented if there is the political will to enact the tenets of Freinet's ideas. I recently encountered a diagram of a machinic object, which represents the multiple third way of educational nomadology of this chapter in terms of convergence between Freinet and Guattari, and points to a new form of educational materialism:[1]

1. Guattari–Freinet machinic object
2. breakthrough/breakdown/breakout
3. self-immolating line of flight – contra *machinic répétition mortifère*

In Figure 4.1, first, the Guattari–Freinet machinic object cuts through the plane of interaction as a dynamic line of flight. This is the idea of implementing a Freinet education system, such as in Finland, that incorporates Guattari's ideas on group dynamics (see Genosko, 2002). This is the project that is being proposed by this chapter as educational nomadology, to be completed by a future generation. Secondly, it represents the breakout/breakthrough/breakdown points that show how the jumps between moments in this educational schema work. These points are necessary to galvanize force and to breach the ways in which the sedentary, capitalist and ideological may reterritorialize the Guattari–Freinet machinic object (educational nomadology in action) as duality. Finally, the self-immolating or nomadic line of flight functions against the *machinic répétition mortifère*, which is the process whereby sedentary, capitalist and ideological forces can produce frozen and non-productive regimes of thought and a resulting psychological disturbance in the subject.

If one applies this diagram (Figure 4.1) to the questions that surround the educational nomadology of this chapter, and how they refigure the good and bad (and multiple ugly) in education – Guattari's model of group creativity, derived from the pedagogy of French educationalist Célestin Freinet, founder

[1] I would like to thank Joff P. N. Bradley (2011) for this diagram and the representation of the *machinic répétition mortifère*.

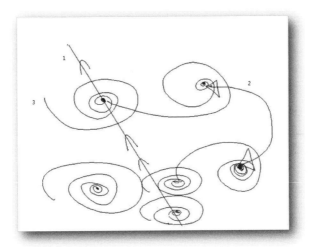

Figure 4.1: A nomadic line of flight

of the Modern School Movement, invokes a responsive, creative, and engaged mode of teaching and learning. After Freinet, Guattari (1995) was interested in creating a de-Oedipalized context for education, to escape the entrapment of closed systems represented by harsh, disciplinary classrooms and non-equivocal textbooks that explain 'the truth'. Guattari's group work looked to forge connections with the outside, to produce open systems that complement the philosophy that Deleuze brings to the project of educational nomadology. Writing before the invention of the internet, Freinet encouraged students to trace their material connections to the world through objects, machines, people and places. Through reading, discussion, performance and reflexive journal writing Freinet re-envisaged teaching and learning as a space for collective imagination and engagement. The core concepts of Freinet's (1994) philosophy of education are as follows:

- Student work must be productive and useful.
- Cooperative learning is necessary in the productive process.
- Group enquiry-based learning is based on trial and error.
- The natural method is based on an inductive, global approach.
- Centres of interest are grounded in children's learning interests and curiosity.

Through triangular experiments, which use a mediating object or a collectively produced monograph, the purpose of learning according to Freinet is to create progressive scenes of desubjectification, to overcome what Guattari's

mentor Fernand Oury designated as the *encaserné scolaire* (school-as-barracks). Guattari (1995) was concerned to think through the role of the group-subject and the subsequent creativity in radical pedagogy. Freinet (1994) emphasized the act of writing as an individual and collective project that not only allowed for expression of meaningful interests by individuals, but also realized a sense of success in communication, that is to say, being read or heard by one or many others. Teachers set up a pedagogical scene of subjectification, for example exploring how one may experience bullying – and the scene was guaranteed to be discussed through the circulation of published and reproduced texts. This process entailed reading before the class, but only from those sections of one's personal 'free text' that would interest the group. The group would then pass a certain kind of judgement, making corrections and suggestions, and carrying out editing towards its inclusion in a collective publication. Work would also be addressed and readdressed in correspondence between individuals, between individuals and groups, and in the group-to-group exchange of collectively written manuscripts between geographically diverse schools. The school journal in this context works as a third (but multiple) object that opens the students to the world. Two becomes three, but three is not just three, more precisely it is (3 + n). It is through the diagram of the triangle and the production of threes (+ n) in education that micropolitical pedagogies manifest. In the meeting, the teacher is one among many participants, and, although he/she may veto the motions, the class remains active as a self-directed group. Parallel to Guattari's (1995) sense of a group-subject that formulates its own projects, speaks and is heard, the group puts itself at risk in pursuing its own ends and taking responsibility for them. The school journal, in a sense, brings the group to language. It is created, reinvented, and maintained by the group over time. This mediating third machinic object operates outside of face-to-face relations (it is nomadic).

Important aspects of educational nomadology are represented through the experimentation with writing formats as described above. Writing is here not an imperial or top-down form of literacy, that looks to check and contain children in their subjective, linguistic skills. Rather, writing is about setting the writer free, about putting into play the good and bad (and ugly) in education, and about introducing writing projects that are driven by group dynamics. One might say that this is a long way from lines of domesticated children practising their writing skills on separated desks, under threat of punishment if they lift their heads or stop practising the work of the scribe. Teachers may baulk at the possibility of introducing the free movement of group dynamics in their classrooms, as elements of rebellion, revolt, dissension and struggle may be

introduced into the context of teaching and learning (see Cole, 2009). Yet, these social elements of change define a range of actions that show how nomadology may force gaps in the sedentary. The 'take over' of education by the group does not mean one should re-establish a hierarchy of teenagers in the place of the adult, but that one is releasing forces amongst teenagers in an educational context. This is an important aspect of nomadology, in that the collective 'voice' that will emerge from group dynamics defines much of the politics that one may deal with in the adolescent context (see Cole, 2008). For example, if the mediating third (multiple) object had been used with groups of adolescents involved with the London and UK unrest of 2011 – their sentiments might have been articulated before they took to the streets and took militant action in their local contexts. This articulation would have gone some way to assuage their desires, and to reroute their energies into alternative forms of cultural statement such as the collective expression of insurgency. This point takes us to the last section of this chapter, which will join the notion of educational nomadology with policy, so that the power relationships that are established due to educational nomadology may retain nomadic fluidity for the nomad in education to work (as pragmatics).

Educational policy (power) and nomads

The question about how to mesh educational policy with nomadology is virtually intractable, owing to the fact that educational policy could be viewed as an example of state or royal science (see Deleuze and Guattari, 1988) from which nomad science is ontologically different. Yet to deny the connection between educational nomadology and policy is to interrupt power functioning in the nomad, as it is through policy that current educational systems are orchestrated, so to block nomadic policy is to neutralize educational nomadology. The nomad does not exist in an abstract educative space, gallantly working from the outside to change the platitudes of the system. Rather, the nomad in education focuses on the ways in which deterritorialization happens in teaching and learning. Educational policy presents an example of how territories are governed and run. Presently, governments use specialist research and targeted professors to gather evidence about the best educational strategies to deploy in populations. The results of these commissioned studies are bundled and presented as policy by state bureaucrats in terms of standards, guidelines and directives. Policy works in tandem with the curriculum to deliver the requisite knowledge and

skills necessary for economic growth. However, in an age of economic crisis (see Cole, 2012b) market volatility and growing pressure on public financing, the stress on policy mechanisms are immense and have been increasing over the years (see Ball, 1990). One might move to relieve this pressure by the application of educational nomadology to the processes that make the policies that govern teaching and learning practice by:

1. Questioning the ways in which policy relates to populations of teachers and students. This relationship represents a moving, flexible target for nomadology.

2. Examining evidence for the claims of policy, as this evidence may be based on sedentary forms of power and entrapment.

3. Paying close attention to the constructions of subjectivity in policy, especially with respect to teachers and students and their potential divisions. Educational nomadology is here closely aligned with the application of Foucault's notion of power and the subject in education (see Jardine, 2005) – the difference gained from the use of the nomad is to increase the speed of movement in the subjective analysis of power, and therefore not to get caught in ranges defined, for example, by social justice.

4. Understanding that the language of policy carries markers of sedentary functioning that should be deterritorialized.

5. Noticing that all developmental schemata in policy, for example in terms of professional improvement in teaching and learning include the myth of continuity between discrete criteria. Educational nomadology promotes breakout from every criterion as unexplored, non-linear lines of flight, parallel to the Guattari–Freinet machinic object above (Figure 4.1). This unlocking of professional schemata does not lead to chaotic teaching and learning – nor unregulated pedagogy – but increased creativity at every level of pedagogic functioning.

6. Defining educational policy as the nomadic, traverses towards future society, and introduces a 'zigzagging' between statements, relationships and functioning in teaching and learning mores.

7. Introducing the mediated third (multiple) item between policy and application as a means to understand the power relations produced by policy and a new form of educational articulation (beyond duality). The mediating third (multiple) item should be negotiated and freely communicated between teachers, students, researchers, administrators and bureaucrats as a machinic object.

These seven points *will not* be used to produce a new-nomadic hierarchy in education. Rather, they represent an important aspect of the non-representative politics that this chapter is articulating through educational nomadology. This politics conjoins with a notion of policy prolepsis:

> We wanted to reinforce ideas that policy inherently contains multiple, contra-dictory, incoherent, and fluid meanings and are always becoming through assembling senses. We also wanted to posit this paper as part of a rhizomatic politics (Youdell, 2011), for we believe that a policy prolepsis can be a powerful heuristic for critical policy researchers and teachers to better understand how policy positions problems, solutions, and more importantly, subjectivity.
>
> Webb and Gulson, 2012, p. 100

The prolepsis of policy points to the rhetorical ways in which problems are antici-pated and nullified due to educational policy. This nullification of forces in education is part of the sedentary domestication of teaching and learning, which this chapter seeks to address. Policy may dominate a territory and anticipate the movement of populations through rhetorical means. Educational nomadology addresses the meaning of policy, by setting free alternative meanings that one may deduce from a text. This process is in contrast to the designation of unambiguous guidelines for teaching and learning, which seal off different potentials for the classroom as 'other'. Educational nomadology engages with new potential for teaching and learning as continuous innovation in form and content. One could counter that this type of pedagogic scheme requires a boundless and irrepressible energy, which is almost impossible to keep up given the current stresses in education. However, this point is precisely why education should be reorganized on nomadic grounds: in order to free up pedagogic energy, and to dismantle the 'castles of the mind' that have been built through sedentary conditioning. Far from unleashing a random and chaotic notion of education that would be impossible to implement – educational nomadology should bring one closer to how learning actually happens, and therefore connect policy to 'the real' – the statement of teaching and learning becomes contiguous with the bottom-up dynamics of group interaction. Educational nomadology is a future orientation for policy development for the next generation …

Conclusions

John Halder did not have educational nomadology working to free him from the decision of 'either-or' between his liberal arts university instruction and

fascist ideology. In contrast, this writing advocates using the nomadology from Deleuze and Guattari (1988) for educative purposes (the multiple third way), in order to work a way around the current impositions of free-market neo-liberal economics. The present-day serious threat to scholastic freedom is through the disposition of liberal market economics to reduce all thought to a financial (use) value. The deployment of educational nomadology is parallel to the engagement with concept creation that Deleuze and Guattari (1994) put forward in their last combined work. Educational nomadology is the concept that this writing has posited, and this acts as a bridge from the minutiae of duality in decision-making to credible new-nomadic policy options. The legitimization of this concept will be by future generations, who will work to take the stress out of education – they will build new schools that are not sedentary nodes of conditioning – the curriculum will be constituted by autonomous units of teaching and learning that address local issues and incorporate global knowledge(s) to the advantage of sustainable life-forms. However, the path to this educational future will not be constituted by a smooth transition, as the introduction of educational nomadology will cause the unconscious defence-mindedness of sedentary functioning to operate. This is why educational nomadology should employ disguise, camouflage, and stealth tactics to pass beneath the radar of the castle guards … this writing is an 'inter-collapse'.

References

Anyon, J. (2005) *Radical Possibilities: Public Policy, Urban Education, and a New Social Movement*. New York: Routledge.

Ball, S. J. (1990) *Politics and Policy Making in Education: Explorations in Policy Sociology*. London: Routledge.

—(2007) *Education PLC: Understanding Private Sector Participation in Public Sector Education*. London and New York: Routledge.

Becker, H. J. (2001) *How are Teacher Trainers Using Computers in Instruction?* Available at http://www.crito.uci.edu/tlc/findings/special3/How_are_teachers_using.pdf (accessed 11 January 2010).

Bergson, H. (1994) *Matter and Memory*, trans. N. M. Paul, and W. S. Palmer. New York: Zone Books.

Bradley, J. (2011) 'Materialism and the Mediating Third', *Educational Philosophy and Theory*. doi: 10.1111/j.1469–5812.2011.00801.x.

Braudel, F. (1967) *Capitalism and Material Life: 1400–1800*, trans. M. Kochan. New York: Harper & Row.

Cole, D. R. (2005) 'Education and the Politics of Cyberpunk', *Review of Education Pedagogy and Cultural Studies*, 27 (2): 159–70.

—(2008) 'Deleuze and the Narrative forms of Educational Otherness', in I. Semetsky (ed.), *Nomadic Education: Variations on a Theme by Deleuze and Guattari.* Rotterdam: Sense Publishers, pp. 17–35.

—(2009) 'The Power of Emotional Factors in English Teaching', *Power and Education*, 1 (1): 57–70.

—(2011, August) "The Actions of Affect in Deleuze: Others Using Language and the Language that We Make ...', in: D. R. Cole and L. J. Graham (eds), *The Power In/Of Language*, special issue of *Educational Philosophy and Theory*, 43 (6) (August): 549–61.

—(2012a) 'Matter in Motion: The Educational Materialism of Gilles Deleuze', in D. R Cole (ed.), *The Future of Educational Materialism,* special edition of *Educational Philosophy and Theory,* 44, S1 (May): 3–18.

—(ed.) (2012b) *Surviving Economic Crises through Education.* New York: Peter Lang.

Daignault, J. (2008) 'Pedagogy and Deleuze's Concept of the Virtual', in I. Semetsky (ed.), *Nomadic Education: Variations on a Theme by Deleuze and Guattari.* Rotterdam: Sense Publishers, pp. 43–61.

Darder, A., Baltodano, M. and Torres, R. (eds) (2009) *The Critical Pedagogy Reader*, 2nd edn. New York: Routledge.

DeLeon, A. P. (2010) 'Anarchism, Sabotage, and the Spirit of Revolt', in A. P. DeLeon and E. W. Rose (eds), *Critical Theories, Radical Pedagogies, and Social Education.* Rotterdam: Sense Publishers, pp. 1–12.

Deleuze, G. (1990) *The Logic of Sense*, trans. M. Lester and C. Stivale. New York: Columbia University Press.

—(1994) *Difference and Repetition*, trans. P. Patto. London: Athlone.

Deleuze, G. and Guattari, F. (1984) *Anti-Oedipus: Capitalism and Schizophrenia*, trans. R. Hurley, M. Seem, and H. L. Lane. London: Athlone.

—(1988) *A Thousand Plateaus: Capitalism and Schizophrenia II*, trans. B. Massumi. London: Athlone.

—(1994) *What is Philosophy?*, trans. H. Tomlinson and G. Burchill. London: Verso.

Doll, W. E. Jr. and Gough, N. (eds) (2002) *Curriculum Visions.* New York: Peter Lang.

Fisher, M. (2009) *Capitalist Realism.* London: Zero Books.

Freinet, C. (1994) *Oeuvres pédagogiques, Tomes I et II.* Paris: Editions du Seuil.

Genosko, G. (2002) *Félix Guattari: An Aberrant Introduction.* London: Continuum.

Guattari, F. (1995) 'La Borde: A Clinic Unlike Any Other', in S. Lotringer (ed.), *Chaosophy.* New York: Semiotext(e), pp. 28–46.

—(2009) *Chaosophy: Texts and Interviews 1972–1977*, ed. S. Lotringer. Los Angeles: Semiotext(e).

Habermas, J. (1987) *The Philosophical Discourse of Modernity: Twelve Lectures*, trans. F. Lawrence. Cambridge, MA: MIT Press.

Holland, E. (2011) *Nomadic Citizenship: Free-market Communism and the Slow-Motion Strike.* Minneapolis: University of Minnesota Press.

Jardine, G. M. (2005) *Foucault and Education*. New York: Peter Lang.

Jones, K. (2010) 'Crisis, What Crisis?', *Journal of Education Policy* 25, (6): 793–8.

Liu, A. (2004) *The Laws of Cool: The Culture of Information*. Chicago: University of Chicago Press.

Martin, G. (2006) 'Remaking Critical Pedagogy: Peter McLaren's Contribution to a Collective Work', *International Journal of Progressive Education*, 2 (3) (October) (Online)

Marx, K. (1976) 'Capital, Vol. 3', in *Marx/Engels Collected Works*. London: International Publishers. Available online at: http://www.marxists.org/archive/marx/works/1894-c3/ch15.htm

Nietzsche, F. (1982) *Daybreak: Thoughts On the Prejudices of Morality*, trans. R. J. Hollingdale. Cambridge: Cambridge University Press.

OECD (2006) *Assessing Scientific, Reading and Mathematical Literacy: A Framework for PISA 2006*. Paris: OECD Publishing.

Rogers, C. R. (1980) *A Way of Being*. Boston: Houghton Mifflin.

Rogoff, I. (2008) *Turning e-flux*. E-Journal (E-flux) (November). Available at http://www.e-flux.com/journal/turning/ (accessed 17 February 2014).

Rose, N. S. (1999) *Powers of Freedom: Reframing Political Thought*. Cambridge: Cambridge University Press.

Seltzer, K. and Bentley, T. (1999) *The Creative Age: Knowledge and Skills for the New Economy*. London: Demos.

Taylor, C. P. and Wrathall, J. (writers) (2008) *Good* (film). Budapest: Thinkfilms.

Unknown (2005) Hyperstition blog. Available at http://hyperstition.abstractdynamics.org/archives/2005_01.html (accessed 17 February 2014).

Webb, T. and Gulson, K. N. (2012) 'Policy prolepsis in education: Encounters, becomings, and phantasms', *Discourse: The Cultural Politics of Education*, 33 (1): 67–101. *Special edition on Education and the Politics of Becoming*, edited by Diana Masny and David R. Cole.

Yochai, B. (2006) *The Wealth of Networks; How Social Production Transforms Markets and Freedom*. New Haven, CT: Yale University Press.

Youdell, D. (2011) *School Trouble: Identity, Power and Politics in Education*. New York: Routledge.

Diagramming the Classroom as Topological Assemblage

Elizabeth de Freitas

Introduction

This chapter focuses on the research practice of diagramming classroom inter-action. Diagrams are used extensively in educational research, often imposing a reductive coding on complex social processes, and operating as instruments of control and policy intrusion (St Pierre, 2004; Mazzei, 2010). The flow chart or the Venn diagram or any other schematic or 'graphic organizer' serves a particular image of education. The diagram is a political act, carrying and conveying capitalist, imperialist and commercial interests. My aim in this chapter is to show how Deleuze helps us rethink the diagram so that we might push back at the regimes of signification that curtail creative inquiry in our field. In this chapter I pursue philosophy (and educational research) in the experi-mental spirit, and reclaim diagramming as a political form of intervention. Deleuze and Guattari (1987) use diagramming in just this way, and argue for a new kind of non-reductive diagramming that amplifies and ramifies and multi-plies that which it engages.[1]

I put forward the proposal that topological thinking offers up an entirely new way of diagramming the entanglement of classroom interaction without imposing a reductive code. Topological thinking cuts through Cartesian ways of conceptualizing spatial relationships, and shifts our attention away from concepts of measure and rigid transformation, focusing instead on the stretching and distortion of continuously connected lines and surfaces. Topological diagrams break with traditional rules of representation, and attend

[1] See, for instance, the diagrams on pp. 135, 137, 146, 185, 218 in *A Thousand Plateaus*. See also the beautiful diagramming of chapters from *A Thousand Plateaus* by Marc Ngui retrievable at http://www.bumblenut.com/drawing/art/plateaus/index.shtml

to boundary relationships, curvature, proximity, orientation, connectedness and singularity. I first discuss issues with current diagramming practices in educational research, drawing on the work of Latour (1990), Lynch (1991) and Moxley (1983), to show how diagrams function ideologically in the social sciences. I then discuss Deleuze and Guattari's use of the term *diagram* and their argument that diagrams are creative capture machines. I suggest that topological thinking offers a way to study the movement of power and affect across the classroom, and gives us an alternative way to think about diagramming classroom interaction as an assemblage constituted of vibrant multi-dimensional flows. My intention is in part to disrupt the scopic regime that structures our 'flatland of pictorial rationality' (Lynch, 1991, p. 1) in educational research. Thus I offer these alternative diagrams as tools that actually undermine the usual conventions of graphic representation in educational research, not simply to disrupt for the sake of disruption, but to invite speculation about how we might develop different diagramming habits. My proposal is offered as a 'breaching experiment' (Lynch, 1991, p. 15) inviting the reader to break with the usual diagram conventions, and imagine a new diagramming practice that might better address the irregular and asymmetric tangles of interaction.

The politics of educational diagrams

Latour (1990) suggests that we attend to the way that our diagramming practices actually constitute and control what is taken to be visible (and invisible), and that such practices are indeed part of capitalist, imperialist and commercial interests. He notes how social and physical scientists gain status and leverage when they mobilize their preferred inscriptions and gather the gaze of others to these inscriptions: 'Scientists start seeing something once they stop looking at nature and look exclusively and obsessively at prints and flat inscriptions'. The flatness of the diagram is also crucial in invoking and mobilizing mastery; one can dominate a flat surface where there are no hidden convolutions or shadows. Whenever one needs to master a subject, says Latour, look for the flat surfaces that enable that mastery – a map, a list, a file, a census, a diagram. If we attend only to the diagrams without placing them within the turmoil of political vying for power and status pursued by various subjects (or actants/quasi-subjects, in Latourian terms), then we will either be 'mystical' about semiotic material – by fetishizing its free and emergent power – or we will imagine that there is some *a priori* logic to why some inscriptions work while others do not. These concerns

speak directly to educational researchers whose aim is to advance social justice through inquiry. And yet we rarely if ever examine our diagramming practices and interrogate the way they entail particular tacit assumptions about education.

Diagrams are used regularly in educational research to convey the 'essential' components and relationships involved in teaching and learning. The diagram, however, functions all too often as a crude tool for reducing the complexity of these situations to a set of inadequate tags that often entirely mis-recognize the actors and actions involved. Consider, for instance, Friedrich Froebel, the inventor of the kindergarten in 1840, and also a specialist in mathematical crystallography, who theorized student learning in terms of particular geometric and spatial forms, with particular emphasis on the binary branching of choices, using the tree or T diagram to depict cognitive development. The branching tree diagram is composed of binary breaks, each of which is meant to exhaust the contrasting choices that an individual might take. Such diagrams entail a tacit image of a 'learner' whose internal cognitive structure operates through individualized intention. Moreover, the connection between elements is usually presented as a straight line or multiple straight arrows, in order to evoke causality (before and after) or strong correlation (thing and word). The straight line also evokes rule and rigour.

In the first diagram, the straightness of the line conveys the rule of authority or command, while in the second the circle captures the inevitability of the effects, while also assuming a delivery or banking model of education. Moxley (1983) argues that the circle diagram characterizes cybernetic models that entail feedback, putting in motion the middle, beginning and end. He argues that the circular three-part diagram replaced the two-term model when systems theory became more dominant in educational theory. He also aligns this diagramming habit with new psychological theories of learning that were more functional and less descriptive. These diagrams, however, suggest a closed system rather than an open one, and can be found throughout commercial and corporate documents as forms of control. The circle diagram serves as a reminder of the totalizing loop of capital. There is no room in these diagrams for rupture, or for lines of flight.

In addition to diagrams that claim to represent cognition and learning, one also finds diagrams that pertain to classroom interaction. These diagrams tend to enforce hierarchical models and metaphors of causality as unitary and linear. They represent the individual student in isolation, and fail to capture the dynamic and collective nature of interaction. Most of these diagrams remain reductive in that they trace or represent links between *isolated* speakers without

attending to how non-verbal links might function on occasion as disruptive lines of flight that actually rupture the presumed dimensionality and flatness of the diagram. The traditional educational diagram functions as a highly restricted and ossified image of linear relationality, rather than as a creative force for imagining interaction as entanglement. Consider, for instance, the diagram in Figure 5.3 depicting the spatial coordinates of students and teacher. This diagram traces verbal interaction between the teacher and students using the arrow to indicate who is speaking to whom, the thicker lines indicating higher frequencies of interaction. Such graphical representations suggest that interaction entails linear and direct transmission and reception. In addition, it fails to tap into the temporality or speed of the event, and privileges meaning over the materiality of language-use. This diagram refuses to reckon with how the spoken word is a sonic addition to the classroom, saturating the space of its emergence like waves in a pool. A diagram like Figure 5.1 cannot engage with the undulating and indirect way in which meaning and matter are melded together in interaction.

Latour (1990) identifies nine aspects of the power of diagrams in furthering a cause, mustering allies and mobilizing people (and things) in support of particular agendas. These nine aspects of the power of diagrams are: mobility, immutability, flatness, reproducibility, changes in scale, potential for being superimposed or recombined with text and other inscriptions, and lastly, occupying the plane where axioms of geometry and measure can be applied. One can see immediately how qualities such as flatness, immutability and rigid measure lend themselves to reductive coding habits whereby linear models of growth are imposed on complex social processes. If our diagrams mobilize particular ways of thinking about classrooms, and impose a flatness and Cartesian measure onto classroom interaction, we need to recognize the ways in which they also muster support for particular curricular and instructional agendas. To summarize, Latour identifies the particular diagramming habits that have come to dominate the Euclidean models of growth and interaction we take for granted in educational research.

It might seem at this juncture that diagrams – as Latour has described them – are inappropriate for the study of complex educational processes. For Deleuze and Guattari (1987), however, diagrams are more than reductive codes; they are creative generative devices. Instead of a reductive metric or essentializing repre-sentation, the diagram is a becoming or ontogenetic material act. Reduction, on the other hand, is a form of *encoding*, as though a priestly unveiling of meaning. As Buchanan (1997) argues 'of abstraction, Deleuze and Guattari say they can

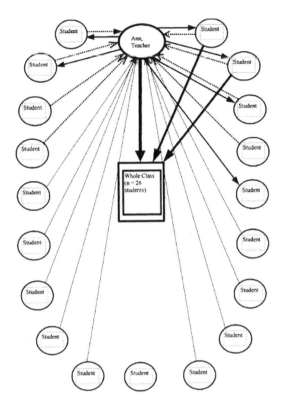

Figure 5.1: Whole class interaction (Nathan & Knuth, 2003)

never get enough; of reduction, they say they can never get too little' (p. 83). Thus a diagram can be used to find out how a classroom thrives, rather than unveiling what its interaction means. Such diagrams would be about realizing abstractions rather than identifying the referent to which the diagram refers. Buchanan (1997) suggests that 'to abstract means to isolate the triggers that will produce new Universes of reference – to use Guattari's felicitous phrase – whereas to reduce means to isolate the triggers that would enable the restoration of a Universal referent' (p. 84). Thus the function of the diagram, suggests Frichot (2005), is actually to step outside of illustration, figuration and representation. A diagram is an experiment, inventing lines of flight at the threshold between the actual and the virtual. As a 'gestural deployment of material' (Frichot, 2005, p. 73), the diagram operates through potentiality and possibility. In Deleuze's terms, 'the essential thing about the diagram is that it is made in order for something to *emerge* from it, and if nothing emerges from it, it fails' (Deleuze, 2002, p. 102).

Deleuze and Guattari show us how to rescue diagramming from the staid and compliant semiotics that treats diagrams *only* in terms of signification. It is worth noting that the pragmatist semiotician Charles Peirce also advocated for a generative or creative diagramming practice. Bezerra *et al.* (1998) highlight Peirce's 'insight into the generative role played by diagrams in the origination of "unexpected truths"' and the realization that 'diagrams have a creative function' and that they are not 'simple redescriptions of known facts' (Bezerra *et al.*, 1998, p. 339). All too often, however, Peirce's semiotic typologies are used as reductive codes for analysing activity, imposing a straitjacket on complex relationships. The aim of this chapter is to imagine a diagramming practice that confronts a capitalist axiomatics of confinement and control, and offers a concrete alternative practice. Such a diagram can function politically in constructing a new real that is yet to come, acting as a plane of creation, and sundering pre-existing forms of content and expression. The diagram, in this sense, should not be seen as a tracing or reductive model. According to Deleuze and Guattari (1987), the inventive diagram knows nothing of the distinction between the real and the not-real, since it is neither substance nor form, but rather pure function and abstract matter. The inventive diagram knows only potentiality, lines of flight, 'particles-signs' (p. 142). Such a diagram is absolute positive deterritorializing, an abstract machine, operating by function (not form) and by matter (not substance). To honour the creative impetus of our diagrams, and to recognize their political power, we must see them as events by which matter is carved up in new ways.

In the context of classrooms, a new diagramming practice must engage with the materiality of classroom life. The theory of assemblage offers a way to do so, suggesting that the power of an alliance is mostly enhanced by the ontological heterogeneity of it. In this vein, Bennett (2010) gleans from Latour and Spinoza a method for studying human/non-human interaction:

> Bodies enhance their power in or as a heterogeneous assemblage. What this suggests for the concept of agency is that the efficacy or effectivity to which that term has traditionally referred becomes distributed across an ontologically heterogeneous field, rather than being a capacity localized in a human body or in a collective produced (only) by human efforts.
>
> Bennett, 2010, p. 23

Assemblages are composed of diverse elements and vibrant materials of all kinds. The classroom assemblage is composed of humans, writing implements, writing surfaces, texts, desks, doors, as well as disciplinary forces whose power

and agency are elicited through various routines (singing the anthem) and references ('In algebra, we always do this ...'). Power is not distributed evenly across the surface of an assemblage, since there are joints or nodes where there is more traffic and affect than at others. Assemblages have 'uneven topographies' and possess emergent properties (Bennett, 2010, p. 24). Certain individuals and objects in a classroom – often those who speak up or take action or function as sites for visibility (i.e. smartboards) – leverage this power differential. Mapping the movement of power across the classroom involves attending to the way that affect or feelings emerge and are mobilized and blocked (Webb, 2008). Affectivity is associated with students and other agents, but perhaps more importantly, affect is associated with the assemblage itself, traversing its writhing tangled lines of interaction. It is important to conceive of the agency of the assemblage in terms that do not simply reduce it to a static structure imposing fixity on the active agents within it. The power of the assemblage is not merely negative as a constraint or passive as an enabler. The assemblage is a fluid, folding agent as well. Coole (2013) argues for a revisioning of agency in terms of 'agentic capacities' by which one might escape from the discrete individualism assumed in most approaches to the study of classroom inter-action. Coole describes a spectrum of agentic capacities housed sometimes in persons but sometimes in physiological processes and sometimes in transper-sonal intersubjective processes. Bennett wants to extend these capacities beyond the human realm and into the realm of human/non-human assemblages. The classroom becomes a swarm of intensities: 'The task becomes to identify the contours of the swarm and the kind of relations that obtain between its bits' (Bennett, 2010, p. 32).

The classroom assemblage grows like a rhizome, in that it twists, loops and ruptures. Sprouting and fleeing and looping back, the assemblage is a 'veritable becoming ... not an imitation at all but a capture of code, surplus value of code, an increase in valence, a veritable becoming, a becoming-wasp of the orchid, and a becoming-orchid of the wasp' (Deleuze and Guattari, 1987, p. 10). It is through these twists and ruptures, these lines of flight and capture, that rhyzo-matic assemblages stretch outside of code in some material way. New kinds of agents become part of the loops, and the rhizome itself incorporates these new agents. Although the looping back is often the result of control and/or oppressive forces, a rhizome involves sites of 'asignifying rupture' which work against the 'oversignifying breaks' that segment and separate and cut across the structure (Deleuze and Guattari, 1987, p. 9). A differentiated line suddenly splits off and erupts into another potential for differentiation, disrupting the patterns

of growth that may have become entrenched. As Braidotti (2006) suggests, Deleuze is challenging us to think past linguistic mediation and identity, towards a 'non-unitary, radically materialist and dynamic structure of subjectivity' (p. 2). The rhizome becomes more and more appropriate as a way to think the socius and the subject, as each and together are a multiplicity without unity or essence. Indeed, the classroom as rhizome helps us think about the event-structure of classroom interaction. To study the classroom as rhizomatic assemblage is to study the moments of rupture, to identify and follow the lines of flight and differentiation: 'Always follow the rhizome by rupture; lengthen, prolong, and relay the line of flight; make it vary, until you have produced the most abstract and tortuous of lines of n dimensions and broken directions' (Deleuze and Guattari, 1987, p. 11). It is precisely this proliferation of rupture and capture – this acentric and non-linear growth – that allows a rhizome to thrive. We are always in the midst or the milieu of a rhizome, always located at one of the many middles that constitute a rhizome.

The challenge is to imagine how a diagram might evoke the classroom as '*some* couchgrass or *some* of a rhizome' (Deleuze and Guattari, 1987, p. 9). How can we diagram lines of flight erupting, differentiating, proliferating, and being brought back into the fold? How might such a diagram be plugged into the classroom so as to become part of a creative moment when a rupture in a seam is allowed to flourish, rather than function as a static copy that imposes a closed reading? The problem with modelling classroom interaction using the rhizome is that the rhizome, by definition, 'is not amenable to any structural or generative model. It is a stranger to any idea of genetic axis or deep structure' (Deleuze and Guattari, 1987, p. 12). Although Deleuze and Guattari ask that we abandon the search for deep structure and genetic axis, they are, I believe, deeply committed to a manner of diagramming which experiments with rhizomatic assemblages. They offer up the rhizome less as a tracing of the social (since a tracing, they argue, encapsulates the tree logic of representation) and more as a map. A map, unlike a tracing, 'is entirely oriented toward an experimentation with the real' (p. 12). The map does not represent the territory – the map constructs the territory. The map is itself part of the rhizome. A map, like the rhizome, has multiple entry points and can be opened up for additional connections in all of its dimensions. In this sense, mapping subjectivity across the classroom would be less about identifying stages in a genetic axis or positions in a deep structure, or about *representation* of interaction, but would involve following the affects and percepts in their twisting, braiding and knotting emergence. Along these lines, we could create a rhizomatic 'group map'

for the classroom, by which we might capture or evoke the conflicting processes of dispersal and massification. We might draw the lines that survive the folding back of state-sanctioned curricula, and map their potential growth into new dimensions that rupture the map itself, as these lines continue to proliferate, 'if only underground, continuing to make a rhizome in the shadows' (Deleuze and Guattari, 1987, p. 14). This group map might function as the abstract machine or diagram of the classroom, not a reductive encoding of classroom interaction, but an engine itself for creative imagining, an ontogenetic device. A diagram of this sort will break with the Scopic regime of Euclidean space and the absolute measure of Newtonian space, and in so doing rupture the managerial technocraticism at work in current diagramming practices. In the next section I explore a non-Euclidean approach to space that opens up such possibilities.

The topological turn

Informally referred to as 'rubber sheet geometry', topology is concerned with bending, stretching, twisting, or compressing elastic objects (Stahl, 2005; O'Shea, 2007; Richeson, 2008).[2] Originally known as *analysis situs* (analysis of place), topology emerged formally in the eighteenth century when Euler discovered and proved his polyhedral formula relating the number of faces, edges and vertices.[3] The significance of this event is huge, as it marks an entirely new way of looking at geometric objects. Despite thousands of years of studying the metric relationships of polyhedra, no one had studied the non-metric relationships of connectedness.[4] Through the work of Gauss, Klein, Riemann, and Poincaré, topology became the qualitative study of surfaces, manifolds, boundary relationships, and curvature. In *Geometry and the Imagination* (1952), Hilbert and Cohn Vossen claimed that 'in topology we are concerned with geometrical facts that do not even involve concepts of straight line or plane but only the continuous connectedness between points of a figure'. As Smith (2006) explains, topology was initially a problematic science in that it operated according to a concept of invariance that clearly belied Euclidean distinctions

[2] Topology is the study of those properties of geometric objects that remain unchanged under bi-uniform and bi-continuous transformations (Debnath, 2010).

[3] $V - E + F = 2$. The term 'topology' was introduced by Listing.

[4] We know that Leibniz was already familiar with the formula, and historians speculate that Descartes was aware of a similar one (Richeson, 2008). Although Euler's solution to the bridges of Königsberg problem (1736) comes prior to his letter to Goldbach about polyhedra, the significance of the latter is noted here due to the way it breaks with prior mathematical treatments of polyhedra.

between geometric figures. If distortion is allowed, and indeed encouraged, the circle is then equivalent to the square and the rectangle, and any other closed polygon. Smith (2006) suggests that this demanded an extension of 'geometric "intuitions" far beyond the limits of empirical or sensible perception (à la Kant)' and then quotes Deleuze and Guattari on the impact of topology, 'the limits of sensible or even spatial representation (striated space) are indeed surpassed, but less in the direction of a symbolic power of abstraction [i.e. theorematics] than toward a trans-spatial imagination, or a trans-intuition (continuity)' (Deleuze and Guattari 1987, p. 554; Smith, 2006, p. 151).

The ideas of topology were used extensively by Deleuze and Guattari (1987) to explore the nature and relationship between smooth and striated space. In particular, the work of Bernhardt Riemann on manifolds plays an important role in their theorizing the political structuring of the socius. In a topology of manifolds,[5] geometries are merely special cases emergent in localized environments, and variable curvature of a surface might allow for multiple and contradictory geometries on the same surface. The manifold, like the smooth space of Deleuze, is constituted by assemblages of local tactile spaces and sustained through the relations between them. In Riemannian mathematics, space is thus in some important sense primary and not derivative from a set of points. Deleuze and Guattari (1987) draw on the philosopher of mathematics Albert Lautman to interpret Riemannian topology in terms of how it presents the concept of smooth and striated space:

> Riemann spaces are devoid of any kind of homogeneity. Each is characterized by the form of the expression that defines the square of the distance between two infinitely proximate points … it follows that two neighbouring observers in a Riemann space can locate the points in their immediate vicinity but cannot locate their spaces in relation to each other without a new convention. Each vicinity is therefore like a shred of Euclidean space, *but the linkage between one vicinity and the next is not defined and can be effected in an infinite number of ways. Riemann space at its most general thus presents itself as an amorphous collection of pieces that are juxtaposed but not attached to each other…* In short, if we follow Lautman's fine description, Riemannian space is pure patchwork.
>
> p. 485

In other words, Riemann's contribution has to do with his offering a new intrinsic metric for studying the changing curvature of a surface, rather than studying its curvature in relation to an external space in which it was embedded.

[5] See Riemann's papers at http://www.maths.tcd.ie/pub/HistMath/People/Riemann/Papers.html

O'Shea (2007) describes this contribution in terms of a new way of thinking about space that dislocates it from geometry and opens up the possibility of multiple geometries. He also explains in detail how Riemann created a way of talking about curvature that had escaped Gauss (his teacher) by studying the *changing* area of a triangle on the given surface as one moves its three points together. It was the introduction of this movement of the three points that allowed for a *differential* measure of curvature. If the angles in a triangle add to 180° on a 'flat' surface, they either add to more or less than 180° on negatively or positively curved surfaces (as in the cases of triangles on spheres or tori). Curvature is characterized by the speed of an object moving along a curve on it, a speed that might differ from point to point. Riemann offers a calculus for studying the curvature of a surface without reference to the metric of an enveloping space around it. As Durie (2006) puts it, the main advance of topology 'consisted in the proposal that a surface can be conceived as a space in itself, rather than being embedded within a higher-dimensional space (in classical geometry, a surface is studied on the basis that it is a figure lying within three-dimensional space)' (p. 177). Thus surfaces are granted a sort of immanent ontology instead of being decoded by some transcendent reference scheme. Surfaces become spaces in themselves, rather than being embedded in space. Plotnitsky (2006) describes the difference between geometry and topology in terms of measurement, suggesting that 'Geometry (geometry) has to do with measurement, while topology disregards measurement and scale, and deals only with the structure of space qua space, and with the essential features of shapes' (p. 191). One can say, as Durie does, that topology is the study of local relationships, in that it is concerned with the proximity or connectedness of points and regions and to what extent this proximity or connectedness is maintained under particular kinds of transformations. Connectivity in a surface is characterized in terms of the closed curves on the surface and whether these curves are able to collapse into points when shrunk (or whether a hole in the surface keeps them from doing so). Plotnitsky (2006) points out that curvature is determined internally, 'rather than in relation to an ambient space, Euclidean or not' (p. 200). This allows us to study spatial relationships in terms of the particular localized ontology that applies.

The significance of this shift from geometry to topology is that it disallows a global striating of space, as Plotnitsky suggests, and offers us a way to resist an imperialist geometry that defines the conditions of all experience. Perhaps topology allows us to study difference less as judgement (from outside) and more as distinctive relations. Building on Plotnitsky (2006), I suggest here that

topological thinking about the classroom might produce smooth spaces that resist striation altogether (p. 201). Through topological thinking, one might begin to imagine folding, unfolding and refolding into a new Baroque-inflected nomadic interaction. Or if this seems too optimistic, one could at least leverage topological thinking to study how space and spatial practices become striated and controlled, since it allows us to closely examine the contours of energy flow. This latter situation seems more likely, if less utopian.

In pursuing a 'topo-philosophy' (Plotnitsky 2006, p. 190) that attends to the interlacing of the smooth and striated, my aim here is to experiment with alternative diagramming practices. For instance, one might put to work the concept of 'essential singularities' from differential equations, the field in which the mathematician Poincaré was working when he realized the potential links to topology (O'Shea, 2007). The mathematical concept of singularity names a disruption or break or extreme divergent behaviour in a family of curves. One can imagine these singularities erupting in a classroom, when something unexpected occurs and begins to act almost like an attractor, shaping the flow of energy and affect in the room. Poincaré studied the behaviour of composite functions around singularities and found four essential singularities each having solution curves that displayed distinctive visual features. Figure 5.2 shows distinct singularities for a given dynamic system.

The first kind of singularity is the *node*, a point through which an infinity of solution curves pass. The second is the *col* or *saddle point*, neither a maximum nor a minimum. Two solution curves pass through the saddle point and operate as asymptotes, constraining all the other solutions. The third kind is the *foyer*, a point towards which solution curves spiral, as though along logarithmic slides. The fourth kind is the *centre*, a point around which concentric closed solution curves gravitate without penetrating. Delanda (2006) refers to these as the long-term tendencies in a dynamic system, or the states that the system may adopt in the long run. We can imagine the flow of affect and power across the dynamic classroom assemblage in terms of these essential singularities and their structuring of behaviour. An essential singularity might be simply something the teacher said, something that radically restructured the collective movement of affect. Or it might be the arrival of an unexpected guest who moves through the room in new unscripted ways. Educational researchers could look at classrooms for the singularities or catalysts that structure activity, and map the flows along the contours, tracking the way the energy concatenates or erupts in a line of flight. These dynamic tendencies might help us grasp the complex ways in which power and affect weave across the space of interaction.

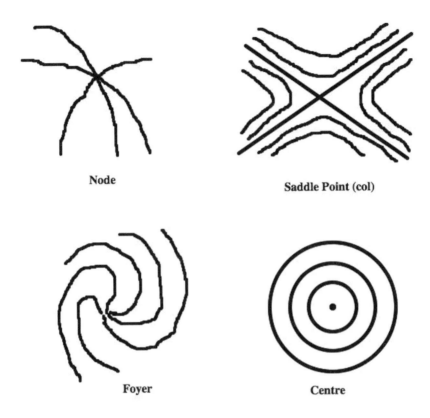

Node

Saddle Point (col)

Foyer

Centre

Figure 5.2: Figure found in Duffy (2006, p. 139)

The beauty of these diagrams lies in part in their vagueness and their conjuring of mobility, as well as their openness to variation and their emphasis on proximity (between curves) rather than measure. Instead of deploying Euclidean models and diagrams that seem confined to rigid transformations or linearity, these diagrams offer us a way to break with the old metric and its mis-measure of relationality. Deleuze (1990) develops the concept of sense (as both sensation and meaning) through reference to these diagrams, and in particular Lautman's reading of these. For Deleuze, these diagrams allow us to theorize a field of singularities that condition the possibility of sense making. The solution curves proliferate and undulate and constitute a surface around singularities of a given equation, where the equation functions as an originating problematic. The problematic – rather than the axiomatic – is the source of this field: 'For example, in the theory of differential equations, the existence and distribution of singularities are relative to a problematic field defined by the

equation as such' (p. 54). It is the singularities – rather than the equations – that most interest him, for they seem to preside or structure the behaviour of the possible solutions. Deleuze states, 'The problematic is both an objective category of knowledge and a perfectly objective kind of being' (p. 54). The problematic is not simply a feeling of uncertainty, but the empirical engine of becoming.[6] Here Deleuze wants us to move away from the psychological and recast our encountering of the problematic in terms of 'pre-personal singularities'. He states this in no uncertain terms: 'We seek to determine an impersonal and pre-individual transcendental field, which does not resemble the corresponding empirical fields, and which nevertheless is not confused with an undifferentiated depth' (p. 102). If we borrow this approach to study classrooms, we need to be sure that our diagrams are not used to capture the individual in terms of will or identity, but rather to follow the turning points or actions as part of a field of indeterminate singularities.

Plotnitsky (2012) offers the term 'non-Euclidean mathematics' to capture the kind of mathematics that confronts its epistemological limits and the heterogeneity of its practices. Thus he uses the term non-Euclidean broadly to designate particular trends in the history of mathematics, not simply to describe topological thinking, and suggests that 'reciprocal traffic' between literature, art, science and mathematics has seen corresponding developments in other domains, suggesting in fact that the non-Euclidean 'problematic' comes to mathematics from other fields, in particular philosophy and poetry. He focuses on events in the history of mathematics where the existence of a mathematical object 'beyond the reach of a given mathematical theory' shook the foundations of the field, as occurred with the 'discovery' of incommensurables, complex numbers and Gödel's theorems. For instance, 'in confronting the question of the diagonal and the side of the square, Pythagorean arithmetic encountered an epistemological limit of the non-Euclidean type, which it could not handle' (p. 412). This development was the 'Gödel theorem' of Ancient Greek mathematics in that it radically disrupted the particular mathematical practices of the time. In some sense these are events in the history of mathematics that involve the construction of the unthinkable, and hence there are the usual antagonistic responses towards them. Perhaps the most disturbing thing is that these unruly objects emerge from within mathematics by 'the surprising capacity of mathematics to discover the irrational and to do so rationally, by means of a

6 See Smith (2006) for excellent descriptions of Deleuze's recounting of the history of mathematics in terms of axiomatics and problematics.

rigorous procedure established within and by mathematics itself' (p. 417). Here we see how the boundary between sense and non-sense or the rational and the irrational is bound up with the given limits of visualization and conceptualization in mathematics at any given time in history. I am focusing less on the logic entailed in these historical moments, and more on the power of diagrams and new forms of visualization to make something visible and thus sensible (in both nuances).

The development of topological knot diagramming in the nineteenth century is an excellent example of an inventive practice that would 'smash the classical relationship between letter and image' (Châtelet, 2000, p. 184). Knot theory began to flourish when physicists speculated that each atom in the enveloping ether was a contorted knot. In the nineteenth century, the term *ether* referred to an elastic quasi-rigid inert medium purportedly filling up universal space. Each fundamental atom was considered a unique knot in the ether. Scientists using these diagrams recognized how they were not simple illustrations in that they broke the rules of the Cartesian plane.[7] Mathematicians – unlike sailors – were less interested in how tension made a knotted rope taut, and more interested in the distinctness of knots, and so they joined the ends of the rope after tying the knot, essentially capturing the knot in a closed curve. Such contained knots could then be studied, compared and sorted. Mathematical knot diagrams are elastic and deformable. The apparent crossings in the knots in Figures 5.3–5.6 create a multi-dimensional effect, suggesting a layering precisely where Cartesian geometry would have imposed an intersection. The trefoil knot (Figure 5.3) is a prime knot with a crossing number of 3. The knot in Figure 5.4 remains equivalent to the trefoil knot, even though its three leaves have been twisted. One can obtain the trefoil from the knot in Figure 5.4 by simply unfolding these twists, and contracting the elastic rope. Note that neither knots 5.3 nor 5.4 can be deformed into the circle (Figure 5.5) which is termed the 'unknot' and has crossing number 0. And yet the seemingly complex knot in Figure 5.6 can be shown to be equivalent to the unknot after a series of simple unravelling moves.

As a kind of diagram, the knot has no interior or exterior. It is all line, or all outside. Thus the knot behaves rhizomatically in pursuing its proliferating lines of flight – we are always in the milieu of the knot, along its paths and expanding or contracting loops, and never positioned at a fixed point, or at a beginning or

[7] Theories of knots and knot diagramming continued to evolve in the twentieth century. The concept of ether, however, was abandoned.

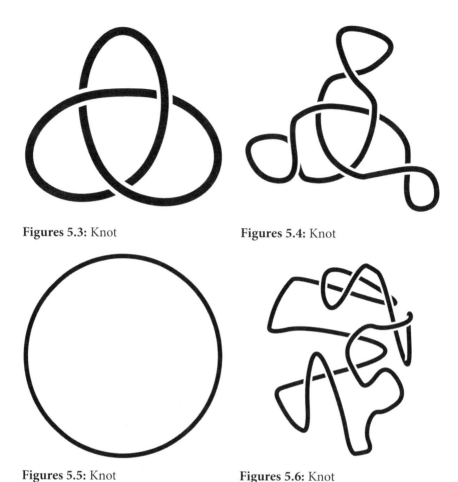

Figures 5.3: Knot **Figures 5.4:** Knot

Figures 5.5: Knot **Figures 5.6:** Knot

end. The knot is like a rhizomatic assemblage, which is, as Deleuze and Guattari (1987) claim, 'precisely this increase in the dimensions of a multiplicity that necessarily changes in nature as it expands its connections. There are no points or positions in a rhizome, such as those found in a structure, tree or root. There are only lines' (p. 8). A knot follows a one-dimensional path through three-space (or greater dimensional spaces), connecting elements in all these different planes. 'It is necessary to imagine foldings, invaginations, exquisitely complex situations that generalize the practice and the idea of the knot to all imaginable dimensions' (Serres, 2008, p. 78). Cutting is the only way to introduce new knotted segments into a knot diagram. Through a cut, one is able to create new lines of flight, new crossings and folds, ruptures and new segments. Cuts or 'lines of flight' or positive nomadic paths of (de)territorialization mark the

emergence of a singularity within the system. The knotted assemblage is always growing, cutting and chasing the proliferations of lines, while also assembling or joining with other knots. At any site of rupture, two knots can be joined to form compositions or more complex assemblages.[8] Knot diagrams can be stretched and deformed until they barely resemble the original diagram. They break with flatness because of their over and under crossings.

Figures 5.7 and 5.8 are knot diagrams of classroom interaction, focusing on how teachers and students alike are in the milieu of the knot, where various forces tighten and twist the rope. The knot possesses no definitive orientation, exemplifying instead an always provisional disorientation. Affect and power stretch across the knot assemblage, mapping the segmentation of interaction while also following the emergent ruptures. If affect circulates across the psychic network of the classroom assemblage, dispersing intensity on body and other surface, we need to imagine interaction in terms of apersonal and non-individuated agency, as though energy were flowing across the surface or through the rhizomatic assemblages of linked singularities (Massumi, 2002). In Figure 5.7, the classroom interaction is highly controlled, without line of flight or rupture. The labels point to the actions of different kinds of agents (teacher, policy, tests) and various forms of folding whereby compliance and resistance occur. The knot consists of two components, each with directionality (arrows) whereby the flow is forced along the line.

In contrast, Figure 5.8 is composed of one component with ruptures. At the far right the knot is highly symmetric, which might capture cooperation or coercion, depending on how one values symmetry. The diagram was created by joining three distinct knots, one with ten crossings (far right), five crossings (middle) and three crossings (left). Joining the knots meant reducing the number of crossings by one in each case, and then distorting the portion that remained in order to introduce new crossings. Since this knot diagram is not a closed curve, it can easily unravel. As a diagram of classroom interaction, it captures the delicate nature of interaction and points to the tensions between order or symmetry (managed behaviour) and more divergent thinking or actions.

[8] In forming assemblages, a small piece of the rope is removed from each knot, and the ends are tied to the other's ends. Other kinds of assemblages called 'links' can be formed using multiple closed knots that become entwined without joining. Knots that involve two or more entwined components (two twisted closed lines in space), can be studied and contrasted by examining the nature of the crossings in each component. Distinct components are identified and studied when each knot is given an orientation (pick a direction to travel around each of the closed curves), and then each crossing that involves both components is labelled as either under or over.

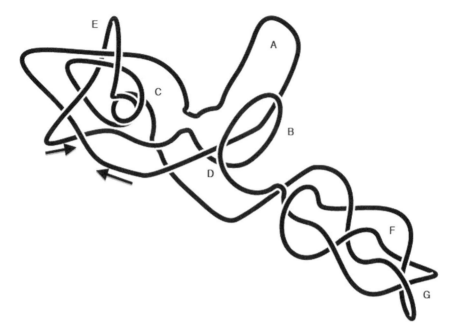

Figure 5.7: Knot

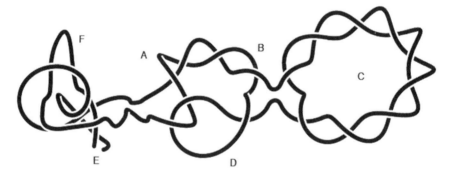

Figure 5.8: Knot

These diagrams and their legends are offered as experiments rather than signifying codes. Granted, I am tapping into knot theory as a source of inspiration, but I am using these diagrams as a 'countersignifying semiotic' rather than a model or system that blocks lines of flight through axiomatization.[9] The diagrams are meant to disrupt or even 'blow apart' the codes of interpretation

[9] It is important to note that I am breaking with the rules of formal mathematical knot diagramming by allowing ruptures and lost threads to remain untied.

that dominate our field (Deleuze and Guattari, 1987, p. 136).[10] My hope is that these diagrams might trigger both a critique of our current practices and an exploration into new strategies for studying interaction. The diagrammatic, as an abstract machine, constructs a real yet to come, 'a new type of reality' (p. 142). This new reality breaks apart the linear models of positivist social science research, and shows us how to advance educational inquiry so that the complexities of classroom interaction might be better studied.

Directions for further research

This chapter calls attention to the unexamined role of diagrams in educational research and offers examples of alternative diagramming practices based on topological thinking. I have argued that we need to interrogate our diagramming practices because they reveal various kinds of ideological investment. I have suggested that topological thinking and non-Euclidean mathematics – as defined by Plotnitsky – might help us study the complex entanglements of classrooms and direct us to how we might resist the rigid measure of technocratic managerialism. I have offered knot diagrams as one kind of topological diagram that breaks with traditional diagramming habits, thereby troubling all that they entail. Knot diagrams point to the elastic and multi-dimensional nature of relations in classrooms. Moreover, materialist approaches to the classroom point to the mingling of human and non-human facets of classroom relationality, and demand, as Barad (2007) suggests, a topological analysis, where 'questions of size and shape (geometrical concerns) must be supplemented by, and re-evaluated in terms of, questions of boundary, connectivity, interiority, and exteriority (topological concerns)' (p. 244). Topological thinking moves us towards a disoriented sense of space, attending to that which is localized and incommensurable with other maps. The breaks or cuts in the knot diagrams are the productive problematic sites of rupture where the diagram plugs into the classroom or other assemblage, where the map veers up and grasps the 'real', and refuses to become an image or representation of interaction. The singularities of the knot diagram are precisely where signification is refused, where the diagram punches through the surface

[10] Of course, even an attempt at an asignifying diagram 'harbors knots of coincidence' that seem to be 'waiting' for code (Deleuze and Guattari, 1987, p. 138).

of meaning, breaks with flatness, and dethrones its own capacity to depict or refer, opening up instead a space of becoming.

References

Barad, K. (2007) *Meeting the Universe Halfway: Quantum Physics and the Entanglement of Matter and Meaning*. Durham, NC: Duke University Press.

Bennett, J. (2010) *Vibrant Matter: A Political Ecology of Things*. Durham, NC: Duke University Press.

Bezerra, R. F., Sullaiman, J., and Stevenson, J. (1998) 'Formulating Hypotheses Graphically in Social Science', *Quality and Quantity*, 32: 327–53.

Braidotti, R. (2006) 'Affirming the Affirmative: On Nomadic Affectivity', *Rhizomes* 11/12. Available at http://www.rhizomes.net/issue11/braidotti.html (accessed 17 November 2012).

Buchanan, I. (1997) 'The Problem of the Body in Deleuze and Guattari, or, What can a Body Do?', *Body and Society* 3 (3): 73–91.

Châtelet, G. (2000) *Les enjeux du mobile*. Paris: Seuil (English translation by R. Shore and M. Zagha (2000) *Figuring Space: Philosophy, Mathematics and Physics*. Dordrecht: Kluwer).

Coole, D. (2013) Agentic capacities and capacious historical materialism: Thinking with new materialisms in the political sciences. *Millennium – Journal of International Studies*, 41, 451. Available at http://www.yumpu.com/en/document/view/18580070/agentic-capacities-and-capacious-historical-materialism-thinking- (accessed December 2013).

Coole, D. and Frost, S. (eds) (2010) *New Materialisms: Ontology, Agency and Politics*. Durham, NC: Duke University Press.

Debnath, L. (2010) 'A Brief Historical Introduction to Euler's Formula for Polyhedra, Topology, Graph Theory and Networks', *International Journal of Mathematical Education in Science and Technology*, 41 (6): 769–85.

Delanda, M. (2006) *A New Philosophy of Society: Assemblage Theory and Social Complexity*. New York: Continuum Press.

Deleuze, G. (1990) *The Logic of Sense*, trans. M. Lester. New York: Columbia University Press.

—(2002) *Francis Bacon: The Logic of Sensation*, trans. Daniel W. Smith. Minneapolis: University of Minnesota Press.

Deleuze, G. and Guattari, F. (1987) *A Thousand Plateaus: Capitalism and Schizophrenia*, trans. Brian Massumi. Minneapolis: University of Minnesota Press.

Duffy, S. (2006) 'The mathematics of Deleuze's differential logic and metaphysics', in S. Duffy (ed.), *Virtual Mathematics: The Logic of Difference*, pp. 118–44.

Durie, R. (2006) 'Problems in the Relation between Maths and Philosophy', in S. Duffy

(ed.), *Virtual Mathematics: The Logic of Difference*. Bolton, UK: Clinamen Press, pp. 169–86.

Frichot, H. (2005) 'Stealing into Gilles Deleuze's Baroque House', in I. Buchanan and G. Lambert (eds), *Deleuze and Space*. Toronto: University of Toronto Press, pp. 61–79.

Hilbert, D. & Cohn-Vossen, S. (1952/1983/1990) *Geometry and the Imagination*, 2nd Edition. Trans. P. Nemenyi. New York: Chelsea Publishing Company.

Latour, B. (1990) 'Drawing Things Together', in M. Lynch and S. Woolgar (eds), *Representation in Scientific Practice*. Cambridge, MA: MIT Press, pp. 19–68.

Lynch, M. (1991) 'Pictures of Nothing? Visual Construals in Social Theory', *Sociological Theory*, 9 (1): 1–21.

Massumi, B. (ed.) (2002) A Shock to Thought: Expression after Deleuze and Guattari. New York: Routledge.

Mazzei, L. A. (2010) 'Thinking Data *with* Deleuze', *International Journal of Qualitative Studies in Education,* 23 (5): 511–523.

Moxley, R. (1983) 'Educational Diagrams', *Instructional Science* 12 (2): 147–60.

Nathan, M. J. & Knuth, E .J. (2003). 'A Study of Whole Classroom Mathematical Discourse and Teacher Change'. *Cognition and instruction*, 21 (2): 175–207.

O'Shea, D. (2007) *The Poincaré Conjecture: In Search of the Shape of the Universe*. New York: Walter and Company.

Plotnitsky, A. (2006) 'Manifolds: On the Concept of Space in Riemann and Deleuze', in S. Duffy (ed.), *Virtual Mathematics: The Logic of Difference*. Bolton, UK: Clinamen Press, pp. 187–208.

—(2012) 'Adventures of the Diagonal: Non-Euclidean Mathematics and Narrative', in A. Doxiadis and B. Mazur (eds), *Circles Disturbed: The Interplay of Mathematics and Narrative*. Princeton, NJ: Princeton University Press, pp.407–46.

Richeson, D. S. (2008) *Euler's Gem: The Polyhedron Formula and the Birth of Topology*. Princeton, NJ: Princeton University Press.

Serres, M. (2008) *The Five Senses: A Philosophy of Mingled Bodies*, trans. Margaret Sankey and Peter Cowley. London: Continuum.

Smith, D. W. (2006) 'Axiomatics and Problematics as Two Modes of Formalization: Deleuze's Epistemology of Mathematics', in S. Duffy (ed.) *Virtual Mathematics: The Logic of Difference*. Bolton, UK: Clinamen Press, pp. 145–68.

Stahl, S. (2005) *Introduction to Topology and Geometry*. Hoboken, NJ: Wiley-Interscience.

St Pierre, E. A. (2004) 'Deleuzian Concepts for Education: The Subject Undone', *Educational Philosophy and Theory*, 36 (3): 283–96.

Webb, T. (2008) 'Remapping Power in Educational Micropolitics', *Critical Studies in Education*, 49 (2): 127–42.

Education Needs to Get a Grip on Life[1]

Jason J. Wallin

A people to come. Is such a thought even fathomable in institutional education, that for its general reactivity towards life has produced the extreme blinkering of expression at varying scales from kindergarten to the university? Suffice it to say that education has *always* been a matter of producing people, yet certainly not of that nomadic and experimental quality Deleuze and Guattari (1987) connect to the creation of a war-machine or 'outside thought' transversally poised to break with the *doxa* of an age. The dream of technical efficiency grounding the early curriculum work of Taylor (1911), the ideal of Fordian utilitarianism in Bobbitt (1924) and the valorization of progress and instrumentalism in Tyler (1949) suggest the image of a people, yet a very *specific* image adapted to the homogeneity of factory routine, the generalized reproduction of class distinctions and the reification of *the given*. In a vision of schooling as prescient today as at the turn of the twentieth century, Cubberly (1916) extolls that 'our schools are, in a sense, factories in which raw materials (children) are to be shaped and fashioned into products to the meet the various demands of life' (p. 338). While the image of the factory that dominated early curriculum thought is slowly being deterritorialized upon the 'flexible' ideals of neo-liberal corpo-ratism, what remains intact is the school's figuration in the production of social life-forms. The school not only anticipates the kind of people it will produce, but enjoins such production to an *a priori* image of life to which students are interminably submitted. Despite the general wearing out and criticism of such forms of educational organization, the fabulation nevertheless 'retains its place and hangs on like an ailing patient' (Guattari, 2009, p. 173). Such American educational policy-programmes as *No Child Left Behind, America 2000* and,

[1] The title of this chapter is borrowed directly from Guattari's (2009) provocation that 'Psychoanalysis needs to get a Grip on Life'.

more recently, the Obama administration's *Race to the Top* repeat an image of ends-means production and conformism that were the *telos* of curriculum's pre-war metanarratives, palpating the renewal of standardization and its deleterious effects upon the material actualization of difference in classrooms today.

The Molar Institution: Schools are not made for children: Children ought to be made for schools

Aoki (1993) refers to the closed and self-referential educational territory of standardization as the *planned curriculum*. For all intents and purposes, the *planned curriculum* functions as an image of thought for coding, albeit inexactly, the desiring-flows of the classroom towards homogeneous and regulated outcomes. In this vein, the planned curriculum functions as a mechanism of negation and opposition, reactively constraining the flows of the classroom according to injunctions of what it *ought to do*. Such injunctions, Aoki argues, are abstractly mapped, yet materially lived via such curricular order words as 'goals', 'aims' and 'objectives' (Aoki, 2005, pp. 202–3). Constituting an image of the 'possible' for the material life of the classroom, the *planned curriculum* arrays desiring-flows within highly blinkered forms of institutional expression and production, palpating both the dependency of the subject upon the institution's mechanisms of representation, problem-solving and, ultimately, the standardization and infantalization of desire under bureaucratic controls. It is unfathomable, Guattari (2009) argues, that life in schools could be thought of in a manner *wholly independent* of such abstract forms of reference. As the strategic reduction of teacher agency and systematic institution of universalizing standards irrespective of local difference demonstrate, the very question of how the school works is bound to the problem of an image of thought that for its contraction of classroom life to *prior* circuits of desire is definitively *real*. 'What are the … possibilities for intervention' Guattari asks, 'what degree of freedom do teachers, mental health workers, and social workers really possess?' (p. 45).

Guattari's question remains germane to the contemporary conceptualization of the school and the image of universalization that informs upon it as the *planned curriculum*. What is at stake in such a scenario but the very possibility that education might become a matter of both producing and following singularities, or, rather, of palpating the 'freedom of individual and collective creation away from … conformism?' (Guattari, 2009, p. 203). Amid innumerable problems facing the future of education is perhaps the most

destructive 'squeeze on … the singular' being promulgated by the increasing instumentalization of schooling and its submission of institutional life to the dominant values and systems of perception lauded by both the State and the private sector (Massumi, 2002, p. 21). It is on this point that the annihilation of the singular[2] constitutes a *key political problematic* for educational thought in so far as it negates the potential for thinking a people *out-of-sync* with the *people in general*. As it pertains to the historical relation between schooling and social engineering, this annihilation functions to buttress the educational ideal of an adapted '*public*' and *prior* 'territorialities of use' through which thought and action are brought into regulatory collusion (Guattari, 2009, p. 48). Today, the effects of such abstract ideations persist. On 9 October 2012, the *New York Times* reported a growing trend among physicians to prescribe such psycho-stimulants as Adderall to students experiencing academic and/or behavioural difficulties at school (Schwarz, 2012). Assenting to the supposed inalterability of contemporary schooling and its general failure to recognize the lives of those that undergo it, what option remains, the proponents of medicalization suggest, but pharmacological intervention aimed at the regulation of neuronal activity *as it suits the demands of the institution*. Among a litany of issues inhering such pharmacological 'mediation' is a key premise implicated in the obliteration of the singular: *Schools are not made for children: children ought to be made for schools*. This is hardly a new sentiment, remarkable only in so far as it signals the continual assault on difference at intensifying scales of control.

The people are missing in education

As a social machine through which 'labour power and the socius as a whole is manufactured', schooling figures in the production of social territories that already anticipate a certain *kind* of people (Guattari, 2009, p. 47). And what *kind* of people does orthodox schooling seek to produce but a 'molar public', or, rather, a public regulated in the abstract image of segmentary social categories (age, gender, ethnicity, class, rank, achievement) (Deleuze and Guattari, 1987)? Such an aspiration is intimately wed to the territorializing powers of the State,

[2] The notion of singularity plied in the course of this chapter is a means to think the unique being or, rather, the individuation of pedagogical life. It is, in this way, a means of thinking about education subtracted from the common notion of the singular *as a universal*. As it is employed throughout this chapter, the notion of singularity by contrast pertains to the immanent differences or *sensitive points* inhering institutional life and through which the institution might be thought about anew.

for as Deleuze and Guattari argue (1983), State power *first* requires a 'representational subject' as both an abstract and unconscious model in relation to which one is *taught* to desire. As Massumi (2002) writes, 'the subject is made to be in conformity with the systems that produces it, such that the subject reproduces the system' (p. 6). Where education has historically functioned to regulate institutional life according to such segmentary molar codes, its modes of production have taken as their teleological goal the production of a 'majoritarian people', or, more accurately, a people circuited to their representational self-similarity according to State thought. This is, in part, the threat that Aoki (2005) identifies in the *planned curriculum* and its projection of an abstract essentialism upon a diversity of concrete educational assemblages (*a* school, *a* class, *a* curriculum, etc.). Apropos Deleuze, Aoki argues that the standardization of education has effectively reduced difference to a matter of difference *in degree*. That is, in reference to the stratifying power of the *planned curriculum,* Aoki avers that difference is always-already linked to an abstract image to which pedagogy *ought to aspire* and in conformity to which its operations become recognizable as 'education' *per se*. Against political action then, orthodox educational thought conceptualizes social life alongside the 'categories of the Negative', eschewing difference for conformity, flows for unities, mobile arrangements for totalizing systems (Foucault, 1983, p. xiii).

Twisting Deleuze, might we claim that *the people are missing* in education? That is, where education aspires to invest desire in the production of a 'majoritarian' or 'molar' public, the prospect of thinking singularities are stayed, not only through the paucity of enunciatory forms and images available for thinking education *in the first place*, but further, through the organization of the school's enunciatory machines into vehicles of representation that repeat in molarizing forms of self-reflection, 'majoritarian' perspective, and dominant circuits of desiring-investment. Herein, the impulse of standardization obliterates alternative subject formations and the modes of counter-signifying enunciation that might palpate them. Repelling the singular, the 'majoritarian' and standardizing impulse of education takes as its 'fundamental' mode of production the reification of *common sense*, or, rather, the territorialization of thought according to *that which is given* (that which everyone already knows). Figuring in a mode 'of identification that brings diversity in general to bear upon the form of the Same', *common sense* functions to stabilize patterns of social production by tethering them to molar orders of meaning and dominant regimes of social signification (Deleuze, 1990, p. 78). As Daignault argues, in so far as it repels the anomalous by reterritorializing it within prior systems of representation, *common sense*

constitutes a significant and lingering problem in contemporary education (Hwu, 2004). Its function, Daignault alludes apropos Serres, is oriented to the annihilation of difference. Hence, where the conceptualization of *'public'* *education* is founded in *common sense*, potentials for political action through tactics of proliferation, disjunction, and singularization are radically delimited and captured within prior territorialities of use (Foucault, 1983, p. xiii). The problem of this scenario is clear: *common sense* has yet to force us to think in a manner capable of subtracting desire from majoritarian thought in lieu of alternative forms of organization and experimental expression. In so far as it functions as a vehicle of 'molarization', reifying a common universe of reference for enunciation, the school fails to produce conditions for thinking in a manner that is not already anticipated by such referential 'possibilities'. Hence, while antithetical to the espoused purpose of schooling, the majoritarian impulse of the school has yet to produce conditions for thinking – at least in the Deleuzian (2000) sense whereupon thought proceeds from a necessary violence to those habits of repetition with which thought becomes contracted.

The teachers are missing

The general challenge that *a people are missing* in education might be extended to teachers, whose desiring-production has become equally regulated by the demands of both the State and private sector. As Deleuze (2004) queries, *who are our teachers today?* On the question of what constitutes a teacher, Deleuze is upfront: Our teachers are those capable of inventing new techniques of thought and action correspondent to contemporary difficulties and enthusiasms, of palpating an original thought in the style of an 'unheard music', of summoning new themes and polemics for the permanent revolution of categorical orders (p. 77). Deleuze suggests Sartre as an epitome of such revolutionary pedagogy. During the Liberation, Deleuze writes, 'who except Sartre knew how to say anything new? Who taught us how to think?' (p. 77). And on the question of how he taught, Deleuze connects Sartre's pedagogy to the event. The performance of *The Flies,* the publication of *Being and Nothingness,* and *Existentialism and Humanism* become, Deleuze argues, inventive conductors for new ways of thinking and responding – a new nervous system capable of affecting and being affected differently.

Throughout their oeuvre, Deleuze and Guattari extend this revolutionary diagram of the teacher to the singular styles of Bene, Joyce, Kafka, Klee, Mallarmé

and Nietzsche, among others. While each produces something unique, as when Nietzsche introduces a new style of philosophical thought with the aphorism, they share a fuzzy resonance with Deleuze's image of the pedagogue as one who represents nothing, or, rather, becomes unhinged from the *doxa* of their time (Deleuze, 2004). In each of their specific ways, the thinkers Deleuze links to revolutionary pedagogical action *speak in their own name – in a style that productively breaks circuits of habit and response* – hence engendering new forms of experience and dilated potentials for social production. Of course, there are teachers, yet increasingly they succeed in the character of the *public professor*, or, rather, an order of teacher whose desiring-production has become finely adapted to the orthodoxies and conferrals of the State, or, rather, of a 'majoritarian thought' oriented to the reification of prior territorialities (Deleuze, 2004). In so far as the *public professor* acquiesces to forms of common sense and the reified categories of the State, however, it might be said that *he fails to teach*. Put differently, where the *public professor* labours to trace prior territories of thought, to denude the world qua representation, or reify the 'heroic' conceit that the world *is as it is given*, he fails to instantiate conditions necessary for the relaunch of thought alongside original difficulties and enthusiasms out-of-step with the *given*. What is it that supplements teaching in this instance but the consecration of a habitual gesture in which the world is continually made to conform to an image that *everyone already knows* – an encyclopedic image of thought that has effectively produced a generation *without teachers* – at least of that kind extolled by and having inspired Deleuze (2004). Where education has become a 'majoritarian' social machine oriented to the delimitation of experimentation and expression, we might once again rejoin that the *people are missing*.

Death-State

That education has become recalcitrant to the emergence of the singular implicates a series of social problems whose effects might be known by other means. Parallel to the increasing overdetermination of school curricula qua standardization, the auditing of measurable outcomes by external 'experts', and emerging modes of control linking tenure to 'official' markers of productivity, forms of institutional illness have intensified. In 2009, the Office for National Statistics (ONS) in Britain reported an 80 per cent increase in rates of teacher suicide, 40 per cent higher than the national average. Preliminary studies into this marked

increase implicate the pressures of standardization and its effective production of a 'Death-State' in modern schooling (Holland, 2011). As Holland (2011) elides, the 'Death-State' functions by demanding the submission of life under State-thought such that the State itself might be sustained as a model for social life and civility. However much implicated in the production of institutional violence and crushing neurosis, labour in the name of the State has become a 'positive' condition for teachers' investment in and fidelity to the 'majoritarian' life of the 'good citizen' education presupposes as its 'ideal' effect. Today, this manipulative ethos proliferates through the strategic scapegoating of teachers, who are blamed for myriad social issues produced by the very State apparatus they are demanded to submit their desiring-production to *sustain*. Herein, potential modes of expression that speak in their own name (singularities) have been made to perform in the name of the State, and more specifically, in correspondence with institutional order words that have frozen circuits of thought and production within the fetishized concepts of implementation and outcomes relative to an image of *the* curriculum where there might otherwise be several, or as Aoki (2005) argues, 'as many as there are teachers and students' (p. 426).

The destructive effects of standardization are, of course, not limited to teachers alone. Within a single generation, adolescent suicide rates have increased significantly. In South Korea for example, youth suicides have increased by a staggering 500 per cent. While not conclusive, such increased rates of suicide have been indirectly linked to stultifying levels of expectation and pressure for academic performance and institutional conformity (McDonald, 2011). South Korea is not alone in its speculative connection of youth suicide to the increasing standardization of life. Throughout North America, Japan, Europe and China connections between standardization, depression and suicide have become increasingly commonplace, pointing to an epidemic of psychological violence born from mechanisms of homogeneity and conformism. Here, we might rejoin Holland's (2011) conceptualization of the Death-State and the conditions of submission it requires of the 'good citizen'. That is, a founding premise of the school as a social machine within the Death-State pertains to its production of coerced allegiances to State-thought. Herein, the 'Death-State' produces a repressive scenario in which the majoritarian citizen's sense of 'belonging, commitment and engagement' extends from the State as a master-allegiance (p. 62). In this cul-de-sac of representation, it is presupposed that State or majoritarian thought constitutes the *only* legitimate means of investing desire institutionally, hence producing the 'reality' of State ideals in the material life of the school. In this dire scenario, desire is continually made to desire its own repression (Guattari, 2009).

The molecular institution: Supple lines

While it would be erroneous to ignore the segmentary organization of life in schools and the material effects it produces in those that undergo it, it would be equally remiss to suggest that the analysis of education pertains to segmentation or molarity alone. As Deleuze and Guattari's schizoanalytic method suggests, the analysis of life by dint of segmentation is only one, albeit important, mode for thinking the challenge of a *missing people in education*. In *A Thousand Plateaus* (1987), Deleuze and Guattari's schizoanalysis is diagrammatically thought along *three* lines. Where segmentary (molar) lines work as sedimentary powers, constraining life in arboreal reference to the *given*, what Deleuze and Guattari dub a *supple segmentarity* functions to dismantle, albeit minimally, the rigidifying effects of the molar. This supple line, Deleuze and Guattari (1987) contend, bores a subterranean passage through 'concretions of rigid segmentarity' (p. 205). Importantly, the supple line does not come *after* segmentation, but rather 'is there from the beginning' (p. 205). This is to say that both majoritarian thought and the representation of life as an exclusively molar phenomenon is always suffused by lines of disorientation that break from the calculable segment. The supple line continually wards off the threat of centrality that is both the arboreal image of the curriculum-as-plan and the powers of standardization that are its effect. Aoki (2005) dubs this supple line the *lived curriculum*, hence rethinking pedagogy in terms of its differentiation from a calcified image of *currere*: that bureaucratic *course teachers and students 'ought' to run*. As any first-year teacher well knows, things rarely go according to (the curriculum as) plan. This realization is a failure only in so far as the planned curriculum, that image of what students and teachers *ought* to do, becomes the only means of investing desire within the institution. Rather, that things fail to go according to plan might mark the affirmation of a supple line that differentiates from the molar segment. Put differently, the supple line becomes a way to begin thinking about the composition of *a people* whose production is not simply reflected in the planned curriculum but whose desire cuts across the molar line of standardization and conformism in an act of albeit minimal deterritorialization.

Rock n' roll curriculum

Amidst the cliché images of teaching and learning that populate mainstream Hollywood cinema is a focus on supple lines of deterritorialization and their fabulation of *a people* not reflected by molar *generalities.* Where teaching ostensibly goes right in such films is when it falls out-of-step with the imperial model it is 'supposed' to reflect. Among other things, Richard Linklater's (2003) oft-celebrated *School of Rock* affirms the composition of a singular life subtracted from standardization and orthodoxy. Through the incorporation of new enunciatory forms, 'imposter' teacher Dewey Finn (Jack Black) palpates a supple line that escapes the overdetermined life of his surrogate class, who occupy a heavily territorialized stratum highly coded by systems of institutional reward and conformism. Producing a conductor for the rebellion of his students through rock n' roll, Finn palpates a molecular desire for difference, or, minimally, the expression of 'authentic' desires out-of-sync with those 'official' circuits of production given institutionally. While *School of Rock* is not without its issues, its affirmation of original modes of pedagogical enunciation and subjectifying processes participate in the active fabulation of *a people* who no longer belong to the school proper, but fall out of representation and in doing so fulminate a singularity that critiques the institution from within. That is, *School of Rock* asks the important question of *what a school might do,* or, rather, *how education might go once detached from the image of how it ought to go.* Albeit minimally, *School of Rock* asks not what a school *ought* to produce, but rather, what it *might* become capable of producing.

School of Rock is by no mean exemplary in terms of its filmic innovation or experimentalism. However, its counter-actualization of pedagogical life born from the material reterritorialization of standardized-production poses a compelling challenge to the presumption that the *people are missing in education.* That is, *School of Rock* suggests the emergence of *a* singularity (*a* class, *a* curriculum) through the evocation of molecular impulses *always-already* unequal to molar powers of conformism and regulation. Perhaps this is a moot point. As classroom teachers know well, there persists, beneath the regulated gestures and routines of institutional life, a *thousand tiny lives* continually exerting their pressure and influence against the molar presumption of how pedagogy *ought* to go. Such '*lives*' are not solely human, and of course, pertain as much to local events, obfuscated curricular directions, and untimely classroom encounters as much as they do the unconscious desiring forces of

institutional group-subjects. To rejoin Guattari and Rolnik (2008), however, the question of how such molecular forces of resistance and difference might become enfolded with institutional life remains to be seen and overwhelmingly, orthodox education continues to exert by way of its organization and official circuits of desiring-production the overcoding of molecular impulses. As A. S. Neill (1992) criticized, the founding precept of schooling suggests that life should submit to the demands of the school rather than thinking the school as conductor for the singularization of *a* life – an *indefinite* life whose image is not yet anticipated in the image of *the people* with which it is presumed to conform.

Against drowning

To what should education aspire but the detection of a supple line capable of differentiating education from the abstract-machine of *education in general*? This is, in part, Deleuze's (1994) challenge to pedagogy as exemplified in his oft-cited example of swimming instruction. As Deleuze argues, it is only when the student learning to swim is able to differentiate between their lessons in *general* and their necessary counter-actualization in relation to new problems that they might *truly* become capable of swimming. Put differently, it is wholly insufficient that a student learning to swim simply reproduce those 'molar' or 'official' gestures taught to them poolside. Rather, the student must become capable of palpating a supple line capable of deterritorializing the general gesture in relation to the heterogeneous conditions in which one enters as a swimmer. For example, having sensed the pull of a rip current, it becomes utterly inadequate for the swimmer to represent the gestures taught to them poolside. One must not simply *represent*, but become prepared to deterritorialize with infinite speed such that the institution's official gestures can be modulated in connection with and production of new problems. Failure to produce a line of deterritorialization specific to Deleuze's pedagogical challenge is surely to court drowning.

This danger is no less for the student whose desiring-production is captured in the reflection of the institution's official gestures, and by dint of such self-resemblance becomes habituated against experimentation and risk. In this institutional circuit, a reactive block is erected against the emergence of molecular flows, producing an implicit dependence of the student upon those transcendent forms, bureaucratic guides, and superegoic bosses poised to *think on their behalf*. As Guattari and Rolnik (2008) develop, this is a prescient danger of the State apparatus through which everything is made to pass 'in a

relation of dependence that produces an infantilized subjectivity' not simply by controlling 'grids of behaviour and social activity' but through 'the modelization of unconscious activity' (pp. 208–9). Today, students have learnt this lesson *all too well*. While ostensibly counter-intuitive, student despondency, ambivalence and inactivity might illustrate the 'success' of an institutional machine predicated on delimiting the *ways a life might go*, blocking flows of difference until the virtual is all but suffocated (p. 76). Herein, the pedagogical ethic that '*life has a chance*' or rather, '*that group-desiring-production matters to life in schools*' is placed under significant threat. On this point, however, we might rejoin Deleuze's contention that the 'official' gestures of the institution must *necessarily* differ from themselves in relation to new challenges and problems. *They must be resingularized.*

Resingularizing institutional life

It is crucial to rejoin that the supple line is ambivalent (Deleuze and Guattari, 1987). It strays from the orthodox rigidity of its territory, but, of course, we do not yet know how it will reterritorialize. As a case study, we might point to Guattari and Oury's experimentation with the material organization of the clinic at La Borde and its singular intervention with the hierarchical and sedimented roles inherent to its pedagogy. In a manner not dissimilar to problems facing contemporary education, Guattari and Oury's analysis of the La Borde clinic detected the worsening of patients' psychological health and in certain instances the emergence of new neurosis and symptoms. What Guattari's work within the psychiatric institution would reveal is that such emerging illnesses were an effect of the institution itself. Within the traditional psychiatric setting, Guattari observed, patients '[lost] their characteristics, becoming deaf and blind to all social communication' (Guattari, 2009, p. 177). In response, Guattari would begin to articulate the ways in which the institution had failed to treat the patients and further, the ways in which it had effected the production and acceleration of patient neuroses. Guattari would point to several contributing factors for this failure, including the reification of vertical power relations (arboreal hierarchies), the bureaucratic segmentation of institutional life into 'specialist' roles, and the alienation of patients from institutional processes. Via the 'segregation of inmates … locked rooms, severely limited freedoms, [and] intense surveillance', the institution would become less oriented to treatment than its absolute obstruction (Genosko, 2002, p. 68).

Guattari and Oury's material experimentation at La Borde would commence a supple line by straying from the rigid model of the clinic without courting its complete disintegration or its reterritorialization upon some new fascism or rigid segmentarity. Against either annihilation or re-Oedipalization, Guattari and Oury's experiment would be commenced along a line of cautious destratification. In this mode, *La Borde's* reconfiguration would occur through such institutional strategies as the introduction of a rolling work rotation schedule in which clinical personnel (medical and non-medical) and patients would comprise heterogeneous groups to perform clinical duties. Dubbed *la grille* (the grid), this work rotation schedule would produce non-representational group-subject cartographies counterposed to both the hierarchical stratification of 'specialist functions' and presupposed institutional identities. A group tasked with the facilitation of clinical workshops might later function to organize art and theatrical activities (Dosse, 2011). Some patients assisted in dispensing medications, while hitherto 'untouchable' medical staff performed custodial duties. Other modulations in the clinical setting saw the establishment of a patient's club where non-medical personnel, clinical staff and patients could mix (Dosse, 2011). In turn, new potentials for group-desiring-production and enunciation were created by linking the mixed space of the patient's club to the clinic's newspaper, *La Borde Éclair*. Through the tactical mixing of segmented and supple lines, *La Borde* fulminated an experiment in assessing the permeability of space through which patients, doctors and other clinical staff became productively delinked from their bureaucratic ensconcement within the clinic's organization.

The 'mini-revolution' at La Borde would inhere broader stakes for education. 'One can only dream of what life could become in … schools … if instead of conceiving them in a mode of empty repetition, one tried to redirect their purpose in the sense of permanent, internal re-creation' (Guattari, 2009, p. 182). Here, Guattari advocates an image of schooling composed via the mixing of molar and supple segments, or, rather, the continual modulation of institutional life in support of its 'permanent reinvention' (p. 182). Such reinvention is intimately concerned with *a people*, or, rather, the ways in which the molecular revolution of institutional space and pedagogy might fulminate new processes for producing *subjectivities*. This is not simply a *magical idea*. At La Borde, the modulation of institutional space, labour and desiring-production aimed to desiment 'practico-inert' forms of group relations co-extensive of institutional seriality, or, rather, the overdetermination of both subjective and collective life-forms (p. 180). What form of anterior activism would be required

to ward off the 'serialization' of life, Guattari insisted, but the resingularization of the institution, its modes of labour, and desiring-machines? Through the mixing of supple (molecular) and molar lines, *La Borde* became an experiment in producing new universes of reference, or, rather, new conductors for the creation of subjectivities not given in advance. In this vein, the desedimentation of organizational hierarchy, 'expert' roles and clinical space would palpate a *becoming* necessary to recommence institutional analysis *from within*.

Nomads in the institution

Guattari and Oury's experiments at *La Borde* might be thought of as a material practice in the creation of *smooth space* and, concomitantly, the production of new processes for the creation of *a* people out-of-step with an abstract image of *the* people *in general*. Herein, *La Borde's* internal revolution detects two trajectories *unthought* by standardized education. First, *La Borde's* internal revolution is not *solely* material. Rather, as 'the grid' demonstrates, *La Borde's* experiment is concomitantly one that pertains to the modulation of the *abstract-machine* immanent to the social field of the institution itself. More specifically, the mini-revolution at *La Borde* is *first* an intervention with the *abstract-machine*[3] of institutional relations and their affects upon material life therein. Where the *abstract-machine* functions as 'the cause of the concrete assemblages that execute its relations', the creation of a new image of thought informs upon the very tissue of the assemblages produced (Deleuze, 1999, p. 37). In this vein, the material reconfiguration of *La Borde's* social organization and its creation of new potentials for group-subject formation is productively linked to the work rotation schedule (*la grille*) as a horizontal or minimally rhizomatic image of thought. This trajectory of intervention suggests that political action, or, rather, the potential to palpate forms of life and styles of living not accounted for within dominant regimes of signification, necessitates the tactical counter-actualization of abstract institutional diagrammatics. Crucially, what the case of *La Borde* demonstrates is not only that the material organization of the institution is immanently suffused by the image of thought contracted with it, but, further, that modulations of this institutional image are capable of dilating how *material* life might organize within institutional spaces. Such interventions, by

[3] Here, I am taking the abstract machine as an abstract representational map of institutional relations, connections, and potentials for exchange.

Guattari's own admission, are immensely difficult, and the threat of reterritorializing the institution's *abstract-machines* within fascist formations remains a problem for which one must always be on the lookout. As Guattari articulated, La Borde would continually face the challenge of overly territorial staff, the over-identification of doctors with the medical hierarchy, and the continual threat that original group-subject formations would become subjected under external metrics of organization (Guattari, 2009).

This leads to a second trajectory implicate to *La Borde's* revolutionary micropolitics. While the Labordian revolution intervenes with an image of thought that suffuses the material relations and subjectifying processes of institutional life, the radicality of *La Borde's* experimentation emerges by dint of its connection to the virtual. This is simply to say that the revolutionary impulse of the Labordian experiment is commenced on a line of escape from the abstract as a *transcendent ideal*. Herein, *La Borde's* mini-revolution owes more to the detection of the actual-virtual quality of life, and further, a speculative relaunch of '*as if*' or, rather, incompossible worlds *out-of-synch* with the transcendent idealization of the world *as given* (Deleuze, 2003). The problem of standardization, Guattari and Rolnik (2008) implies, is its covering-over of such incompossible or '*as if*' worlds as to suggest only one way for the organization of life to be thought. Counter-actualizing the illusion of the universal, *La Borde's* experiment rethinks the abstract-machine or institutional image of thought alongside a virtual or 'as if' world concerned with the resingularization of the institution in a manner no longer linked to vertical striation, subjective alienation, or the overdetermination of patient enunciation by the psychiatrist as the *subject-supposed-to-know*.

In the exceptional *Teachers in Nomadic Spaces* (2003), Roy argues on the necessity of thinking the school as a qualitative multiplicity or mixed composition in which supple lines of deviation are continually active as 'potential' conductors for institutional reinvention. Where this virtual ecology is severed, Roy articulates, teachers and students encounter a kind of institutional 'insanity' marked by a symptomatic adherence to fixed positions and the presumption of personal ownership over scholastic knowledge, skills and attitudes (p. 110). Against such institutional sedimentation, Roy's practical Deleuzism articulates the case of a high school where students design and offer semester-long courses in areas of collective interest and, further, where collective approaches to decision-making take seriously the productive link between student enunciation and the organizational fabric of the institution. Herein, there is resonance between Roy's institutional *nomadism* and Fernand

Oury's[4] 'institutional pedagogy' in so far as each aims to rehabilitate the severed relationship of students from the fabric of the institution by tethering the enunciation of group-subjects to material transformations of institutional life (Guattari, 2000). Through the mixed composition of both molar (territorial) and supple (deterritorializing/reterritorializing) lines, both Roy and Oury would relink institutional pedagogy to its experimental potential to modulate the organization from within, or rather, to detect the always-already 'trembling organization' of the institution (Thanem and Linstead, 2006). Further to this, Roy and Oury would each detect the crucial Deleuzeguattarian (1987) insight that 'practice does not come after the emplacement of the terms and their relations, but actively participates in the drawing of the lines' (p. 203). This insight might in turn be extended to the pedagogical work of Guattari, (Jean) Oury, Freinet and Neill, who each in their singular ways demonstrate that the differentiation of pedagogical thought-practice can palpate new forms of social organization and less harmful processes of subject creation.

The point I would like to make at this juncture is quite straightforward: If education is to dilate its potentials for political action, or, rather, to produce conditions capable of palpating *a* people, it must become able to produce an image of thought through which new forms of material organization might be actualized. To think of the institution as a mixed space composed of both molar and supple lines, where the latter pose opportunities to break pedagogical routines, forms of mimesis and the habitual striation of institutional space, constitutes one such image. In Aoki's (2005) terms, we might otherwise dub this image the *lived curriculum,* where the striated line of the curriculum-as-plan is crosscut by the heterogeneous desiring-production of the teachers, students and others who encounter it. The challenge of pedagogy, Aoki intimates, pertains to the affirmation of the supple line that crosscuts the molar curriculum's presumption of how a life *ought* to go. To rejoin Deleuze and Guattari (1987), where pedagogy falls short of being able to affirm *a* people through the commencement of a supple line of *necessary* deterritorialization and reterritorialization, *a singular people remain missing*. This necessitates rethinking the school from under standardization in such a way as to recommence its 'baroque' character, or rather, its *always-already* mixed composition of lines. Such an

[4] Guattari would encounter Fernand Oury at the age of 15 as a member of the youth hostelling movement (Guattari, 2009). This encounter would spark Guattari's militant activism in so far as the youth hostelling movement would bear upon the production of collective autonomy and group-self-definition apart from superegoic injunction. Comprising a para-scholastic education, the youth hostelling movement shifted the backdrop of pedagogical experience upon a quasi-nomadic heterogeneity born from the experience of collective caravan travel.

approach to pedagogy inheres the genius of Celestin Freinet (Acker, 2007), whose incorporation of a classroom printery as a conductor for the desiring-production of his pupils begins by understanding that enunciation without authority,[5] the connection of pedagogical life to the broader social fabric, and the dehierarchization of classroom labour are integral to the creation of conditions through which *a* people might be composed. As a careful experiment in mixing supple and molar segments, Freinetian pedagogy maintains the role of 'standards', yet renders them immanent to the desiring-production the group, its special interests and auto-articulation through the press as an enunciatory vehicle for connecting the life of the school to broader social forces and realities.[6]

Thinking through the institution: Lines of flight

Only once pedagogy has become a matter of unleashing thought and action from material repetition will it become capable of creating new styles and images of living. To think in this direction, however, institutional education must *get a grip on life*. Where this challenge has historically been redressed by way of submitting life to intensifying mechanisms of control and habituation, or rather, by organizing the supple forces of *zoe* in the representational image of molar individualism (*bios*), it has become complicit in perpetuating a form of ontological violence highly recalcitrant to the fabulation of *a* people out-of-step with the representational *people-making* of the State and the labour requirements of private industry (jagodzinski, 2011). Against this ontological violence, we have begun to think 'institutional pedagogy' as a mixed composition of molar and supple lines, where the latter function as a probe-head for detecting and producing potential alter-institutional formations out-of-step with the *given*. Yet, as Deleuze and Guattari warn, it is not enough to expect that a smooth or destratified space will save us. A supple line might always fall back into new microfascist behaviours.

While a supple line might reterritorialize upon molar tendencies that have outlived their usefulness, Deleuze and Guattari suggest that they might eclipse

[5] Replacing 'official schoolbooks [and classes] with student-produced material', Freinet overturns the education of children and youth as it is imagined by the elite (Acker, 2007, p. 83).

[6] Freinet would incorporate the use of a school journal, or, rather, an enunciatory vehicle for group-subject interest and commentary on issues of local and regional concern. Occurring every other day, the interscholastic exchange of the journal would reach upwards of twenty different schools and social groups (Acker, 2007). Through this transversal exchange, Freinet aimed to adjust the general dissociation of schools and students by opening the potentials for following each other's lives and forming collective movements relative to shared experience and desire.

the 'strange attractor' of the molar line and fulminate a *line of flight* that disappears into the distance. For contemporary education, it is the *line of flight* that constitutes the greatest political challenge in so far as it might become capable of evading the image of an adapted and homogeneous people implicate to the teleology of standardization, producing instead the conditions for a nomadic war-machine capable of fulminating a critique of the State from the position of an *outside thought*. In this vein, it might be said that the *dropout* constitutes one of contemporary education's greatest political problems. Of course, to suggest such a thing warrants caution, for the very image of the *dropout* is one fabulated as a foil to the idealization of a well-adapted and homogeneous institutional subject. Yet, in so far as the dropout deviates from the image towards which institutional life is made to aspire, it *might* function to illustrate tendencies of molecular revolution and, further, the emergence of a people-in-becoming *not yet given institutionally*. Aoki (2005) points to this molecular revolution via a Canada-wide study of dropout rates from university science programmes in the early 1990s. Why had one-third of previously successful students in science dropped out by the third year of their university science-degree programmes, Aoki informs, but for the reason that their education had failed to grasp prescient crises in the discipline and, further, the virtual potential for science to take up new issues and problems particular to the lives of students (pp. 199–200). According to the programme's dropouts, their science education had failed to produce a salient attachment to life, or at least those molecular impulses of difference unequal to the edicts of the 'molar institution'.

For Aoki (2005), the *dropout's line of flight* fulminates two productive disruptions within the territory of institutional education. First, it deterritorializes the ostensibly stable image of the curriculum-as-plan by exceeding the *a priori* epistemic commitments, methodological habits and utilitarian possibilities presupposed by the plan as *given*. Second, the *dropout* resists integration by plotting a line that no longer differs *by degree*, or, rather, in accord with some founding image of 'identity' as its grounding matrix. The *dropout* might, in this sense, be thought of as a figure of disidentification that is already on the move elsewhere, into an 'open landscape of multiplicity' whereupon *a* people might be composed (p. 207). It is in this vein that the *dropout* might no longer be thought of in pejorative terms, but, rather, as a potential expression of *para-academic, outlander and nomadic* forces through which the molar institution might be confronted with what it is incapable of thinking. The 2012 Quebec protests might be thought of as one such expression, where disidentification with the State's insistence that students be quiet and content was counter-actualized

through the assemblage of molecular revolutions being prepared in other social domains and labour sectors. As spokespeople for CLASSE (la Coalition large de l'Association pour une solidarité syndicale étudiante) would suggest, the success of the student strikes against tuition hikes and the repeal of rights to public assembly and freedom of enunciation would occur via the creation of diverse alliances that for their shared molecular struggle against the dogmatic assertions of State power would comprise a war-machine poised to break territories of power through the materialization of an *outside thought* (Deleuze and Guattari, 1986). The attempted silencing of the student protests through the enaction of *emergency laws*, forcible repression by police forces, and mainstream media attacks branding protestors as irrational extremists would fail to suffocate the heterogeneous *antilogos* being prepared via the spatio-geographic *occupation* of public space, the disruption statistical numerability qua the creation of protest collectives, and the production of affective forces *out-of-sync* with the image of an orderly and adapted public demanded by the State.

As with Deleuze and Guattari's (1986) description of *nomad* tactics, Quebec's micropolitical revolution functions to deterritorialize dominant regimes of signification. Such noological violence is aimed at a people given *in advance*, or, rather, a molar public domesticated in the image of the State and private sector. In distinction, CLASSE palpates a new image for thinking via a line of institutional and economic deterritorialization oriented to the actualization of free post-secondary education for *all*. It is hence via the line of flight, or a creative line of escape from the entrapment of institutionally sanctioned desiring-production that *a* life might be recommenced, or, rather, that institutional pedagogy might more fully re-engage with molecular forms of non-integration and refusal suffusing the contemporary social field. This posed, it is crucial to rejoin Guattari's (2009) insight that it is not simply enough to alter the material organization of the school. As such protest group-subjects as CLASSE illustrate, society *itself* must be revolutionized. It is in this manner that the *dropout* might be repoliticized in terms of its ability to constitute a molecular war-machine that extends beyond the albeit crucial internal revolution of such social institutions as the school. Born from a process of deterritorialization, the *dropout* produces a constitutive line that begins to remap both social terrain and the territories of person-construction inscribed in such mechanisms as educational standardization. The *dropout* is both a process of disidentification and a means to place institutional life in immediate relation with its outside (Deleuze and Guattari, 1986). Herein, the *dropout* might be thought of as a minoritarian figure vague (vagabond) enough to escape molar essences while *fringe* enough

to elude over-identification with a *given* people. It is in this way that the *dropout* is always born on a constitutive line reterritorializing elsewhere – producing or inhabiting smooth ecologies with their own potentials for resingularization, revolutionary instants and experimental surges (Deleuze and Guattari, 1994).

The *dropout's* constitutive line of flight palpates a way in which we might 'think leaving' as an affirmative escape (Arsic, 2005). Contemporarily, such lines of escape are subject to intensifying powers of capture. While labouring under the alibi of 'best pedagogical practice', for example, the advancement of 'no fail' policies in many North American schools masks the contraction of the institutional subject to flows of State funding. Hence, where the *dropout* consti-tutes a potential break in the institution's economic circuit, its threat becomes subjected to policy that effectively prevents 'thinking leaving'. Such a trend might be extended in relation to the lauded educational rhetoric of *life-long learning,* which insists upon processes of *permanent retraining*, *re-accreditation* and permanent registration that effectively tether the desiring-production of the 'educated' subject to forms of institutional regulation and segmentary management. Such regulation of 'pedagogical life' in service of both the State and the private sector are amplified via the production of infinite debt, which produces an intractable barrier to the composition of a politicized nomadism (Holland, 2011). Increasingly, our ability to think *outside* the institution is ostensibly diminishing.

The capture of smooth or otherwise, non-coded social space constitutes a significant problem in so far as education might take seriously the ethico-political challenge that *life has a chance* or, rather, that the *desiring-production of unique group-subjects* can shape the institution and broader social fabric. Again, these are not simply *magic words*. One might detect in the pedagogical thinking of Freinet, Neill, Oury, Guattari and others the *necessity* of *dropping out* in order that new space of alliance and association might be produced. For such educators as Neill (1992), escaping the violence of the modern school (the school-as-barracks) would necessitate the production of a war-machine oriented to the productive destruction of a hierarchical and militarized noology endemic to institutional thought. In brief, Neill's *Summerhill School* is not simply *another* school within the *boutique* milieu of neo-liberal 'edu-consum-erism'. More radically, *Summerhill* is a *dropout school*, or, rather, a school born through a process of productive disidentification with the *school in general*. It is, in many ways, a school different in *kind*. It is the 'outside thought' or resingularization of the standardized school intent on the production of condi-tions (co-operative council, non-mandatory classes, heterogeneous student

groupings) for the creation of new group-subject formations. On this intent, Neill infamously provoked: 'I would rather see a happy street-sweeper than a neurotic Prime Minister' (p. 10). Not without irony, *Summerhill's* future would be threatened in the late 1990s, when Tony Blair's New Labour Government sought to reterritorialize *Summerhill's* singularity back upon the State's model of educational efficiency and production, hence reinscribing it along the presumed necessity of the State as a transcendent supervisory and regulatory power. Against this, *Summerhill* was able to evade capture through the resistance of its 'heterogeneous' advocates, who championed the necessity of its difference in a culture overcoded by party bosses, organizational hierarchies and the clichés of orthodox educational thought.

Four truths

A people-yet-to-come. Where the molar institution presumes an image of how life *ought to go,* this is to neglect the schizoanalytic force of differentiating lines suffusing the social field. The stakes of this analytic neglect are inherently ontological in so far as they pertain to either the diversity or paucity of group-subject and organizational formations *thinkable* in education. In a more straightforward sense, to think in terms of standardization alone is to neglect the ethico-political force of education as the task of palpating *a* people no longer drawn upon a line plummeting towards 'collective murderous and suicidal madness, whose indices and symptoms are amply visible in current events' (Guattari, 2009, p. 199). Anticipated in the very presumption of standardized education and its homogenization of desire, such *a priori* human ends require revolutionary reorientation. Herein, the ability for institutional pedagogy to both detect and affirm molecular (supple) lines of difference are integral to its potential to transform the very conditions that inform upon the creation of *a* people. Of course, this is no easy task. Supple lines risk reterritorializing upon new microfascisms. Lines of flight can accelerate into lines of annihilation. Perhaps the greatest political task of institutional pedagogy pertains to the evasion of these 'botched' scenarios through an approach that retains the *right* to singularity, 'to freedom of individual and collective creation away from technocratic conformism, postmodernist arrogance, and the levelling of subjectivity in the wake of new technologies' (p. 203). This necessitates both the creation of new images for thought and the expansion of experimental practices capable of producing new styles of living and conditions for heterogeneous

group-subject alliances. To begin, however, the *right* to singularity first requires a certain sobriety regarding the mutilating and disastrous powers of stand-ardization and, further, a realization that 'standardization' is only one way that a pedagogical life might be thought about.

We do not yet know how a life might go. Borrowing from Guattari (2009), we would like to conclude by proposing a series of *truths* for institutional education oriented to freeing life from its hyper-repressive 'moulding of every individual and the imposing of a particular lifestyle' (p. 238). Against this, Guattari advocates four levels of associated intervention. The first of these pertains to the necessity of transforming '"heavy" facilities' (p. 199). For education, such a transformation entails the affirmation of molecular tendencies for change, or, rather, the always-already mixed composition of pedagogical life. Such a commitment is oriented to the continual reinvention of the school from *within* as a tactic of warding off molarizing forces and, further, of rethinking the school apace with those molecular revolutions occurring or being prepared in other social spaces. Herein, the commitment to transforming the heavy facility of the school concomitantly necessitates that teacher-educators, teachers and students fight for changes in the material and ethical conditions of the school. Second, Guattari proposes that institutions strengthen their commitment to alternative forms of experimentation (p. 199). This is to rejoin the significance of Freinet, Oury, Neill and others, for whom the school is not simply a model to be traced but more radically a 'problem' unequal to its *prior* solutions. This is simply to say that those habits of method, gestural routines and blinkered forms of desiring-production that characterize the molar institution are *not-all*, and that through the invention of new images and styles of practice, new social life-forms *might* be actualized. Third, Guattari argues that the transformation of the institution necessitates the 'mobilization of a wide range of social partnerships' pertaining to themes of social change and the modulation of how social formations *might* be composed (p. 199). The challenge that *education gets a grip on life* might be rejoined here, in so far as the disalientation of institutional life requires the intensification of relays between the school and broader social fabric. What is crucial here is Guattari's implicit emphasis on 'shared themes' of transformation and change between the school and its social partners such that a line of deterritorialization might be produced between them. This does not entail the dissolution of the school, but rather its assemblage with non-institutional social relays and initiatives capable of modulating *why* and *how* pedagogy might 'happen'. Finally, Guattari suggests that the transformation of institutional structures requires new modes

for analysing the individual and collective unconscious. It is with the three lines articulated in this chapter, the molar, the supple and the line of flight that such an analysis might be recommenced. That is, the three lines that suffuse this chapter are *more than descriptive*. They are vehicles for experimenting with the abstract and material formations of institutional life once it is subtracted from *standardization*. In place of unity or rather a people given in advance, this chapter advances a schizoid or mixed diagram continually tending towards particular becomings *out-of-synch* with the *people in general*. It is here that new conditions for thinking and practice might break from standardized educations' disastrous obliteration of the singular that has effectively produced a *missing people* in contemporary education.

References

Acker, V. (2007) *The French Educator Célestin Freinet (1896–1966): An Inquiry into How his Ideas Shaped Education*. Plymouth: Lexington Books.

Aoki, T. (2005) *Curriculum in a New Key: The Collected works of Ted T. Aoki*, ed. W. F. Pinar and R. L. Irwin. Mahwah, NJ: Lawrence Erlbaum Associates, Publishers.

Arsic, B. (2005) 'Thinking Leaving', in I. Buchanan and G. Lambert (eds), *Deleuze and Space*. Toronto: University of Toronto Press, pp. 126–43.

Bobbitt, F. (1924) *How to Make a Curriculum*. Boston: Houghton Mifflin.

Cubberly, E. (1916/1929) *Public School Administration*. Cambridge, MA: Riverside Press.

Deleuze, G. (1990) *The Logic of Sense*, trans. M. Lester and C. Stivale. New York: Columbia University Press.

—(1994) *Difference and Repetition*, trans. P. Patton. New York: Columbia University Press.

—(1999) *Foucault*. New York: Continuum.

—(2000) *Proust and Signs,* trans. R. Howard. Minneapolis, MN: University of Minnesota Press.

—(2003) *Cinema 2: The Time-image,* trans. H. Tomlinson and B. Habberjam. Minneapolis, MN: University of Minnesota Press.

—(2004). *Desert Islands and Other Texts (1953–1974)*. Cambridge, MA: MIT Press.

Deleuze, G. and Guattari, F. (1983) *Anti-Oedipus: Capitalism and Schizophrenia,* trans. R. Hurley, M. Seem, and H. R. Lane. Minneapolis, MN: University of Minnesota Press.

—(1986) *Nomadology: The War Machine,* trans. B. Massumi. New York: Semiotext(e).

—(1987) *A Thousand Plateaus*, trans. R. Hurley, M. Seem, and H. R. Lane. Minneapolis: University of Minnesota Press.

—(1994) *What is philosophy?* (H. Tomlinson and G. Burchell, Trans.). New York, NY: Columbia University Press.

Dosse, F. (2011) *Gilles Deleuze and Felix Guattari: Intersecting Lives*. New York: Columbia University Press.

Foucault, M. (1983) 'Preface', in G. Deleuze and F. Guattari, *Anti-Oedipus: Capitalism and Schizophrenia*. Minneapolis, MN: University of Minnesota Press.

Guattari, F. (2000) *The Three Ecologies*, trans I. Pindar and P. Patton. London: Athlone Press.

—(2009) *Soft Subversions: Texts and Interviews 1977–1985*. Los Angeles, CA: Semiotext(e).

Guattari, F. and Rolnik, S. (2008) *Molecular Revolution in Brazil*. Los Angeles, CA: Semiotext(e).

Holland, E. (2011) *Nomad Citizenship: Free-market Communism and the Slow-motion General Strike*. Minneapolis, MN: University of Minnesota Press.

Hwu, W. (2004) 'Gilles Deleuze and Jacques Daignault: Understanding Curriculum as Difference and Sense', in W. M. Reynolds and J. A. Webber (eds), *Expanding Curriculum Theory: Dis/positions and Lines of Flight*. Mahwah, NJ: Lawrence Erlbaum Associates, Publishers, pp. 181–202.

jagodzinski, j. (2011) *Visual Art and Education in an Era of Designer Capitalism*. New York: Palgrave Macmillan.

Massumi, B. (2002) *A Shock to Thought: Expression after Deleuze and Guattari*. London: Routledge.

McDonald, M. (2011) 'Elite South Korean University Rattled by Suicides'. Available at http://www.nytimes.com/2011/05/23/world/asia/23southkorea. html?scp=1&sq=youth%20suicide%20south%20korea&st=cse&_r=0 (accessed 22 May 2011).

Neill, A. S. (1992) *Summerhill School: A New View of Childhood*. New York: St Martin's Griffin.

Roy, K. (2003) *Teachers in Nomadic Spaces: Deleuze and Curriculum*. New York: Peter Lang.

Schwarz, A. (2012) 'Attention Disorder or Not, Pills to Help in School'. Available at http://www.nytimes.com/2012/10/09/health/attention-disorder-or-not-children-prescribed-pills-to-help-in-school.html?pagewanted=all&_r=0 (accessed 9 October 2012).

Taylor, F. (1911) *The Principles of Scientific Management*. New York: Harper.

Thanem, T. and Linstead, S. (2006) 'The Trembling Organization: Order, Change and the Philosophy of the Virtual', in M. Fuglsang and B. M. Sorensen (eds), *Deleuze and the Social*. Edinburgh: Edinburgh University Press, pp. 39–57.

Tyler, R. (1949) *Basic Principles of Curriculum and Instruction*. Chicago, IL: University of Chicago Press.

Financial 'Innovation', Financialized Education and Deleuzean Modulation

FinLit and the 'Breeding' of Indebted Subjects and Subjectivities

Matthew Tiessen

Man is no longer man enclosed, but man in debt.

Gilles Deleuze, 1992, p. 6

Let me close by reiterating that education – lifelong education for everyone, from toddlers to workers well advanced in their careers – is indeed an excellent investment for individuals and society as a whole.

B. S. Bernanke, 2007, p. 7

Introduction: FinLit's friends

In the face of the ongoing global credit crisis, the proliferation of national 'austerity' packages, persistent transnational currency speculation and debasement, and the emergence of financially 'innovative' mechanisms of leveraged liquidity creation (e.g. collateralized debt obligations, naked short selling, algorithmically driven high-frequency trading, and more), a set of politically and economically motivated policy documents put forward by the Working Group on Financial Literacy and the Ministry of Education for the Provincial Government of Ontario has recently made the case for 'embedding learning about financial literacy in existing mandatory courses' (Ministry of Education: Working Group on Financial Literacy, 2010, p. 12). Indeed, as I write this chapter in late 2011 the embeddedness of financial literacy (FinLit) in Ontario's elementary and high schools will have begun in earnest since, as of this school year, students from Grades 4 through 12 will, according to govern-mental policymakers, have 'financial literacy expectations and opportunities'

embedded in all school 'subjects' from Grades 4 through 8 and in 'all disciplines' from Grades 9 through 12 (Ministry of Education 2011, p. 3). So while the Ministry admits that some disciplines may be 'more closely linked to the development of skills and knowledge related to financial literacy than others', it must be emphasized that all disciplines across the elementary and high-school curricula 'provide opportunities to make connections to financial literacy to some extent' (p. 3). Subjects and disciplines ready to be embedded with financialized logics include current Ministry staples such as: the arts, business studies, Canadian and world studies, classical studies and international languages, computer studies, English, English as a second language and English literacy development, French as a second language, guidance and career education, health and physical education, interdisciplinary studies, mathematics, Native languages, Native Studies, science, social sciences and humanities, and technological education. Leona Dombrowsky, the Minister of Education, points out that the blanket embedding of financial logics into all educational curricula is 'very important in today's complex financial world' (Government of Ontario, 2010) and that 'Our kids need to know their dollars and cents just as much as their ABCs' (Government of Ontario, 2011). Leeanna Pendergast, co-chair of the Working Group, echoes these points by insisting that the 'seamless integration' of financial literacy into Ontario's schools 'is one of the best investments we can make in our future' (2010). Financial literacy education, if those promoting it are to be believed, is a win–win situation for everyone: students, consumers, taxpayers, capitalists, governments, industry, etc. With the embedding of financial literacy into school curricula, policymakers insist that tomorrow's financially literate students – those capable of distinguishing 'dollars and cents' – will be empowered to become masters of their own financial destiny and will be able to avoid – by knowing 'their dollars and cents' – the epic and cataclysmic financial pitfalls the financial industry itself has routinely – and recently – provided. As FinLit critic Lauren Willis explains, the allure of bringing financial literacy to the classrooms of today's children (at as young an age as possible) is being promoted across the political and corporate-friendly spectrum as a way to 'teach' financial accountability to the financial industry's future captive clients. In so doing, responsibility for financial outcomes – in an increasingly debt-laden and credit-starved economic future – can be shifted away from governments and the private sector to individually financialized subjects. She writes:

> [Financial literacy] is widely believed to turn consumers into active market players, motivated and competent to handle their own credit, insurance,

savings, and investment matters. Financial literacy education is that rare public policy that entices across the political spectrum. Liberals envision an empowered consumer, confidently navigating the marketplace. Conservatives divine a responsible consumer, who understands her decisions and therefore can be held accountable for them. Free-marketers see flourishing innovation and abundant choices.

<div align="right">Willis, 2008, p. 201</div>

FinLit education, then, by perpetuating dominant financial logics obliquely serves to re-instantiate and re-legitimize the political systems that in our era of credit downgrades of governments by rating agencies like Moody's, Fitch and Standard & Poor's or financial attacks by bond vigilantes rely on the support of the financial sector's central planners in order to stay in control and cling to power. In other words, for today's politicians, to be financially 'downgraded' and required to impose 'austerity measures' on 'entitled' populations is to be politically demoted.

To enrich teachers' ability to move ahead with embedding financialized logics into subject areas from art to Native Studies, the Ontario Ministry of Education has published a 2011 instructional guide, *Financial Literacy Scope and Sequence of Expectations*, which offers financial literacy-bolstering 'teacher prompts' that instructors can use across the teaching of all courses and subject areas. Drama teachers, for example, are encouraged to 'financialize' the study of theatre and theatre acting by 'prompting' students with questions such as: 'What have you learned from your drama studies that you can apply to your part-time job, post-secondary study, or potential employment opportunities?' (Ministry of Education, 2011, p. 11); aspiring musicians can expect to be prompted by their teachers with the question: 'What is the salary range for a member of a classical ensemble? How might a professional musician supplement this salary?' (p. 13); and although the Ministry of Education admits that 'none of the expectations in the classical studies and international languages curriculum relate explicitly to financial literacy', financial literacy can and should still be embedded within the curricula by giving special focus to the 'aspects of trade, economics and use of money in ancient times' or by devoting financially pertinent energies to learning 'about the currency used at present in the various countries' (2011, p. 84).

The emergence of 'financial literacy' as a privileged focus of public education policy in Ontario reflects the increasing emphasis across all levels of learning being placed on financially-infused education as a taken-for-granted way of training today's future taxpayers and debtors. This emphasis on financial logics – which include finance-friendly imperatives such as 'life-long learning',

'distance education', and 'self-training' – is not only additive, but also subtractive in so far as elementary, high-school, and university programming deemed less than financially productive are routinely cut from education curricula (consider the cuts to Women's Studies programmes at Ontario's University of Guelph and McMaster University). In Canada, where the average family's debt-to-income ratio recently reached 150 per cent (CBC News, 2011), the financial literacy agenda is promoted by organizations such as: SEDI (Social and Enterprise Development Innovations); the SEDI- and TD Financial-sponsored CCFL (Canadian Centre for Financial Literacy); CFEE (the Canadian Foundation for Economic Education); and the Canadian Federal Government's own Task Force on Financial Literacy. Indeed, significant levels of Federal Government funding is flowing into the financial literacy field. For example, in the wake of the 2007–8 'credit crisis' the Canadian government took 'extraordinary' actions to shore up the economy through a financing programme known as Canada's Economic Action Plan (http://www.actionplan.gc.ca). This plan included, for example, the government – i.e. the public – assuming $125 billion worth of mortgage risk held by Canada's banking sector (Nadeau, 2009). One plank in the Economic Action Plan is to follow the recommendations of the Task Force on Financial Literacy, which suggests creating a role for a federal Financial Literacy Leader; moreover, the 2011 Canadian Budget provides an additional $3 million per year for financial literacy initiatives (Government of Canada, 2011). The role of the new Financial Literacy Leader would, according to the Task Force's recommendations, be 'non-partisan and directly accountable to the Minister of Finance and would have a clear mandate to work collaboratively with various levels of government and other stakeholders to oversee the Strategy, implement the recommendations and champion the message of financial literacy nationwide' (Task Force on Financial Literacy, 2010).

But while the Task Force's recommendations might encourage 'non-partisanship' in a political sense, its recommendations – and those who make them – can, when looked at with a modicum of scepticism, be regarded as significantly less than objective in so far as they come, in large part, from financial industry insiders who represent corporations whose profits, for the most part, are, as *Financial Post* columnist Jonathan Chevreau observed, 'made on the back of financial illiterates' (2011b). As Chevreau observes:

> Do mutual fund firms sincerely want the public to know that exchange-traded funds (ETFs) are cheaper than mutual funds? Do bank issuers of credit cards really want debtors to know that paying only the minimum monthly balance

ultimately leads to the poorhouse? And do life insurance companies want the public to 'rent' cheap term life insurance instead of buying more lucrative whole-life policies that mix insurance with investing?

2011b

Indeed, the members of the Task Force on Financial Literacy read like a who's who of financial bigwigs whose interests are undoubtedly more in line with the bottom line than with those in the employment line. Indeed, one of the Task Force's central FinLit objectives is for Canadian citizens to receive 'just-in-time' life-long learning designed to be there when citizens need it – a concept cribbed from Toyota Motor Company's factory efficiency strategies and since made popular on assembly lines (and now, seemingly, in education programmes) around the world (Task Force, 2010, p. 8). So while these financial literacy initiatives are 'non-partisan' in a conventionally narrow 'political' sense, they reveal through their promotion of finance-industry-friendly logics the string-pulling power of the trans-political puppeteers calling the shots and setting political policy behind the scenes (not to mention the degree to which politics and the world of finance have been able to blur their mutually dependent relationship and their centuries old legacy).

The proof, as we know, is in the pudding, so here is a brief list of some of the most prominent members Canada's FinLit brigade in charge of ushering the youth of today into the increasingly indebted Western world of tomorrow. The Federal Task Force on Financial Literacy is Chaired by Donald A. Stewart, Chief Executive Officer of Sun Life Financial, while the Vice Chair is L. Jacques Ménard, Chairman of BMO Nesbitt Burns. Other members of the Task Force include: Greg Pollock, president of insurance industry advocate Advocis; Ted Gordon, advisor for Freedom 55 Financial; and Laurie Campbell of Credit Canada. The 'non-partisan' and 'independent' financial literacy-promoting organizations are also populated by financial industry luminaries whose interest in educating the public – and today's students – to make astute decisions about monetary matters would seem to fly in the face of their respective corporate – i.e. profit-making – mandates. SEDI's and CCFL's 2011–12 Board of Directors, for example, is populated by individuals representing Deloitte, PricewaterhouseCoopers LLP, Mulholland Consulting, TD Bank Financial Group, and Coast Capital Savings. The CFEE on its website thanks its major sponsors Investors Group, the RBC Foundation, Scotiabank, TD Bank Financial Group, and the Bank of Montreal, while its Board of Directors features representatives from Groupe Montaigne, Atlantic Canada Consulting Associates, Cadet Capital, Skyservice Investments, Highview Financial Group, and Dundee Wealth.

So while FinLit promoters like the CFEE may indeed be, in some sense or other, 'working to enhance the economic and financial capabilities of Canadians' (http://www.cfee.org/en/) their website's 'About' page reveals that CFEE has also 'worked in partnership [...] on various projects' with, for example: the Bank of Montreal, the Canadian Imperial Bank of Commerce, Imperial Oil Limited, INCO, Investors Group, Royal Bank of Canada, Shell Canada, and Suncor. Indeed, the FinLit bandwagon is getting so crowded that companies and corporations not explicitly involved in education are going to some lengths not only to get the word on FinLit out there, but to show that they too are on board and that they too have the best interests of citizens (i.e. their customers) in mind. In 2010 Visa Canada, for example, launched a financial literacy enhancing video game called Financial Soccer (http://www.financial-soccer.ca/). The free online game requires that players 'play' soccer by answering skill-testing financially related questions. Visa Canada had previously launched an in-school financial literacy resource called Choice and Decisions in 2006 and a more consumer-friendly website called Practical Money Skills in 2005 (http://www.practicalmoneyskills.ca/).

Regardless of the superficially virtuous gloss put forward by these education-friendly corporate financiers, their role as leaders of the financial literacy charge can be understood as the imposition by the most dominant of Canada's financial actors of a status quo promoting financial paradigm upon an effectively captive, ignorant and inadequately prepared student body who, of course, will in the future be the fee-, debt- and student loan-paying minions upon which the dominant financial apparatus feeds. As Carleton University professor of public policy Saul Schwartz writes in an email to Chevreau:

> The taskforce [and other examples of 'FinLit'] consists primarily of financial service providers and financial education consultants – not many teachers, people from community-based organizations, or public servants – and their report reads like the soothing words of the foxes, spoken upon taking command of the chicken coop.
>
> quoted in Chevreau, 2011a

Schwartz's opinion is echoed in another email response to Chevreau's blog post, this time by financial industry critic Andrew Teasdale (moneymanagedproperly. com), who suggests that the primary rationale of the 'task force' is to 'facilitate supply of capital to the capital markets' rather than to 'improve the integrity of the information available about the wealth management process, issues and components'; the task force's message, then, works with the assumption that the

status quo – the one that created the ongoing 'credit crisis' – is 'fine', while at the same time avoiding 'issues that might cause investors to doubt the integrity of the capital markets' (quoted in Chevreau, 2011c). Teasdale points out that if real and significant education of the public about the financial system were to occur, the 'truth about the status quo' would likely lead to a short-term 'loss of confidence in the system that underpins the capital markets, which is not what the objective of the task force is about' (2011c). Instead, he regards the project of the Task Force on Financial Literacy as being a financial-industry-driven and politically-facilitated sort of pamphleteering, one that deals financial products through the public education system itself – what he regards as a 'contrived paradigm where we do not question but learn to accept our role and place in the machine'; the financial system, in other words, seeks opportunities for inculcation through education in order to 'teach' investors about 'the products and the processes they will need to adopt in order to efficiently interact with the process that exists' (2011c). This education of consumers and students is wholly inadequate in so far as it is essentially uncritical of dominant power structures and the financial tactics that help perpetuate their control of, among other things, government educational policy. Indeed, the very idea that with a bit of FinLit education today's market-beholden citizens will be able to effectively take advantage of the speculation-driven liquidity engine of the global capital system – a system premised upon massive knowledge and technological asymmetries between, for instance, individual investors and large brokerage houses and hedge funds – is absurd. And yet, as Willis notes, financial literacy education is a policy tool that necessitates that consumers be 'their own regulators in a domain in which even professional regulators have difficulty' (2008, p. 217). The painful truth of this comment is demonstrated not only by the financial industry precipitating today's credit crunch but by the mainstream trope that no one 'saw it coming'.

From this perspective, the financial industry's lead involvement and priority-setting of financial literacy programmes in Ontario should be read as a sort of sinister smokescreen, as a distraction from the real issues (e.g. our economic paradigm's appetite for perpetual economic growth on a notably finite planet; or the fact that Canadian's mutual fund and bank transaction fees are among the highest in the world). By offering financial-industry-friendly 'solutions' (e.g. education about how to use their financial products) to financial-industry problems (e.g. how to expand deposits, and increase fees and sales of financial products in order to maximally leverage investable assets), the industry in effect is able to provide 'How to' manuals designed to construct students as

perfect users of Big Finance's financial tools (i.e. lines of credit, student loans, mortgages, home equity lines of credit, etc.) in order to become not only knowledgeable about how to navigate the industry's own products and services, but also dependent upon that same system by being beholden to its demands (i.e. debt-peonage, credit-score maintenance, perpetual borrowing, and, in the end, indentured servitude). 'FinLit', then, if instantiated in the form preferred by corporate financial actors, would serve to pull the wool over students' eyes by teaching them about best practices within a corporately controlled and financialized economic paradigm constructed by the financiers themselves (and the political apparatus it supports) rather than considering, for instance, alternative modes of economic activity less beholden to the demands of debt-based currency creation and debt-pushing financiers.

The implications of the embedding of financial literacy into the school curriculum has, however, an even more ominous side, one that finds today's student being interpellated as the future cause of his/her inevitable financial mistakes, thereby operating on an affective register able to impart blame and assign guilt. That is, having been 'educated' in school – having been endowed with the financial responsibility that comes with having been bestowed with the system's financial 'knowledge' – the blame for any future financial failings is effectively transferred from the financial system or purveyor of financial products to the over-indebted customer. In other words, financial literacy instruction functions to reorient blameworthiness from those in charge of the financial system (legislators, banks, insurance companies) to the financial system's most vulnerable participants, its users, by pre-emptively setting the parameters for what is (financially) possible. This reattribution of financial failing is, of course, leveraged by the increasingly impenetrable nature of financial products themselves, which are more often than not designed in the first instance to be opaque in order both to facilitate consumer desires and to escape the scrutiny of the apparently financially literate (consider the black-box nature of mortgage-backed securities and collateral debt obligations that precipitated the US housing crisis while preying on the desires of potential home owners to enact the 'American dream'). As Willis observes, since today's financial products are 'so complex and fluid that few can understand them', financial-literacy education is being implemented as 'a necessary detour on the path to moral blameworthiness':

> Given the vagaries of the stock market, a losing investment strategy would be
> difficult to characterize as a direct result of irresponsibility, laziness, greed or
> abject stupidity. But with the education model, the consumer can be blamed for

failing to become sufficiently literate to handle her retirement savings. Financial-literacy education blames the consumer for her own plight, but shifts from an indictment of raw moral character traits to the 'choice' about whether to attend classes and use the information and skills taught (but not necessarily learned).

2008, p. 277

Agnotological education: Manufacturing false financial options

A recently developed concept that can contribute to a pedagogical under-standing of the type of education being offered by FinLit proponents in Ontario, Canada, and beyond goes by the name of 'agnotology'. This concept, I want to suggest, can be applied within this chapter's critical framework as 'agnoto-logical education'. Agnotology is a term coined by Robert Proctor (2008). It is a neologism combining the Classical Greek word, *agnōsis*, 'not knowing', and *logos* and it describes the study of culturally-induced ignorance or doubt, most notably the publication of inaccurate or misleading scientific (or economic) data or information. My suggestion is that we can understand the agnotological machinations of heavily promoted forms of finance-industry-led 'financial literacy' as the power-promoting strategy of a system that by providing more and more knowledge according to the parameters of its own paradigms leaves the public – both adult and student alike – *less* knowledgeable and *more* uncertain than before. More specifically, the ignorance being manufactured by corporately-sponsored FinLit education is an ignorance about the significance of, and alternatives to, privately created credit-money, post-Keynesian economic systems, the potential for money to operate as a public utility, and other heterodox economic strategies that attempt to address the need for governments to reassume their ability to create credit – and collective wealth – in ways that are not beholden to the private-sector banks. In other words, alternatives to the dominant paradigm provided by Canada's finance-based rentier capitalists is being kept in the financial shadows by financial education itself. As Proctor explains it, agnotology is a 'missing term to describe the cultural production of ignorance' (2008, p. 1). (And, I might add, where ignorance fails, the harshest measures of repression begin, as demonstrated by the police crackdown on students protesting against tuition increases and other 'neo-liberal' policies in the province of Quebec). The assumption of any agnotologically driven pedagogical study, of course, would be that ignorance – like knowledge – is something actively produced, taught and shaped as much by the production of

false opinions, false options and false beliefs as by secrecy or the withholding of knowledge. The implication, of course, is that ignorance itself can be manufactured; moreover, secrecies can be as effectively generated by apparent transparency (i.e. the idea that FinLit provides students with an understanding of all available options) and exposure as by concealment. In other words, as Roberts and Armitage (2008) explain, ignorance can sometimes be most effectively manufactured through the concurrent manufacturing of knowledges that pull a veil over the discovery of more truthful alternatives (indeed, the popular assumption that we are living in 'knowledge economies' can itself be described as an agnotological ploy to disguise the 'offshoring' of manufacturing jobs, technical 'know-how', etc.). As Roberts and Armitage explain:

> the knowledge economy is precisely rooted in the production, distribution, and consumption of ignorance and lack of information. What we are suggesting, then, is that the knowledge economy is one wherein the production and use of knowledge also imply the creation and exploitation of ignorance, for not only knowledge but also ignorance now play a main role in the formation of advanced global capitalism.
>
> 2008, p. 345

Or as Proctor quips: 'ignorance is more than a void' (Proctor, 2008, 3).

Like the financial system itself (not to mention derivatives, collateralized debt obligations, securitization, etc.), corporately driven and governmentally mandated and programmed FinLit 'education' fits Proctor's agnotological paradigm in so far as it is *assumed* to be a wealth-generating, socially beneficial necessity, rather than a set of policies that re-inscribes the public as fee-paying debtors beholden to the finance/corporate/governance machine. Indeed, in a financialized world of unrelenting financial innovation, products and services, the overwhelming complexity of financial products themselves functions as a conduit for the imposition of financial literacy education as a necessary (though wholly inadequate) response to what would otherwise be rampant confusion (or stricter consumer-oriented financial regulation). Roberts and Armitage acknowledge this effect when they observe that the more 'specialized the knowledge base of an economy, the more opportunities there are for the exploitation of ignorance for commercial purposes'; in their view the apparent gap that exists in the public's knowledge about the economy is a gap that has been pre-emptively added to serve the ends of the economy itself. That is, the complexity of contemporary financial products necessitates that more and more knowledge be provided to the public in order for them to be able to filter it all.

Ignorance-overload, then, results from info-overload (not to mention info-asymmetry): 'our capacity to manage and comprehend information is not keeping pace with either the growth of information or its management' (2008, p. 347). Ignorance-production concealed as education, illiteracy dressed up as literacy is of course a highly profitable business if one is setting the agenda. Indeed, knowledge-monopolization 'depends on the escalation of ignorance. The expansion of ignorance through the appropriation of knowledge previously freely available is a global phenomenon with major consequences' (2008, p. 348).

One of the more practical bits of financial advice being offered by industry experts, of course, is easy to grasp: buy financial products you understand. But, as already seen, this rule of thumb runs contrary to the wants and needs of the financial industry itself that preys on ignorance to service and expand profits. Indeed, Willis correctly points out that if consumers never bought financial products they understand, they would simply never buy any financial products at all:

> Teaching consumers not to buy any financial product they do not fully under-stand, if taken to heart, would mean some consumers would not buy insurance, invest, or borrow at all; this would not be good financial behavior. Consumers who truly followed a message to buy only what they need would bring our economy to its knees.
>
> 2008, p. 225

Deleuze and 'the whole perverse apparatus of repression and education'

> For the school system: continuous forms of control, and the effect on the school of perpetual training, the corresponding abandonment of all university research, the introduction of the 'corporation' at all levels of schooling.
>
> Gilles Deleuze, 1992, p. 7

> Canadians must make financial literacy a lifelong endeavour, and stakeholders need to create the conditions to support this.
>
> Task Force on Financial Literacy, 2010, p. 85

> Use your Royal Credit Line for everyday expenses, home renovations, investments, to pay off other, higher interest debts and more. In fact, even if you don't need to borrow right now, it may make sense to apply for a Royal Credit Line today.
>
> Royal Bank, 2011

The implications of the implementation of agnotological financial education into today's Canadian education system would not be lost on Deleuze and Guattari, who recognized that the manufacturing of debt-peonage and obedient and financialized subjectivities is the most effective tool for disciplining labour, perpetuating capitalism and maintaining social 'order'. For Deleuze and Guattari, disciplinary shifts towards less rigid and more modulated forms of social coercion were inevitable in a world of increasing financial flux. Indeed, for them the loosening up of the disciplinary yoke was necessary and inevitable in so far as it mirrored the imposition of floating exchange rates following the removal of commodity-based monetary discipline thanks to Nixon's nixing of the Bretton Woods financial regime when he unilaterally – in the face of mounting financial pressure – decoupled the US dollar's relationship to gold bullion in 1971: 'Knowledge, information, and specialized education are just as much parts of capital ("knowledge capital") as is the most elementary labour of the worker' (Deleuze and Guattari, 1983, p. 234). In other words, Deleuze and Guattari knew that in a world of floating exchange rates and seemingly infinite credit, the removal of monetary restrictions (i.e. money's relationship to gold) demanded the imposition of new, less rigid and restrictive, forms of control designed to modulate social behaviour and individual desires invisibly and imperceptibly, but also ubiquitously and perpetually. Deleuze observed that the so-called disciplinary societies described by Foucault[1] relied on fixed boundaries and enclosures designed to hem humans within prescribed limits while ushering them from one enclosure to another: school > military > factory > hospital > etc.; societies of control, on the other hand, allowed for the breaching of the limits of the disciplining enclosures because the controlled subject will have internalized the expectations, affects and desires of those doing the modulating, diligently capitulating to the demands of the modulators in order to succeed at life, in order to better him-/herself. As Deleuze explains:

> Perhaps it is money that expresses the distinction between the two societies best, since discipline always referred back to minted money that locks gold in as numerical standard, while control relates to floating rates of exchange, modulated according to a rate established by a set of standard currencies. [...] The disciplinary man was a discontinuous producer of energy, but the man of control is undulatory, in orbit, in a continuous network.
>
> Deleuze, 1992, pp. 5–6

[1] Foucault has brilliantly analysed the ideal project of these environments of enclosure, particularly visible within the factory: to concentrate; to distribute in space; to order in time; to compose a productive force within the dimension of space–time whose effect will be greater than the sum of its component forces. (Deleuze, 1992, p. 3)

The monumental monetary shift inaugurated by Nixon, of course, was designed to facilitate money's ability to pursue its own ends – to endlessly and without restriction pursue and manufacture new markets in need of financing, to endlessly unleash credit (and debt) in order to keep up with the exponential debt-expansion that was needing servicing by money itself. The effect on the individual would be, Deleuze and Guattari foresaw, to service money's demands, to fill the gap left by the flight of manufacturing and capital to the Third World by embracing credit-driven consumption that, since 1980, has been greased by ever-shrinking interest rates for the privilege of borrowing (i.e. bringing into existence) the world's reserve currency – the US dollar: from 20 per cent in 1980 to 0.25 per cent in 2011. But while the incredible shrinking interest rate – or cost of money creation – served as a sort of carrot on a string for borrowers, the exponential power of compounding debt has led to a concurrent growth in individual and family indebtedness (in Canada, for instance, personal debt to personal disposable income stands at 150 per cent in 2011 – up from less than 100 per cent in 1995) (http://www.statcan.gc.ca/daily-quotidien/101213/t101213a2-eng.htm). So while this period of consumer debt-expansion has, until the credit crunch of 2007–8, attempted to keep pace with credit-money's need for nominal, debt-driven expansion, consumers in Canada (and the US) risk finding themselves so overburdened by debt-servicing that more borrowing will no longer be possible since future payments simply will not be able to be met. It is in this environment of debt-saturation that we now find the industry- and government-sanctioned push for 'financial literacy'; moreover, when the financial industry's enthusiasm for FinLit is looked at through the long-term lens of an unsustainable post–1971 expansion of credit (and debt) their motivation becomes clear: the debtor-class must be trained not to default in order to limit the risks that could – as we have seen with the demise of Lehman Brothers in the United States – topple the Ponzi-esque house of cards of the financial system itself (Minsky, 2008; Nesvetailova, 2008).

Educational policy's emphasis, then, on financial literacy must be regarded with great suspicion: Who, in the end, is being served? How is power – as it is distributed across the political and financial landscape – 'modulating' the situation for its own benefit and desires? For Deleuze and Guattari, the motivations behind educational policy (and legal systems, and government policy, etc.) are clear: the objective is to 'breed man' in the image of the system he/she is being made to serve. As they explained in 1983:

> All the stupidity and the arbitrariness of the laws, all the pain of the initiations,
> the whole perverse apparatus of repression and education, the red-hot irons, and

> the atrocious procedures have only this meaning: to breed man, to mark him
> in his flesh, to render him capable of alliance, to form him within the debtor–
> creditor relation, which on both sides turns out to be a matter of memory – a
> memory straining toward the future. Far from being an appearance assumed by
> exchange, debt is the immediate effect or the direct means of the territorial and
> corporal inscription process. Debt is the direct result of inscription.
>
> Deleuze and Guattari, 1983, p. 191

Power, then, must inscribe indebtedness on its subjects and, through life-long learning, teach him/her how to service it through what Graeber calls the paying of 'tribute' (2011, p. 367). Moreover, the breeding of the debtors is most effective when it begins when the debtors are young and at school, both contextualizing and accompanying them throughout their lives, defining their options and conditioning their potential: 'Far from being an appearance assumed by exchange, debt is the immediate effect or the direct means of the territorial and corporal inscription process' (Deleuze and Guattari, 1983, p. 190).

The conditioning must also breed social and economic competitiveness so that the aggression and resentment that might build up in individual debtors is expressed and distributed horizontally rather than vertically – so that the targets for annihilation are friend and neighbour rather than creditor and modulator. Indeed, when one of FinLit's legitimating rationales is that today's students must be prepared for an increasingly competitive world – one where globally and technologically interconnected debtors face off against one another in a race to the low-waged bottom – this only serves to objectify the ideological/financial oligarchy today's education system is being designed to serve. By pitting the employees of tomorrow against one another in a Darwinian pursuit of merit-based gains (whatever that might mean) the system is able to re-legitimize itself, dig in its heels and sow the seeds of its own perpetuation. Indeed, Deleuze presciently observed that the 'modulating principle of "salary according to merit" has not failed to tempt national education itself', and that 'just as the corporation replaces the factory', so too today's 'perpetual training tends to replace the school', which, in turn, is 'the surest way of delivering the school over to the corporation' (Deleuze, 1992, p. 5).

So let us make no bones about it: with the imposition of FinLit into elementary- and high-school education systems by corporations – particularly financial corporations that live off of the debt-peonage of their clients – the political process has paved the way for private financial interests to take over education in Ontario (not to mention other jurisdictions). The embedding of financial literacy training into all school curricula *after* the enduring economic

crisis of 2007–8 also demonstrates that the financial industry is most interested in 'helping' the public after the fact – after the bailouts, after the removal of mortgage risks from their books by the taxpayer (both in Canada and the United States), after the explosion of student debt – and prior to the next (perhaps final or decisive) financial meltdown. Indeed, now that so many sections of society have maxed out their metaphorical credit-card – from national and provincial governments to families, individuals, and students – the financial system has its own set of existentially-driven reasons to get serious about 'teaching' the rules of being an obedient and profitable (for them) debtor in order to assure that their collective and interconnected balance sheets will not be the next ones to implode. We are then, at a point of ubiquitous debt-saturation across vast (if not all) levels of society, and responsibility for tomorrow's cascading crises is ready to be placed on the shoulders of individuals apparently educated in the dark arts of financial literacy. It is, as Deleuze presciently observed, 'the beginning of something': in the case of the school system, this new beginning necessitates that the school system adopt 'continuous forms of control' and 'perpetual training'; he also suggests that this new finance-driven beginning requires the 'abandonment of all university research' that does not pave the way for 'the introduction of the "corporation" at all levels of schooling' (Deleuze, 1992, p. 7).

In light of this new beginning – this society of control – premised on the financial industry setting the education agenda by embedding their logics across all financial disciplines and by constructing and reinforcing a culture of competition for credit, Deleuze observes that today's and tomorrow's students are liable to embrace the new financialized terms being thrust upon them with open arms, believing that if they only play the modulated game on offer by the plutocrats correctly (i.e. according to the rules) they stand to win in what is being framed as a sort of merit-based life-lottery. Deleuze observes, for example, that today's young people 'strangely boast of being "motivated"', that they request and 're-request apprenticeships and permanent training' as a good faith and exuberant expression of trust in a system bent on providing for their well-being though education. But, Deleuze, warns, [it is] 'up to them to discover what they're being made to serve' (1992, p. 7).

Flows of capital and 'infinite debt'

I cannot help seeing those truly international, homeless, financial recluses who, with their natural lack of state instinct, have learnt to misuse politics as

an instrument of the stock exchange, and state and society as an apparatus for their own enrichment.

> Nietzsche, 2006, p. 93

Education is the best investment.

> Bernanke, 2007, p. 1

The business community has an obvious interest in how well our schools prepare students for a future in the workforce and should actively participate in the debate. But we all have a stake.

> Bernanke, 2007, p. 5

In so far as the success of Ontario students' futures relies on their being debt servicers to a financial oligopoly, the Task Force's recommendation to 'embed' financial literacy – as defined by the financial interests of the financial monopoly itself – is perfectly adequate in order to keep the game going a little longer. If, however, the objective is to educate today's students about economics and finance, then the recommendations of these 'Task Forces' are a failure. This failure is not merely one of explanation or of misallocation of resources, but more fundamentally a failure of the imagination: a failure to think beyond the confines of a money system that demands the creation and servicing of infinite credit on an increasingly finite planet; a failure to imagine a truly sustainable financial architecture wherein money itself becomes a publicly owned and controlled utility for the pursuit of socially beneficial ends. Indeed, the failure to even allow for the imagining of a financial system beyond our present one – one with two receding and increasingly destructive poles: (1) infinite credit expansion on the one hand, and (2) exponentially increasing indebtedness on the other – finds the Task Force's 'research' (and those who sponsored it) engaging more in indoctrination than education. For Deleuze and Guattari, of course, the co-mingling of the interests of the state (via the education system) and the interests of capital is integral to the workings of power. Moreover, as they suggest, the logic of the state/finance assemblage must, to be effective and to reproduce itself across generations, be internalized by the state's citizens, must become that which defines and orients their desire. The state, they argue, forms a 'metaphysical system' with two primary components to its processes of becoming: (1) 'its internalization in a field of increasingly decoded social forces forming a physical system', and (2) 'its spiritualization in a supraterres-trial field that increasingly overcodes, forming a metaphysical system' (Deleuze and Guattari, 1983, p. 222). What these two components rely on – echoing Nietzsche's analysis of guilt and its relationship to indebtedness (Nietzsche

1994) – is that the state/finance assemblage's subjects internalize a belief and a trust in their own indebtedness and that modulated mechanisms of control (social, financial, educational) be put in place capable of rendering indebtedness and 'bad conscience' infinite. As Deleuze and Guattari explain:

> The infinite debt must become internalized at the same time as it becomes spiritualized. The hour of bad conscience draws nigh; it will also be the hour of the greatest cynicism, that repressed cruelty of the animal-man made inward and scared back into himself, the creature imprisoned in the 'state' so as to be tamed.
>
> 1983, p. 222

As finance-capitalism continues to infiltrate society – and is increasingly embedded in public education systems – smaller and less obviously 'financial' socio-culture minutiae are being monetized in pursuit of new markets able to support finance-capital's need for endless streams of liquidity. This results, in turn, in capital parasitically feeding off the socius that gives it life. Finance-capital becomes, as Deleuze and Guattari warn, 'the full body, the new socius or the quasi cause that appropriates all the productive forces' (Deleuze and Guattari, 1983, p. 227). Money's pursuit of new markets, and its attempts to mobilize money's users to satisfy its own ends, functions to usurp the desires that its subjects never knew they had (and were never able to have). Money's demands, then, saturate the social field, creating the complete conditions upon which decisions are made, options laid out, and futures afforded. The relative financial illiteracy of the population – including elementary- and high-school students destined upon graduation to be offered the rope of post-secondary education student loans with which to hang themselves – is a product not of the inadequacies of the education system, but of the demands of money itself to conceal through complexity and obfuscation its appetite and its need to consume productive sources of energy to feed its insatiable debt-servicing requirements. In a particularly prescient passage Deleuze and Guattari ask: 'And what about the effects of money that grows, money that produces more money?' The effects, they point out in their book on capitalism and Oedipal logics, are that the manufacture of desire, lack, indebtedness 'depend on [money] rather than being its impetus'. For them money's flow brings desire along with it for the ride; it follows, of course, that the ride's destination will be chosen by money itself rather than by the desires of those that are its passengers. Deleuze and Guattari answer their own question as follows:

> For it is a matter of flows, of stocks, of breaks in and fluctuations of flows; desire is present wherever something flows and runs, carrying along with it

interested subjects – but also drunken or slumbering subjects – toward lethal destinations.

<div align="right">Deleuze and Guattari, 1983, pp. 104–5</div>

Money, then, from Deleuze and Guattari's vantage point, is lethal, killing not only the potential to desire *differently*, but any potential at all that does not correspond with money's non-human (but human-devouring) demands. So while the effects of money's demands take time to materialize (indebtedness is always best imposed upon a blank slate full of apparent potential), they always lead to the same lethal conclusion (at least if one is not the creditor). Money's mechanism, in other words, operates as a magical vortex, extracting wealth incrementally and across generations at the same time as it seems to produce it. As Deleuze and Guattari put it: 'In a word, money – the circulation of money – is the means for rendering the debt infinite'; for the state/finance assemblage's role as 'infinite creditor' (i.e. lender of last resort and too big to fail) has abolished the existence of more 'finite debts', resulting in the infinite debt becoming a more generalized 'debt of existence, a debt of the existence of the subjects themselves'. Indeed, they observe that a 'time will come when the creditor has not yet lent while the debtor never quits repaying, for repaying is a duty but lending is an option' (Deleuze and Guattari, 1983, pp. 197–8).

Conclusion

The financial literacy education programmes being promoted by government-sponsored groups such as the Canadian Federal Government's Task Force on Financial Literacy and the Province of Ontario's Working Group on Financial Literacy, and the financialized curricula implemented in 2011 by the Government of Ontario are all designed to define the 'knowledge' and financial understanding of financialized actors from a young age (financial literacy in Ontario is now being embedded across the curriculum starting in Grade 4 and continuing until Grade 12). This training, rubber-stamped by Canada's big banks and insurance companies, is designed, as Deleuze and Guattari describe, to 'breed' future consumers, borrowers and debtors according to the parameters set out by those institutions, whose interest is served by inculcating students in a financial literacy curriculum of their own design, one where debt is not to be avoided, but managed and embraced.

Preparing students from the bottom up for a life of debt-servicing is

particularly apt in light of the fact that funding for Canada's education is persistently being squeezed from the top down. That is, in the face of the systemic debt-saturation problems facing the world and its governments, one effect has been for elementary- and high-school students to foot an increasingly large portion of the bill if and when they decide to pursue yet more education at a public university or college (as recent protests in Quebec reveal, many students are not happy with this). Higher education costs, then, are being downloaded onto students rather than being taken up by governments. Indeed, university tuition in, for example, Ontario has exploded over the past decade – since 1990 university tuition in Ontario has gone up 244 per cent (Shaker and MacDonald, 2011). This increase in tuition has resulted in graduates being burdened with an average debt load of $26,700 CAN. This debt load plus interest (currently around 4 per cent) leads, of course, to far larger amounts being owed. While this debt burden might serve as a good reason to inculcate students with financial literacy training in earlier years, the debt burden faced by today's students is as much a function of government spending priorities as it is about larger fiscal realities. As Shaker and MacDonald point out, the corporate tax cuts to corporations worth $1.6 billion for fiscal year 2011–12 that the Ontario Government gave to corporations could have been put towards rolling back university tuition to 1990 levels (adjusted for inflation) (2011). Given these realities, the relationship of the Government of Ontario to corporate interests seems clear: not only will the Government of Ontario bail out corporations when they require the funds and provide them with exorbitant tax cuts along the way, it will also precondition the workforce to service these same corporations' need for profit by breeding a student population trained – from the beginning – to service the financialized desires of a modulating system of political/financial control that agnotologically manufactures ignorance using education and economic prosperity through exponentially growing layers of debt.

References

Bernanke, B. S. (2007) 'Education and Economic Competitiveness'. Remarks by Mr Ben S. Bernanke, Chairman of the Board of Governors of the US Federal Reserve System, at the US Chamber Education and Workforce Summit, Washington, DC, 24 September 2007. Available at www.bis.org/review/r070928a.pdf (accessed October 2011).

CBC News. (2011) 'Family Debt-to-income Ratio Hits Record: Debt Rises 78% in

20 years, To an Average of $100,000' (accessed October 2011). http://www.cbc.
ca/news/business/story/2011/02/17/vanier-institute-household-debt.html?ref=rss
(accessed October 2011).

Chevreau, J. (2011a) 'Does the Financial Services Industry Profit from Financial
Illiterates?', *Financial Post*. Available at http://opinion.financialpost.com/2011/02/11/
does-the-financial-services-industry-profit-from-financial-illiterates/ (accessed 13
October 2011).

—(2011b) 'Financial Literacy: Does the Industry Really Want Us to be Educated?,
Financial Post. Available at http://www.financialpost.com/personalfinance/Financ
ial+literacy+Does+industry+really+want+educated/4266178/story.html (accessed
October 2011).

—(2011c) 'Readers Sound Off over Financial Literacy', *Financial Post*. Available at
http://opinion.financialpost.com/2011/03/07/readers-sound-off-over-financial-
literacy/ (accessed October 2011).

Deleuze, G. (1992) 'Postscript on the Societies of Control', *October*, 59: 3–7.

Deleuze, G. and Guattari, F. (1983) *Anti-Oedipus: Capitalism and Schizophrenia*.
Minneapolis: University of Minnesota Press.

Government of Canada. (2011) 'Enhancing Financial Literacy: Continuing in the
Next Phase of Canada's Economic Action Plan'. Available at http://www.actionplan.
gc.ca/initiatives/eng/index.asp?mode=2&initiativeID=323 (accessed October
2011).

Government of Ontario. (9 November 2010) 'Financial Literacy Part of Student Success
and Strong Economy'. Available at http://www.news.ontario.ca/edu/en/2010/11/
financial-literacy-part-of-student-success-and-strong-economy.html (accessed
October 2011).

—(28 February 2011) 'Teaching Students How To Manage Money.' Available at http://
www.news.ontario.ca/edu/en/2011/02/teaching-students-how-to-manage-money.
html (accessed October 2011).

Graeber, D. (2011) *Debt: The First 5,000 Years*. Brooklyn, New York: Melville House.

Ministry of Education. (2011) *Financial Literacy Scope and Sequence of Expectations
(Resource Guide: The Ontario Curriculum Grades 9–12)*. Ontario Ministry of
Education. Available at www.edu.gov.on.ca/eng/document/policy/FinLitGr9to12.
pdf (accessed October 2011).

Ministry of Education: Working Group on Financial Literacy. (2010) *A Sound
Investment: Financial Literacy Education in Ontario Schools (Report of the Working
Group on Financial Literacy)*. Ontario Ministry of Education. Available at www.edu.
gov.on.ca/eng/Financial_Literacy_Eng.pdf (accessed October 2011).

Minsky, H. (2008) *Stabilizing an Unstable Economy*. New York: McGraw-Hill.

Nadeau, J. F. (2009) *The Insured Mortgage Purchase Program*. Library of Parliament,
Canada. Available at http://www.parl.gc.ca/Content/LOP/ResearchPublications/
prb0856-e.pdf (accessed October 2011).

Nesvetailova, A. (2008) 'Ponzi Finance and Global Liquidity Meltdown: Lessons

from Minsky'. Working Papers on Transnational Politics, City University, London, October. Available at http://openaccess.city.ac.uk/1286/ (accessed August 2010).

Nietzsche, F. (1994) *On the Genealogy of Morality*. New York: Cambridge University Press.

—(2006) 'The Greek State', in K. Ansell-Pearson and D. Large (eds), *The Nietzsche Reader*. Oxford: Blackwell Publishing, pp. 88–94.

Proctor, R. (2008) *Agnotology: The Making and Unmaking of Ignorance*. Stanford, CA: Stanford University Press.

Roberts, J. and Armitage, J. (2008) 'The Ignorance Economy', *Prometheus*, 26 (4): 335–54.

Royal Bank (2011) Available at http://www.rbcroyalbank.com/products/personalloans/royal_credit_line.html (accessed October 2011).

Shaker, E. and MacDonald, D. (2011) 'For Ontario's Low- and Middle-income Families, Paying for University Involves Priority Roulette'. Available at http://www.policyalternatives.ca/publications/commentary/ontarios-low-and-middle-income-families-paying-university-involves-priority (accessed October 2011).

Task Force on Financial Literacy. (2010) 'Canadians and Their Money: Building a Brighter Financial Future'. Available at publications.gc.ca/collections/collection.../fin/F2–198–2011-eng.pdf (accessed October 2011).

Willis, L. E. (2008) 'Against Financial Literacy Education'. University of Pennsylvania Law. School Public Law and Legal Theory Research Paper No. 08-10 and Loyola University Law School, Los Angeles Legal Studies Research Paper No. 2008-13. Available at papers.ssrn.com/sol3/papers.cfm?abstract_id=1105384 (accessed October 2011).

Amputating the State: Autonomy and La Universidad de la Tierra

Matthew Carlin

The problem of education is not an ideological problem but the problem of the organization of power: it is the specificity of educational power that makes it appear to be an ideology, but it's pure illusion.

<div align="right">Gilles Deleuze, 2009, p. 36</div>

The State is desire that passes from the head of the despot to the hearts of his subjects, and from the intellectual law to the entire physical system that disengages or liberates itself from the law.

<div align="right">Gilles Deleuze and Félix Guattari, 1983, p. 221</div>

Unitierra: Not a school

A dusty road leads up to La Universidad de la Tierra (the University of the Land, also known as 'Unitierra') on the outskirts of La Colonia Ampliación Maravilla en San Cristóbal de Las Casas, Chiapas, Mexico. San Cristóbal is the main colonial town in the state of Chiapas, the southernmost state in Mexico as well as home to the largest percentage of indigenous people in all of Mexico. It was also, famously, one of the primary sites for the 1994 neo-Zapatista uprising where indigenous people from all over Chiapas took over the seven major towns of Chiapas and began their long journey towards the creation of what they call an autonomous life.

San Cristóbal lies high in the mountains, almost 7,000 feet up and is populated by a mixture of *coletos* – typically light skinned, wealthy economic and political elites who still claim some affinity and connection to the original Spanish colonizers in the region, and the indigenous Mayan peoples (the

Tzotziles, Tzeltales, Choles, Tojolobales, Mames, etc.) who are poor, largely uneducated, and live on the margins of the town. The town is named after one of the first bishops of Chiapas, Bartolomé de las Casas, who was known as that 'protector of Indians'– a benefactor of 'Indians' for the simple fact that he advocated using Africans instead of 'Indians' as slaves. The city was founded in 1528 and served as the capital of Chiapas until 1892, when Tuxtla Gutiérrez took over as the primary urban and political centre of the State – about the same time that Mexico annexed the state of Chiapas from Guatemala. The combination of being the last state to be formally annexed to Mexico and, at the same time, being a state full of 'Indians', speaks to the way that Chiapas has always seemed to have one foot in and one foot out of the nation.

The city's link to the old colonial days is as evident in starkly defined lines between the rich and poor as it is in the actual homes one comes across while walking around – run-down shanty towns that exist on the surrounding hills on the outskirts stand in contrast to the adobe, red roofed buildings in the centre of town rumoured to be some of the oldest original colonial structures in the whole of Latin America – with the oldest of these, called La Paloma (reportedly the oldest in all of Latin America) now serving as a trendy restaurant and night spot for tourists. Sitting almost 7,000 feet above sea level, the days are filled with intense sun, while the nights are almost always cool – a contrast that seems to do nothing but reinforce the social and cultural forms of stratification that exist between the people who inhabit this place.

In spite of its size – less than 100,000 people – it is still an urban area and as such it is (unlike much of rural Chiapas, where formal education is either non-existent or terribly insufficient) the home to many elementary, middle, and prep schools. There are also a number of universities in San Cristóbal: the Autonomous University of Chiapas (UNACH); the Center of Superior Anthropological Research (CIESAS); and the Chiapas Highland University (UACH), among others. There is one university, however, that is not part of the national system of schools and universities and that is La Universidad de La Tierra – the University of the Land or *Unitierra* as it is often called by locals. In fact, in spite of the use of 'university' in the title, *La Universidad de La Tierra* is, from the perspective of those who work there, not a school at all. It is, however, part of a larger education project called The Indigenous Intercultural System of Informal Education that, along with *Unitierra,* includes the Indigenous Center for Integral Work, the Center for Intercultural Studies, the Center of Immanuel Wallerstein Studies, and the University Center of Open and Distance Education, all of which are all located on the same 20-acre parcel of land.

To get to *Unitierra* from town is not difficult, but it is located on the periphery of San Cristóbal, on a stretch of hills that surround the city. The hills are forested – covered in young pine trees and rocks that sporadically appear amidst eroded top soil – and are not that high. However, at the top, one can see the whole of San Cristóbal and the way that the four principal churches are aligned on the edges of town in the shape of a cross.

The university was not always located in the place where it currently stands. *Unitierra* started as a school on the opposite side of town as a project of the Catholic Church and Bishop Samuel Ruiz – the famous liberation theologian who died in 2011 and drove the local coletos crazy with his constant talk of working for a better life for the poor and indigenous people. *Tatik,* the Mayan word for father, is what his congregation called him out of reverence.

In its original spot in 1983, the project began as a vocational school for indigenous students. It was a way for youth from surrounding rural communities to train for a trade that might allow them to someday find a job as a mechanic, carpenter, hairdresser, shoemaker, electrician, etc., while helping to provide monetary relief to their own farming communities that typically have only sporadic or seasonal access to actual money.

Six years later, in 1989, the school moved from one side of San Cristóbal to its current location in the northern part of the town, and in the process cut all previously-established connections it had to civic life, including the use of any resources traditionally supplied by the government, including electricity, land, and water. Although in 1989 the full force of the political upheaval that would accompany the enactment of NAFTA (the North American Free Trade Agreement) and the rise of the neo-Zapatistas in 1994 were still to come, the decoupling of *Unitierra* from any and all government support or sponsorship is an indication that the dreams of neo-Zapatista autonomy were already well on their way to coming to fruition in the late 1980s.

Unitierra is easy enough to visit provided that one has a specific intention, for example if you know someone who works there, someone would like to learn more about *Unitierra* or someone attending one of various academic events that occur throughout the year and are open to the public. *Unitierra* students sometimes attend the academic events, but the majority of the attendees come from the surrounding community and universities.

As one gets closer to the entrance, the beautifully designed and brightly coloured buildings become more visible. The buildings are made of brick and wood, brightly coloured and painted cement, wooden frames, and orange tiled or red aluminum-roofs. An open garage that serves as a training centre for

mechanics sits about 50 metres in front of the entrance, where cars and trucks of various sizes stand out front. Other buildings are situated to the left and right, with each one serving as a site for a specific kind of training, study, and learning. The majority of one- and two-storey buildings (there are eight in total) are circular, and all of them are painted with a specific colour that indicates its function. These buildings are often two-floor structures that have multiple open rooms and levels. The spatial organization within the structures allows for different tasks and kinds of work/training to be going on simultaneously.

Gravel and dirt paths weave between all of the different structures in the area. The building with the orange trim is the site where students learn to be electricians, learn to do metalwork and soldering, and repair electronic equipment. The yellow building is the art building, where students can learn to draw, paint and sculpt. The pink building is the university health centre, where students work and train as nurses while learning about basic nutrition and forms of healthcare. The green buildings mark the site of the university farm, where rabbits, pigs, chickens, sheep, and ducks are bred, and a variety of vegetables are grown. There are also buildings where students can learn to weave, train in computer science and computer repairs, learn architecture and design, study music and learn to play marimba, piano, guitar, harp, accordion, violin, trumpet and saxophone, and to sing. In each site, the students not only learn a particular skill, but also learn how to take care of and repair the equipment they use.

There is also a *tortillería* on campus, a communal kitchen and dining area where all of the students come together, taking turns to serve, cook and clean. There is also a chapel where the entire community comes together for services and other gatherings, separate sleeping quarters for men and women, and a building that serves as a centre for academic seminars, classes, and conferences that are attended by both students and faculty from different parts of Chiapas. For director Raymundo Sánchez, *Unitierra* was created in response to the growing need to provide indigenous youth, who are for one reason or another unable to attend a local school, the possibility to develop a skill or train for a profession regardless of their level of official, State-sponsored schooling. According to Sánchez, the three primary pedagogical goals are: (1) to learn by doing; (2) to learn to learn; and (3) to learn to be more, in terms of developing an autonomous existence as a 'countertendency' to the modern world. As Sánchez (2005), points out, this 'countertendency' might only have 'the power of an ant', but it is something they are completely committed to.

The first principle, 'to learn by doing', is a product of the fact that students can come and be part of *Unitierra* for a few weeks, one month, nine months,

or longer. Regardless of the amount of time that students are away from or able to leave their communities, *Unitierra* is organized and facilitated in a way that allows students to immediately benefit from their time there by immediately being engaged in specific kinds of vocational activities and collective, autonomous life. As soon as they arrive, they begin to study and work.

The second principle, 'learn to learn', is oriented toward helping students become better self-learners. This self-learning coincides with the autonomous, collective life that exists at *Unitierra* and in dispersed autonomous Zapatista municipalities which refuse to rely on government institutions as the source of their education.

The third principle is what Sánchez claims is the most important, namely that the collective life of the school and the kinds of activities and education taking place at *Unitierra* work to maintain the kind of life that exists in indigenous communities, where greed, although present, does not dominate everyday life. As a deterrent to the mathematicization of the social body and concomitant privatization of social needs inherent to neo-liberal global capitalist culture,[1] the kinds of pre-colonial forms of collective and collaborative relationships to each other and the land, typical of many rural indigenous communities today, are maintained and defended as an integral part of the everyday lives of the students who live and work there.

The specific activities and workshops in which these students are trained are organic agriculture and technology that is organized around the spheres of domestic, artisanal and technical kinds of work and training. All of the students that participate in these activities, regardless of their specific sphere of training, also participate in workshops focused on community nutrition and health issues.

The recognition for this education project is sought in the indigenous communities it serves in Chiapas, avoiding at all costs, its legitimation and capture by the State. In other words, the State does not recognize the kinds of education taking place at *Unitierra,* and the students and facilitators who live and work at *Unitierra* prefer it that way.

In total about 400 or so students live, study and work at *Unitierra*. Any and all of these students are allowed to participate in as many of the organized workshops and training sites as they want and which their schedule allows. The students come from all around the state and speak a variety of languages, including Tzeltal, Tzotzil, Tojolobal, Chol and Mam. In spite of the language

[1] See Berardi (2012) for more on this link between mathematics and global finance.

differences that are more pronounced among the young women who enter the university and often do not speak Spanish, all of the students work, sleep and study together. These students also take an active role in the functioning of the school, including both making and serving breakfast, lunch and dinner to all the people that work and reside there. A rotating schedule ensures that everybody participates, at one time or another, in all of the work necessary to keep the school functioning. Students who have been engaged in their chosen field of work/study also participate in facilitating and helping new students in their work.

There are no prerequisite requirements for entrance, and tuition and living on site are free. With food (including the corn and masa – dough made from corn), water and energy provided in the grounds, and furniture and clothing made there, *Unitierra* is almost completely self-sufficient. However, students, along with their parents and parish representatives, must have a meeting the director before being admitted. Students arrive from the surrounding mountains and jungle with the simple desire to learn a trade that will allow them to make a small amount of money for themselves and their families, and also to actively explore and participate in the expansion of the plan for indigenous autonomy in Chiapas.

Autonomy and el Estado

The Zapatistas – the indigenous-led Anarcho-Marxist social movement that took the world by storm in 1994 and has since almost completely disappeared from the public eye, continue their attempt to create an autonomous life more than 19 years after their initial uprising. Although there is no official or formal acknowledgement of *Unitierra*'s connection to the Zapatistas, there are political murals of EZLN (Zapatista Army of National Liberation) commanders that adorn buildings that are named after such figures as Immanuel Wallerstein and Ivan Illich. There are also whispers that Raymundo Sánchez was one of the original commanders of the EZLN during the 1994 uprising. What really leaves little doubt, however, as to the connection this non-school has to the Zapatista movement, is their embrace of the concept of autonomy.

So, what does it mean to say that a school or university is autonomous? What does it mean to say that *Unitierra* is autonomous? Autonomy here should be understood as the creation of a life at a distance from the State – not simply the local, state and national government – although in a very strict sense that is

exactly what the Zapatistas have done. To be an EZLN autonomous community or family is to accept nothing from the official government – any advice, gifts, help, resources or anything. And to do otherwise, even if it is a small bag of cement or the 2,000 pesos (US$170) that the government sometimes provides for *campesino* families to help them between harvests, is to be expelled from the movement and the governing and military structures that define it. The strict avoidance of involvement in all State-sponsored institutions has been quite controversial – with many families and communities being dropped from the movement simply for sending their children to the local, government-sponsored schools.[2]

However, this question of living at a distance from the State is more than simply not participating in official governing institutions.[3] Although created in the early 1970s, Deleuze and Guattari's conception of the *Urstaat* – what they used to refer to the earliest, original manifestation of the State – is arguably one of their most important political conceptual innovations. It is the *Urstaat* that creates the kinds of collective subjectivities that ensure that productive labour and accumulation find their way into every aspect of contemporary life.[4] This is an especially important concept for understanding what is at issue for this indigenous-led social movement that has been working towards the creation of

[2] The autonomous rebel municipalities that make up the movement are organized around six different locations of government spread out through the eastern half of the state that are called *caracoles* (snails) and serve as collective centres of decision-making designed to foster a life and existence outside of the purview of official, local, state and national government – at least in terms of how these institutional structures have habitually been conceived. In each *caracol* there is a diverse range of ongoing autonomous education projects that serve as the formal education outlet for Zapatista youth.

[3] A fact that differentiates the Zapatista attempt to defend collective forms of life and social organi-zation (including education) from the hyper-individualistic, libertarian current that dominates global capitalism today beneath the veneer of 'freedom' that is celebrated by the profiteers of the marketplace – a trend that inevitably fails to differentiate between a critique of government and a critique of the State As anthropologist Viveiros de Castro (2010) has pointed out, the individual and all of the rights granted to the protection of individuality over and above the socius are dependent upon the State for protection. A society with a State is a society that is thoroughly divided, bound together only through the desire of the despot who serves as a model for the individuals created from the division in the socius. As a result, Castro rightfully claims that 'the individual is a product and correlate of the State ' (p. 30). The result of this confluence of concepts that regularly utilizes the term 'government' interchangeably with 'the State' is that the state becomes interchangeable with society, so that each individual has become its own State. The individualism bound up with free-market libertarianism gives birth to a million little states. Or, as the case is in the US, 300 million little States.

[4] It is also an aspect of Deleuze and Guattari's political work that makes it impossible to genuinely engage with their thought in terms of something along the lines of policy – educational policy or otherwise – for at the core of policy is the inherent presumption that one group of people knows what is best for another. As David Graeber (2004) states, 'the notion of policy presumes a state or governing apparatus which imposes its will on others. "Policy" is the negation of politics; policy is by definition something concocted by some form of elite, which presumes it knows better than others how their affairs are to be conducted … it is inimical to the idea of people managing their own affairs' (p. 9).

an autonomous existence based on the simultaneous defence and re-creation of pre-colonial forms of collective life – a life whose autonomy is based on the elimination of the State from its presence.

So, for Deleuze and Guattari, what exactly is the State? It is well known that Deleuze and Guattari's work on the State emerged out of a sustained engagement with the work of anthropologist Pierre Clastres, who questioned the evolutionary theories endemic to Marxist theories of societal change that traditionally viewed the emergence of the State as the result of the appearance of increasingly complex forms of socio-economic life – a life that grew in tandem with the spread of the capitalist division of labour. By contrast, Clastres posited that the State is something that has always existed, and that those who have managed to avoid its grasp are those peoples (specifically 'primitive' peoples for Clastres) who created the kinds of socio-cultural mechanisms that worked to avoid the imposition of the State. In other words, the earliest/original forms of Stateliness (the *Urstaat*) – the consolidation of power in a few hands, the hierarchical organization of society, a monopoly in the 'legitimate' use of violence, and the ability to forcibly extract profit/riches from the work of others – is always lurking around the corner. While this ideal State has been enacted to varying degrees of success, such despotism has served as the 'horizon' of all that the State desires to be. Those who have managed to avoid such Ur-aspects of Stateliness did so not as a result of an accident, luck or an 'undeveloped' form of socio-economic organization that predated the advent of capitalism, but rather through a form of socio-cultural organization intentionally designed to prohibit, or limit the possibility of, the formation of the State. Why have 'primitive' peoples organized themselves around deterring the formation of the State? Precisely because they are well aware of the consequences of its emergence.[5]

It is frequently argued that the spread of neo-liberal global capitalism has rendered the State – specifically the nation-state – impotent in the face of the decodifying and deterritorializing aspects of our economic reality. While capitalism works in a decodifying capacity in the way that it breaks down territories, languages, traditions, ways of life, social connections, and the decision-making capacities of local and national governments, among other things, the State functions by way of capture. Instead of the dissolution of the State in the face of these massive deterritorializing aspects of the global economy – an assumption that is believed to be true to the degree that one

[5] See Graeber (2004) and Clastres (1987, 2010) for more on this argument regarding 'primitive' peoples' and the State.

believes that the State is that which works *alongside* the socio-economic sphere – the despotic aspects of Stateliness have now begun to invent new codes (Deleuze and Guattari, 1983, p. 218). In other words, the despotism of Stateliness has also been released to work in conjunction with neo-liberal global capitalism to the point that it now has begun to seek out new territories to code. No longer is the State oriented towards capturing those territories existing externally to the socius – in the form of what Marx famously called primitive accumulation – but it is now oriented towards the codification of internal territories (where primitive accumulation is also now directed inward), making the State indistinguishable from society. While limits are overcome or deterritorialized in neo-liberal capitalism, they are overcome only in order to be more stringently reterritorialized or captured in a way that makes them seem immanent to the State/capital bond (Toscano, 2005, p. 45). What is more is that with increasingly complex advancements in communication technologies, the forms of primitive accumulation aimed at the interior of the socius and the capture of the affects, desires and emotional energies of the populace seem to be limitless.

Although there are certainly specific axioms at work in our neo-liberal global capitalist world – ones that work to ensure the proliferation of capitalist accumulation to ever new and emergent territories, there is also the production of specific values that work in tandem with capitalist axiomatics in order to make the sustenance and growth of global capitalism seem absolutely unavoidable. Such values today include increasing forms of competition, envy, and greed, all of which are directed towards the capture of the remaining commons, the destruction of our environment, and the spreading of non-democratic polities, among other things.

The project of autonomous education and the project of *Unitierra* work to uncouple indigenous Mayan peoples from the contemporary social values that have been mapped upon the land and its inhabitants since the foundation of the nation. These are the same kind of social values born out of the cartographic markers that appeared over 500 years ago and slowly built up over time to the point where State and society are no longer distinguishable – a cartography that quantified and domesticated Mayan peoples and their lands as so many men and women, sources of gold, potential slaves (depending on their size and physical strength), heads of sheep, acres of wood, and potential votes guaranteed through the donation of a few extra bags of cement.

Here we should think of the Spanish word for State due to the way it serves as a clue to the operation of Stateliness in the context of formal education in

Mexico – especially with regard to the poor or those living on the margins of the nation. The word for State in Spanish is *Estado*. However, this word also refers to being – specifically, the past participle of *estar* 'to be' that not only indicates a specific kind of being, but also insinuates some kind of ossification of that being – as in what you are now could very well continue into the foreseeable future. To think the State is necessarily to conceive of the capture of being to ensure what has been will continue as it is and remain immanent to the State/ capital nexus. To continue as it is, is to be part of the strict segmentarity inherent in the State and its capitalist axiological machine that spreads itself out to the point of simultaneously extinguishing the appearances of any singularities while dissolving the separation between State and society.[6]

In this context we can understand the education system of the nation-State as a kind of mapping where *el estado* is dead set on continuing the 500-year-old process whereby what was at its very inception continues to be. Mapping its calculating rationality and its inherent infusion of value onto those things that come under its purview, is nothing less than the physiognomy of the State that makes itself evident in formal schooling by constituting the parameters around which indigenous students are to understand themselves within the socio-cultural and neo-liberal economic context of contemporary Mexico. These students are identified as so many sources of cheap labour, potential voters to be bought off, and inhabitants of communal lands whose value is marked in dollar signs (the very thing that Marx identified as magical, in the supposedly very secular universe of capital).

In the case of the Zapatistas, their criticism has historically been directed towards what they call *el mal gobierno* (the bad government). The *mal gobierno* is a government that relies on a system of co-optation through vote fixing and partronage for *coletos* (those who claim Spanish ancestry) and the landed elite that has existed in uninterrupted form since the annexation of Chiapas from Guatemala in 1824. Of course, during this time, there have been countless examples of indigenous uprisings and organized violence against the State and the political elite, of which the Zapatistas from 1994 are only a continuation.

Unitierra is a product of this history. It continues to be an attempt to create a centre of learning that is not a 'school' but rather a new kind of education that allows indigenous youth from around the state a chance to acquire skills and apply them to the creation of a life – *una buena vida* (a good life) that is

[6] See Eduardo Viveiros de Castro (2010) for more on the way that the non-existence of singularities are related to the subsumption of society by the State.

specifically opposed to *una mejor vida* (a better life). As it has been explained to me, *una buena vida* is a life disentangled from the desire and greed inherent in endless accumulation, and is indicative of an ethos that works to escape from an existence that is rendered solely through the eyes of *el mal gobierno*. *Una buena vida* does not entail the constant drive for betterment – for 'a better life' necessitates constant competition and the striving for an existence that puts all of our survival in jeopardy.

To think of how our existence could be otherwise – this State of things and being – is necessarily to think about an autonomous life. To be autonomous is to be free of the cartographic markers that determine Stately being – and as such to reconsider the way that formal education takes place.

The pedagogue of objects and the gas generator at *Unitierra*

Célestin Freinet, the great French teacher and philosopher of education who worked in rural France in the early to mid-twentieth century influenced a range of activities and research related to group dynamics in institutional settings. As a result of his work as a teacher, Freinet served as the one of the primary intellectual influences in the development of what came to be known as 'Institutional Pedagogy' – a psychoanalytic and urban initiative based in Paris and by Jean and Fernand Oury that focused on better understanding the relation between the unconscious of students and processes of learning. Although primarily uninterested in issues pertaining to psychoanalysis, Freinet's work in the classroom served as a great inspiration for the Oury brothers and eventually for Félix Guattari as well, particularly in terms of creating new kinds of group work that challenged the traditional static and hierarchical organizational forms endemic to institutional life. Most notable of these organizational innovations was 'the grid' – a schedule at La Borde clinic where Oury and Guattari worked that attempted to alter the traditionally defined roles and responsibilities of everyone who worked there, including those of patients and analysts. As one of the primary intellectual influences of institutional pedagogy, Freinet is typically described as a tireless advocate for the democratization of the classroom that proceeded through a collaborative approach to student writing and work. This characterization of Freinet as a champion of student initiates and collaborative learning places him firmly within the context of the 'child-centred' educational philosophy of Maria Montessori, Rudolf Steiner, John Dewey, Olvide Decroly and others that was emerging in the early twentieth century. While

these characterizations are true to some degree, they do not fully account for Freinet's innovations. His most enduring contribution to pedagogy was to do with how he conceived of and utilized objects as a centrepiece of his approach to teaching and learning. For Freinet, objects were not ancillary to the more pressing concerns of the ideological role played by curriculum, but rather the driving force in changing the organizational dynamics and social relations of the classroom. Freinet's approach to liberating the classroom from the organon of the State – appearing as much in the dogmatism and reifying dimensions of traditional government-sponsored pedagogy as it did in the French Communist Party's approach to education – was to place objects at the foreground of his teaching and thus place his trust in the power of organization.

Why is Freinet the pedagogue of objects? Freinet is known for placing a printing press in the middle of his classroom. Although he was not the first to utilize a printing press in the classroom, he became well known for using it as a centrepiece in incorporating work and initiating collective-writing projects into the classroom on subject matter decided upon by the students themselves. Strangely enough, his use of the printing press was, at least in part, due to a serendipitous lung injury he sustained in the First World War that made it difficult for him to stand and lecture in the traditional way that teachers in France were trained to do in the early part of the twentieth century. While never specifically discussing the role of objects in his teaching, his use of the printing press in the classroom suggests that he regarded them as conceptual tools, which when unleashed within the context of a classroom had the potential to change the kinds of predetermined relationships that typically existed between students, students and teachers, and also between students and their own work in French schools.

Through the introduction of the printing press into his classroom, the classroom was fundamentally changed. This change was played out through the appearance of one object and the corresponding disappearance of another. The printing press was placed in a central location in the classroom and, as a result, the podium was eventually removed from its primary position in the front of the classroom. The basically teleology of the classroom and how learning was to occur was fundamentally altered as the teacher no longer occupied the same place of authority. A more diverse range of activities and subjects began to be reintroduced into the classroom, not through the implementation of specific curricula, but rather through the aggregate that was created as the students began to engage with and became plugged into the new object that suddenly stood before them as a centrepiece of their learning environment, connecting

them to topics and readings they would never have engaged with otherwise. Traditional hierarchical relationships in the classroom began to dissolve, including that between the students and the teacher. It was the introduction of the object and the work on and through this object taken up by the students that formed new collective learning processes and forms of social organization that helped the classroom become completely free of the limitations, rules, relationships and regulations that saw students sit rigidly in front of the teacher as he recited pre-prepared lessons on history, the nation and the culture in which they found themselves.

The investigations initiated by the students that often took them into their community typically focused on topics and issues related to them and their families' lives in the farming community surrounding the school. These student-driven investigations that took them on explorations into their own communities, along with the corresponding collaborative forms of writing and care of the printing press, formed the basic elements of Freinet's emphasis on work and vocationalism.[7] Freinet's focus on work in the classroom did not take the form of instrumental training, but rather of something conceived of as integral to and indistinguishable from the kind of collective organization of social life they wanted to create beyond the bounds of their institutional setting. The result was that the practice of teaching and the life of the school became free from their traditional forms of support and legitimacy as students, within an institutional setting, became actively engaged in the social life of their community.

New assemblages began to be created within the confines of Freinet's classroom, replacing traditional, institutionally designed directives and government-mandated forms of teaching and learning that emanated outward from the platform and lecture format that accompanied it. The end result was a release of new desires that escaped the impasses of the State. With the arrival of the printing press, the State was subtracted from Freinet's classroom; serving as a foil to the institution's intention to 'conserve.'[8]

For Deleuze (1993), this act of subtraction was exactly what was at work in the plays of Carmelos Bene. It was Bene's theatre, Deleuze argued, that brought traditional plays to life not through criticism, but rather through alterations to the characters that typically drove the story lines and determined the kinds of

[7] The investigations often had to do with exploring the kinds of work that was taking place in their community.

[8] For Deleuze and Guattari (1987) the goal of the State is always to conserve and this is exactly why we can speak of the State in terms of its Spanish translation as *el estado* (p. 357).

sets used in the traditional rendering of the plays he was working with. These alterations took the form of what Deleuze (ibid.) described as 'subtractions' and 'amputations' from the original production. For Deleuze, Bene's act of subtraction of specific characters from a play, 'gives birth to and multiplies the unexpected as in a prosthesis' that brings to life the potentiality of characters that were previously masked (p. 205). In one example, Bene 'amputates Romeo from *Romeo and Juliet*, awakening the previously dormant qualities of Mercutio's life for the first time. For Deleuze, the way that Bene alters a play so as to render it anew made him less of a director than a 'surgeon' or an 'operator' in the sense that these procedures of modification to the body of the play had to take place with absolute precision. In some examples, Bene amputates characters such as Romeo, while in others, he amputates entire structures of power from the plays, as in what he did to the rival families in his interpretation of *Richard the Third*.

Particularly significant is the way that Deleuze reminds us that Bene's acts of subtraction change not only the actual materials in the theatre, but also the 'representational' logic that produces it. By taking away primary, 'stable' components necessary for the reproduction of theatre as 'representational', his creations become a permanent space of 'disequilibrium' that escape the State's desire to conserve. For Deleuze, Bene's work as a surgeon of the theatre becomes the work of a war machine (ibid., p. 207).[9]

If we transpose Deleuze's thought about Carmelo Bene's plays into the context of school where the classroom becomes a theatre with a set and the teacher is conceived as an 'operator', similar questions arise with regard to the dynamics of power, namely how does one extricate a genuine education from a State education, and how does one extricate genuine thought from the thought of the State?

With Bene, as well as with Freinet, such a process of escaping the State does not occur through mere ideological alterations – which in the case of the theatre, Deleuze reminds us, would amount only to the creation of parody or the adding of literature to literature (ibid., p. 205). With school, the focus on ideology most frequently yields a change in the wording in the curriculum – a critique of power focused on alterations to language. A genuine education and thought, however, appear at the point that changes in the organizational dynamics of the institutional setting create new kinds of prostheses that are able to avoid the kinds of impasses that have become standardized – impasses

[9]　Deleuze compares this approach to theatre to the work of Brecht, who is focused on the written word and not the stage (p. 212). Next to Brecht's prioritization of the ideological, Bene's focus on the organization elements of the stage become more clearly identifiable.

that determine the way that students learn and the people within the classroom relate to one another. For Deleuze, the power that is on display in educational settings is less a product of ideology than it is reflective of the organization of the people within that space, the groups that are formed, the interactions that take place, and the decision-making processes that emerge from such groups.

For Bene, the reorganization of theatre that allows for the potential to extricate plays from the representational logic of the State of things operates by way of a subtraction that focuses on the role of new characters who had previously been concealed from view. It is the characters that give 'caprice' to the objects that surround them – infusing them with significance and determining their utility.

While Freinet's intentions are similar, his approach to the set of his classroom operates through an opposing logic. Instead of subtraction, he adds, and instead of prioritizing characters/students, he prioritizes objects. It is the objects for Freinet that give 'caprice' to the students. Something leaves the scene, but the process of subtraction is less drastic, less immediate – not so much reliant on a cut as it is a deterioration. Amputation occurs, but the amputation is the end result of a growing uselessness. The great object of the State in the classroom – the platform – that enables the professor to profess and thus grants him the power to instil in his subjects all of the representational logic inherent in their culture, their history, and the curriculum that reproduces the French nation is rendered useless in a similar way that particular objects of the set of Romeo and Juliet became frivolous upon the amputation of Romeo. However, it is the new prosthesis created through the interaction of the students and the printing press in Freinet's classroom that renders the platform useless, dead, and withered to the point that it falls away. Through addition in Freinet's classroom, the State is removed.

The printing press that was introduced into Freinet's school carried no predetermined prescription; nor did it carry any predetermined intention or aim. In each object, there are various dimensions and limitations (both affective and useful) that determine the specific potentialities that exist as part of any situational aggregate. However, as Guattari (1995) reminds us, 'everything depends on its articulation within collective assemblages of enunciation' (p. 5). In this case, the printing press and its potential was situated in the middle of the classroom space and utilized in such a way that the act of learning became entwined with a process of collective social organization. The end result was that the classroom escaped the traditional subjection of student energies to the whims of the State, transforming the space of Freinet's school and his students' work into a source of micropolitical activity.

So what does the work of the pedagogue of objects have to do with *Unitierra?* The description at the beginning of this chapter was written with the intention of focusing on some of the visible objects that make up *Unitierra.* This was not done with the sole intention of creating a mise-en-scène so much as to bring attention to the aesthetic of the place and the objects that compose it. It is this world of both conceptual objects in the form of autonomy and education, along with the material objects of buildings, materials, colours, plants and animals that come together to evoke the world that is *Unitierra.*

But of course this is not a democracy of objects – all the objects that make up *Unitierra* are not the same, nor do they assume equal importance in the creation of this autonomous educational project. Some of these objects have a distinct importance in terms of facilitating the existence of this place – one such object is the gas generator that exists within the confines of a brick structure about 14-feet high and 10-feet wide. There is nothing particularly exceptional about this structure – it is a simple brick building with a roof made of red clay tiles and a green painted wooden door on the side with painted murals covering the outer walls that depict scenes from rural, indigenous life in Chiapas. From the top of this structure a cloud of black soot spews out in tandem with a loud humming of a machine – a humming that can be heard around campus.

When one enters *Unitierra* it might be easy to ignore this structure; after all it is surrounded by much more important-looking buildings that are bathed in bright paints with neatly kept cobbled walkways that weave in and out of the buildings, greenhouses, duck ponds, and rabbit hutches that sit on the hill opposite the main entrance. However, there is no other object that is so central in enabling this project of autonomy to exist. With this object, the students and workers here are able to physically and materially uncouple themselves from the dependence on the federal government and all the associated forms of patronage and manipulation that have gone hand-in-hand with this colonial relationship over the past 500 years. The creation of *Unitierra,* as well as its ongoing development and use, is absolutely dependent on the existence and maintenance of the gas generator that provides the electrical and material power necessary to create this autonomous territory out of nothing.

As one moves through the university, walking in and out of the buildings and around the campus, one becomes plugged into these rumblings in the same way that every building, machine and classroom is also plugged into the energy that emanates from it. There is something rightly anarchic, and formless, about the sound as it moves and reverberates between and within buildings, and then seeps through the chain-link fence that surrounds the land, drawing and

expanding upon the desire for an autonomous life as it touches the students and teachers who live there. To this end, the object is not just a product of the imputation of value from within to without – an idiosyncratic or social value projected into an object that surrounds us – but also simultaneously a holder of a particular organizational potential and value within the context of this group in much the same way that the printing press served as a focus of collective work in Freinet's classroom. It is the gas generator within this collective educational formation that has provided *Unitierra* with the capacity to focus on the removal of particular inhibitions that have been in place for generations – particularly the ability to work together and participate socially outside of the confines of their own communities and within institutional settings of their own making.[10] Without such a physical uncoupling from the State that the gas generator enables, the contact between people would be largely determined by the capitalist ethos and the concomitant privatization of reproduction that dominates every sphere of Mexican life.

Deleuze argues that what Bene's rendition of the life of Marquis de Sade indicates through the amputation of the sadistic master is that 'the slave is not at all the reverse image of the master, nor his replica nor his contradictory identity: he constitutes himself piece by piece, morsel by morsel, through the neutralization of the master; he gains his autonomy through the master's amputation' (p. 205). Although in many cases, Zapatista autonomous education projects are often forced initially to rely on the spaces, methods, organizational techniques and curriculum of the State (often, that is all they have ever known), the uncoupling from the government structures that have created a debilitating relationship between indigenous peoples and the nation of Mexico has allowed for the possibility of the extrication of the master.

To conclude, the gas generator is the source from which the ongoing reconceptualization of education by and for indigenous students proliferates – their anarchic experimentations with new ways of learning remaining intact. In this way *Unitierra* exists as a pedagogical lesson of sorts through the ways that it provides a salient example of how education can depart from the status of a State institution through the addition of objects that lead to the reorganization of the social life of institutions. The school is what has been left behind at *Unitierra*, and in its place is an education of open constitution – one that works to prepare

[10] See Guattari (1995) for a further discussion about the importance of removing those kinds of superego-induced prohibitions that limit peoples' ability to participate socially (p. 146).

students for an autonomous life, 'a good life', and a life organized outside of the purview of the State.

References

Berardi, F. (2012) *The Uprising: On Poetry and Finance.* New York: Semiotext(e).

Clastres, P. (1987) *Society Against the State.* New York: Zone Books

—(2010) *Archeology of Violence.* New York: Semiotext(e).

Deleuze, G. (1993) *The Deleuze Reader*, ed. C. Boundas. New York: Columbia University Press.

—(2009) 'Capitalism: A Very Special Delirium', in F. Guattari (ed.), *Chaosophy: Text and Interviews 1972–1977.* New York: Semiotext(e).

Deleuze, G. and Guattari, F. (1983) *Anti-Oedipus: Capitalism and Schizophrenia.* Minneapolis, MN: University of Minnesota Press.

—(1987) *A Thousand Plateaus: Capitalism and Schizophrenia.* Minneapolis, MN: University of Minnesota Press.

Graeber, D. (2004) *Fragments of an Anarchist Anthropology.* Chicago: Prickly Paradigm Press.

Guattari, F. (1995) *Chaosmosis.* Bloomington, IN: University of Indiana Press.

Sánchez, R. (2005) 'Entrevista con Dr Raymundo Sánchez Barraza, 8 de Julio, 2005, Chiapas'. Available at http://autonomiazapatista.com/Entrevistas/entrevistas_2.html (accessed December 2012).

Toscano, A. (2005) 'Capture', in A. Parr (ed.), *The Deleuze Dictionary.* Edinburgh: Edinburgh University Press.

Viveiros de Castro, E. (2010) 'The Untimely Again', in P. Clastres, *Archeology of Violence.* New York: Semiotext(e), p. 9–51.

Chaosmic Spasm and the Educational Chaoide

Franco 'Bifo' Berardi

Social subjectivity is continuously changing as a result of the never-ending transformation of the psycho-cultural composition of the collective mind, and as a result of the concatenation between the Infosphere and the mind.

The process of reproduction of social life involves the hard matter of the physical evolution of the environment, but also involves the soft side of intention, perception and imagination. We call subjectivity the soft side of social becoming, and we call subjectivation the process of molecular decomposition and recomposition that leads to the evolution of subjectivity.

One can view the becoming of social subjectivity as the solution and mix of various chemical substances melting together. Consciousness is only the epidermic surface of the perpetual process of decomposition and recomposition that Felix Guattari names subjectivation.

Subjectivation is an endless process of permanent recomposition. However, sometimes human groups tend to fix this ceaseless process of transformation in the forms of identity. Identity is an effect of territorialization of the process of subjectivation, and an attempt to freeze the process of continuous recomposition.

But in the anthropological space of modern capitalism, deterritorialization is the prevailing process, and identities are ceaselessly blurred, confused and disjointed so that the reaffirmation of identity generally requires a violent reaction of reterritorialization that often takes fascist and obsessional forms.

The refrain (*ritournelle*), which is the expressive chain linking the subject of enunciation and the cosmos, can harden and in turn halt the deterritori-alization process. In the case of neurotic identity, the refrain is embodied in hardened representations, as an obsessional ritual or an aggressive reaction to change.

The process of subjectivation is primarily influenced by the speed of the Infosphere and the rhythm of neuro-psychic elaboration of the info-stimulation coming from the surrounding environment.

In the current mutation induced by info-technology and economic global-ization, the social organism is subjected to an accelerated deterritorialization that takes the form of a spasm.

In his last book, *Chaosmosis* (1995), Guattari says that '(A)mong the fogs and miasmas which obscure our *fin de millenaire*, the question of subjectivity is now returning as a leit motiv ...' (p. 135). He goes on to add that 'all the disciplines will have to combine their creativity to ward off the ordeals of barbarism, the mental implosion and chaosmic spasms looming on the horizon' (ibid.). What is the chaosmic spasm that Guattari is talking about?

As far as I know, Guattari did not use this expression anywhere else in his work. Only here, in his last book, published in 1992, the year of his death, he speaks of spasm: chaosmic spasm.

The age of neo-liberal darkness

In the year 1992, the world powers met in Rio de Janeiro to discuss and possibly come to a decision about pollution and global warming which were increasingly a threat to human life on the planet. American President George Bush Sr declared that the American way of life was not negotiable, meaning that the United States did not intend to reduce carbon emissions, energy consumption and economic growth for the sake of the planet's environmental future. In fact, North Americans have refused to negotiate and to accept any global agreement on this subject.

Today, twenty years later, the devastation of the environment in terms of both natural and social life has reached a level that seems to be irreversible. Irreversible is a difficult word to say. It is a word that is totally incompatible with modern politics. When we utter this word, we are declaring *ipso facto* the death of politics itself.

What about the process of subjectivation when the surrounding environment is irreversibly devastated? What about social recomposition when the capitalist capture of social subjectivity is irreversible?

In *Chaosmosis* (1995) Guattari argues that: 'Subjectivity is not a natural given any more than air or water. How do we produce it, capture it, enrich it and permanently reinvent it in order to make it compatible with universes of mutating values?' (p. 135).

The problem is not to resist, nor protect existing forms of subjectivity. Rather, the problem is to invent a form of subjectivity that is compatible with the context of a mutation and simultaneously autonomous and independent of the corrupting effects of the context itself.

Guattari is not merely speaking of change, but more precisely of mutation. Mutation is a word that comes from the field of biology, and implies a process of morphogenesis. Put differently, mutation implies the emergence of new forms that cannot be interpreted or managed within the framework of the previously existing universe.

Guattari says also that we need to produce new subjectivity, and we have to make possible the re-singularization of subjectivity. That means that we should invent a subjective conscience that is free from the surrounding devastation, corruption, subjection and violence that the environment is constantly producing.

But how can we create autonomous subjectivity (autonomous from the surrounding corruption, violence, anxiety)? And can autonomous subjectivity truly be produced in the age of spasm?

Twenty years ago, the neo-liberal age started producing its effects: pollution of the physical environment; pathogenic acceleration of the infosphere; devaluation of labour; and the privatization of social services and resources. The Rio de Janeiro Summit in 1992 marked the emergence of broad-ranging social consciousness about the looming devastation of the environment. It also offered us the first glimpse of the irreversibility of this devastation that was dramatically confirmed in Copenhagen in December, 2009.

In *Chaosmosis* (1995) Guattari writes 'we have to … ward off barbarianism, mental implosion, chaosmic spasm' (p. 135). This expression marks the consciousness of darkness, and of the pathology that capitalism is producing in the planetary environment and particularly in the social mind.

Mental implosion and chaosmic spasm are mentioned together, as a premonition: the new millennium as an age of fog, miasmas, and obscurity. Now we know that the premonition was not so far from true. Twenty years after the publication of this book, we know that the fog is thicker than ever, and the miasmas are not vanishing, but instead becoming more dangerous and more poisonous than they have ever been.

Guattari had never before spoken of the time to come in terms of obscurity. Nor had he ever before spoken of spasm. In his previous books – and in the books written in collaboration with Gilles Deleuze – the process of deterritorialization and acceleration that marks the passage beyond modernity was

described in terms of desire, expansion and richness. Only in the last year of his life did Guattari begin speaking of 'spasm'.

Spasm

What is a spasm? In the medical lexicon, a spasm is a sudden involuntary, generally painful, contraction of a muscle.

In the context of the analysis of social subjectivation, I would say that a spasm is an excessive compulsive acceleration of the rhythm of a social organism – a sort of forced vibration of the rhythm of social communication. In other words, a spasm is a painful vibration that forces the organism to an extreme mobilization of nerves and muscles.

We should understand this acceleration and this painful vibration in relation to the contemporary environment of cognitive work and nervous exploitation. The acceleration produced by info-technologies submitted to capitalism is the environment of semiocapitalism.

When cognitive energy becomes the main force of production, and as capital valorization demands more and more productivity, the nervous system of the organism is subjected to increasing exploitation.

Guattari has always seen info-machines and technology in general as a factor of enrichment, of mind enhancement, and of social liberation. But machines interweave with the capitalist economy and this interaction results in effects of subjection whose finality is the continuous increase of productivity and exploitation. It is within this context that the spasm emerges as an effect of a violent penetration of capitalist exploitation into the field of info-technologies which acts on the sphere of cognition, of sensibility, and of the unconscious.

In other words, sensibility is invested by info-acceleration, and the vibration induced by the acceleration of nervous exploitation is the spasm: spasmic effect. So, what should we do when we are in a situation of spasm? In order to answer such a question we need to consider the entire concept that Guattari develops. It is not, after all, simply the term 'spasm' that we must consider, but rather the 'chaosmic spasm'.

Before turning our attention to the term 'chaosmic' I want to digress by way of discussing the concept of desire. The reason for this is to dispel a potential misunderstanding that might cloud our conception of the term 'chaosmic spasm' in relation to social transformation and the infospheric dimension of the unconscious.

Desire and the organic body

Anti-Oedipus was published in 1972, twenty-three years before *Chaosmosis*. We should keep in mind this temporal difference, and the historical significance of this difference if we want to fully appreciate the tone that accompanies the words utilized in these two books. *Anti-Oedipus* (1972) is the book that promotes desire as a force of subjectivation and liberation. *Mille Plateaux* (*A Thousand Plateaus*), published in 1981, is the book that proposes rhyzomatic proliferation as the methodology for understanding the space of desire and the becoming of language.

Desire and rhizomatic proliferation are the molecular processes that have dissolved the modern classical form of repressive neuroses. However, during the twenty-years separating the publication of the *Anti-Oedipus* (1972) and the publication of *Chaosmosis* (1995), a new form of post-modern power has taken shape. This new form of power exhibits rhizomatic features and is aimed towards the capture and exploitation of desire.

The new form of power – that Michel Foucault (2010) has called bio-political power – can be essentially described as a rhizome feeding itself with pathogenic investment of desire. The collective dimension of the unconscious, being submitted to prolific forms of advertising, televised image, debt, ceaselessly mobilizes the nervous energies of the social body.

The dark side of desire cannot be ignored any more. I would even say that desire is not a force. Rather desire is a field where the most important dynamics of social communication develop, where social movements find their energy, and where the basic struggle between work and capital takes place.

The processes of aggregation and disgregation, essential forms of social composition and basic forms of power tranformation are all deploying themselves in the field of desire.

This is the great theoretical breakthrough that *Anti-Oedipus* (1972) made possible. But this breakthrough has been an object of misunderstanding. We have been led to believe that desire is a force of liberation in itself, and this misunderstanding of desire has sometimes blurred our possibility of comprehension. A certain kind of triumphalism and unilateral exaltation of the multitude, which is a special feature of the Negri-Hardt thought, is based on this misunderstanding of desire.

The energy of desire is not boundless, because the body of desire is organic. In other words, like the body, it is prone to sickness and suffering and death. The acceleration of the infosphere and boundless intensification of attention

fostered by semiocapitalism have pathogenic effects on the body of desire. Desire is taken in the spasm: panic and depression are the dimensions of the spasmodic capture of desire.

In *Anti-Oedipus* (1972) Deleuze and Guattari work out the relation between phenomenology of neurosis and political potential of psychosis, and this elaboration is essential for a acquiring a better understanding of the problem of autonomy in the age of semiocapitalist deterritorialization.

In the age of Freud, neurosis was the prevailing pathological category: desire was denied and removed, and repressed energy was accumulated in a space of denegation. This is why in the framework of Freudian theory, psychoanalysis was essentially about expressing the repressed and hidden contents of the unconscious.

In our present framework of spasm, semiocapital arouses and mobilizes expression, up to the point of a hyper-expressivity that produces psychotic effects.

The Italian psychoanalyst Massimo Recalcati speaks of '(M)an without unconscious' (2010, p. x). What he meant by this is that the context of social imagination is continuously expressed, and thus nothing is left in the dark of the unconscious.

In the space of neurosis, desire was denied in order to give way to the fantasmatic and interiorized potency of reality. On the other hand, in the psychotic space of semiocapitalism, reality itself is denied in the name of the proclaimed boundless potency of desire.

However, the potency of desire is not boundless, because desire has organic, as well as cultural and economic, limits. The desiring body is, in fact, an organism situated within cultural and socio-economic conditions.

This is why we are currently witnessing a new phenomenon that was invisible for the schizoanalytic conception of the autonomous movement of the 1970s.

Drawn by the intensity of semiotic flows that take the physical form of an interrupted flow of neuro-electric substance, desire is captured by processes of acceleration that lead to the pathology of panic. The result is that the conscious sensitive organism (the physical stuff of which subjectivity is made) reacts in a panic mode.

The vibration of the desiring rhythm has grown so intense that singularization is unattainable and the mind is unable to tune into the flow of info-stimulation. The surrounding semiotic universe moves so fast and is so complex that a singular refrain of subjectivity has become impossible. Consequently, the organism enters a phase of panic marked by a hyper-intense painful

vibration that escapes the possibility of singularization and consciousness. In this situation in which suffering is the main feature of subjectivation, exalting the infinite potency of desire is pointless.

The spasm is the panic effect of the accelerated stimulation of the organism resulting from the accelerated rhythm of the Infosphere. The hyper-mobilization of desire succumbs to the force of the techno-economic exploitation of nervous energy.

Chaosmosis and chaoide

Why does Guattari use the expression 'chaosmic spasm'?
Why is the spasm understood as 'chaosmic'?
And what is 'chaosmosis' at the end of the day?

Chaosmosis is the creation of a new (more complex) order (syntony and sympathy) out of the present chaos, which is an effect of the spasmodic acceleration of the surrounding semio-universe. It is the osmotic passage from a state of chaos to a new order. But here the word 'order' has neither a normative nor an ontological meaning. Order is to be understood as harmony between mind and the semio-environment, and also as a sharing of the same mindset: sympathy as common perception. Chaos is when the infosphere goes too fast and the mind is unable to elaborate and comprehend the signs that are coming from it.

In the last chapter of their last book, Deleuze and Guattari (1994) speak about the relation between chaos and the brain. The conclusion of the book entitled *From Chaos to the Brain* starts with the following words:

> We require just a little order to protect us from chaos. Nothing is more distressing than a thought that escapes itself, than ideas that fly off, that disappear hardly formed, already eroded by forgetfulness or precipitated into others that we no longer master. These are infinite variabilities the appearing and disappearing of which coincide. They are infinite speeds that blend into the immobility of the colourless and silent nothingness they traverse, without nature or thought. This is the instant of which we do not know whether it is too long or too short for time. We receive sudden jolts that beat like arteries. We constantly lose our ideas.
>
> p. 201

Consciousness is too slow for processing the information that comes from the world of acceleration (info-technology multiplied by semiocapitalist exploitation); the world simply cannot be translated into cosmos, mental order,

syntony, and sympathy. Consequently we need a transformation, a jump to a new refrain, to a new rhythm. For Guattari, chaosmosis is the shift from a rhythm of conscious elaboration (refrain) to a new rhythm.

In other words, it is a shift in the speed of the processing consciousness – the creation of a different order of mental processing. The osmotic effect that relaxes the spasm and heals the spasmic sensible organism is based on the shift from a rhythm where there was only chaos to a rhythm that makes syntony possible again.

How can this happen? How can our mind perceive a different rhythm and, also, how can mind project its own universe according to a different rhythmic pattern?

In this process there is a neuroplasticity that overcomes the sphere of political action, of conscious and voluntary action.

What is the agent of the neuroplastic re-syntonization that Guattari names chaosmosis?

In order to understand the shift from one rhythm to another rhythm, from one refrain to another refrain, Guattari has proposed the concept of 'chaoide'. Chaoide, for Guattari, is an agent of re-synthonization that makes possible the reconstitution of an order where presently there exists only chaos. Chaoide is a linguistic agent whose purpose and function is to translate the spasmodic rhythm of chaos so that it can become harmonic and understandable. Chaoide is the form (artistic, poetic, political, scientific) that is able to transfer language into another dimension of speed existing outside of the spasmogenic rhythm being dominated by the language of finance.

The dictatorship of financial capitalism is the present spasmogenic rhythm, a spasm that is not only exploiting the work of men and women and submitting cognitive labour to the abstract acceleration of the info-machine, but also destroying the singularity of language, transforming language into a chain of automatic techno-linguistic interfaces. Where are the chaoids that we can use in this situation? Where are the concatenations that today give conscious organisms the possibility of coming out from behind the spasmogenetic framework of financial capitalism?

Financial dictatorship is essentially the domination of abstract language through the command of mathematical ferocity on the living, sensible, sensitive and conscious organism. Art, poetry, therapy and education are the fields in

which chaoids can be produced and put into action, in the present spasmodic condition.

Autonomy and education

Education is under attack. The privatization of the educational system has been one of the tenets of the neo-liberal counter-revolution during the past thirty years. In the wake of the financial crisis in the West and the concomitant calls for 'austerity', cuts to public funding have had a profound effect on cultural institutions, on all levels of schooling, and on all forms of university and scientific research. This has been particularly noticeable in Europe, where the privatization of the education system is a relatively new phenomenon in comparison to the United States.

The effect of this process of financialization and privatization is easy to predict: growing ignorance, violence, misery and precarity. The destruction of the educational system, converging with the acceleration of the Infosphere and the growing complexity of the semiotic environment, is one of the main features of the contemporary spasm. The protests of students and teachers in defence of public education systems (particularly in Europe) are not enough. New educational institutions have to be conceived and built as chaoids, healers of the spasmodic mind and the spasmodic body of society.

The modern educational process has been conceived as a process of critical transmission of knowledge. Because of the spasmodic condition of the social brain, the mind-format of teaching is diverging from the mind-format of the learner. As a result, the formal educational process is less and less effective in transmitting knowledge.

The transmission of knowledge is becoming more and more dysfunctional and empty. The mind-format of the connective generation is scarcely interacting (or not interacting at all) with the mind-format of the alphabetical generation. The spreading phenomenon of 'attention deficit disorder' is only one of the many examples and aspects of the decreasing functionality of educational systems in the present transition that is marked by the spasm.

In the connective sphere of techno-communication, mental energy is incorporated into the semiocapital process of production. This incorporation implies a standardization and formatting of the cognitive body. Bodily meaning and meaningful bodies become an impossibility as a result of the formatting process.

A decisive step in this process of *subsumption* of nervous energy and intellectual work by the techno-financial articulations of semiocapital is the destruction of the

modern institution of the university, and the building of a recombinant system of knowledge exploitation that demands the cancellation of knowledge autonomy while reducing the learning process to a mere acquisition of operational skills.

Autonomy was crucial in the conception and purpose of the modern university. Autonomy was not only independence from academic institutions, but the methodologies of scientific research and artistic practice as well.

In the humanistic sphere of modern bourgeois civilization, each field of knowledge was expected to autonomously establish its own laws: conventions, aims, procedures, forms of verification and change.

Consistently the university was based on two pillars: the first was the relation of the intellectuals to the city (i.e. the ethical and political role of reason and of research); and the second was the autonomy of research, teaching, discovery, innovation, and the production and transmission of moral, scientific and technical acquisitions.

The entrepreneurial bourgeois owner was strongly linked to the territory of his properties. He was also interested in the development of these properties, and knew that the autonomy of knowledge was necessary for achieving productive results. The long process of emancipation from theocratic dogma deeply influenced bourgeois culture and identity throughout modern times.

The financialization of the economy in the post-bourgeois era has led to the de-localization of work and information. The main trend of this transformation has been the formation of the *homo oeconomicus* (Michel Foucault, 2010) in which every act and thought has been translated into economic terms. This transition implies the abolition of the autonomy of knowledge, as the semio-capitalist economy gets hold of every space of social life.

Economics, which is now more a technology for the crystallization of time into capital than a science, has progressively assumed the central place in the system of knowledge and research.

Every act of research, of teaching, of learning, and of inventing is subjected to the following questions: Is it sellable? Is it profitable? Is it helping capital accumulation? Is it meeting the demands of corporate finance?

Those who do not recognize the primacy of the economic principle in the field of education, or those who refuse to worship the central dogma of the neo-liberal church by condemning the rules of competition, profitability and compatibility, are labelled as sceptics, non-believers, atheists and communists. The fate that awaits such miscreants is marginalization and expulsion.

The educational chaoide that we need is a sceptical institution for the re-activation of autonomy of knowledge from economic dogma.

Note on the creation of the European School for Social Imagination (SCEPSI)

In the wake of the financial crisis, in many countries of Europe dismemberment of the public educational system has started, and private profit is taking the place of the common goal of developing the general intellect for the interest of society as a whole.

In Europe, the process of dismemberment and privatization was planned and launched in 1999 with the signing of the Bologna Charter, whose explicit philosophy is to end autonomy of knowledge, making economic competition and profitability the basic aim of education.

In the Bologna Charter – an agreement signed by European education ministers – the formal subordination of teaching, research and learning to the new dogma of neo-liberal economics has been officially asserted. During the following decade, the privatization of educational structures has rapidly advanced, but the destruction of state schools entered a final phase after the financial crisis of 2008. Agencies of fractal, de-personalized cellular trans-mission have begun to proliferate at the expense of public systems of education. Their mission is the formation of flexible subjects who enter and exit from the recombinant process of production, and suffer under the ferocious rules of precarious exploitation.

Student and researcher movements that came to a head at the end 2010 have, in no uncertain terms, criticized the dictatorship of ignorance. However, in spite of their best efforts, they have not been able to stop the destruction of autonomous forms of knowledge.

The city of Bologna has been aptly chosen by the neo-liberal reformers, because nine centuries ago the first European university was founded there. The rise of the modern university was linked to the liberation from theological dogmas that had been the foundations of knowledge and civilization in previous times. The principle of autonomy has been foundational in the history of the modern university. Autonomy is not only a political or juridical feature of the university, but the essential mark of knowledge. Without autonomy, knowledge is nothing but propaganda or dogma: only the autonomy of research and teaching allows for the unfettered advancement of knowledge, and therefore progress in the field of technology and social development. The concept of autonomy occupies a crucial place in the definition of the modern university. This is not only a political concept, referring to the independence of the

academic institution, but an epistemological concept, referring to the inherent methodology of scientific knowledge and artistic practice.

In the transition from the bourgeois era of industrial capitalism to the digital financial era of semiocapital, mental energy (cognition) becomes the main force of valorization. This process implies a special kind of incorporation (Marx (1906) uses the word 'subsumption') of mental energy. This incorporation implies a standardization and formatting of the cognitive body: bodily meaning and meaningful bodies are erased as a consequence of the formatting process. A decisive step in this process of subsumption is the destruction of the modern institution of the university, and the building of a recombinant system of knowledge exploitation that demands the annulment of knowledge autonomy.

Each field of knowledge establishes its laws: conventions, aims, procedures, verification and change. During the bourgeois era, the university was based on two pillars: the relation of the intellectuals and the city, and the concomitant ethical and political role of reason; and the autonomy of the processes of discovery, innovation, and the production and transmission of moral, scientific and technical acquisitions.

The creation of the *homo oeconomicus* implies the abolition of the autonomy of knowledge because the economy now has a complete hold on social life.

The present process of so-called reform of the educational system in every country of Europe is marked by de-financing, cuts, job losses, and also by downsizing of the unprofitable disciplines (the so-called humanities), and supporting capital-intensive fields of research. The leading principle of the reform is the assertion of the epistemological primacy of the economic sphere. The financial collapse that has shaken the European political landscape has accelerated this process of devastation of the educational system, and submitted research to economic profit.

A wide movement of protest has spread from the United Kingdom to Italy and to Spain, but the dismemberment has not stopped, and it is now unthinkable that the educational system may be restored to its modern effectiveness and freedom. The public system of education is unable to face the proliferating and accelerating process of dissolution in the modern form of territorialization. So we have to move forward, if we want to reassert autonomy of knowledge in a form that is not the mere (impossible) restoration of the past forms of state education and universities.

Moving forward means creating new institutions of research and common learning and teaching which have to be conceived in the process of deterritori-alization that is called 'movement'. This is why in 2011 a group of researchers,

artists, scientists, and activists decided to create the European School for Social Imagination (SCEPSI).

Moving from the understanding that the modern university is dead, the European School for Social Imagination's aims are to re-establish the conditions for autonomy of knowledge and self-organization of precarious cognitive workers.

The school was publicly inaugurated in May 2011 in a neutral space, away from Italian barbarity and from European neo-liberal dogmatism: the state of San Marino, independent since the Roman Empire, and still an independent republic, within the Italian peninsula.

The first task of the European School for Social Imagination is a re-imagination of the European mission. The post-war mission of the European Union was peace and overcoming the traditional dichotomy between German Romanticism and French Enlightenment.

In the 1980s the mission of the Union was the coming together of East and West, and defeating the Soviet Empire. Now the mission of the Union seems to be only the dogmatic assertion of the primacy of the economic dogmas on knowledge, science and technology. This is no wonder if neo-Nazis were to do well in the national elections of many European countries, and any imagination of a European future would seem drowned.

In 1087 the university was created as a place for the elaboration of technical, juridical and conceptual features of the bourgeois society. Today autonomy of knowledge is the condition for the creation of the new forms that European society will build, in order to emerge from misery and depression, and the legacy of financial dictatorship.

This is the intention of SCEPSI. This is indeed an ambitious intention. But only courage and ambition can brave barbarity. By creating a space for the proliferation of autonomous knowledge, the school hopes to participate in a new process that is already starting from the margins, from outside the space of *homo oeconomicus*.

While analysing the decomposition of the educational system inherited from the past, we should be able to detect and connect the points of cognitarian self-organization rising from the experiences of conflict, movement, and from the processes of re-activation of the social body: insurrections. Conflicts and movements have been storming the European university since the autumn of 2010, and their influence will expand in the years to come. The aim of their strategy is not the restoration of former state education systems, but the creation of the institutions for self-organization of the general intellect. Scepticism

is the non-dogmatic stance that we adopt against economic dogmatism and neo-liberal arrogance.

References

Deleuze, G. and Guattari, F. (1972) *Anti-Oedipus*. New York: Semiotext(e).

—(1981) *A Thousand Plateaus*. New York: Semiotext(e).

—(1994) *What is Philosophy*. New York: Columbia University Press.

Foucault, M. (2010) *The Birth of Biopolitics*. New York: Picador Press.

Guattari, F. (1995) *Chaosmosis*. Bloomington, IN: University of Indiana Press.

Marx, K. (1906) *Capital: A Critique of Political Economy*. New York: Modern Library.

Recalcati, M. (2010) *L'uomo senza inconscio*. Milan: Raffaello Cortina Editore.

Index